60⁰⁰

Edward Weston

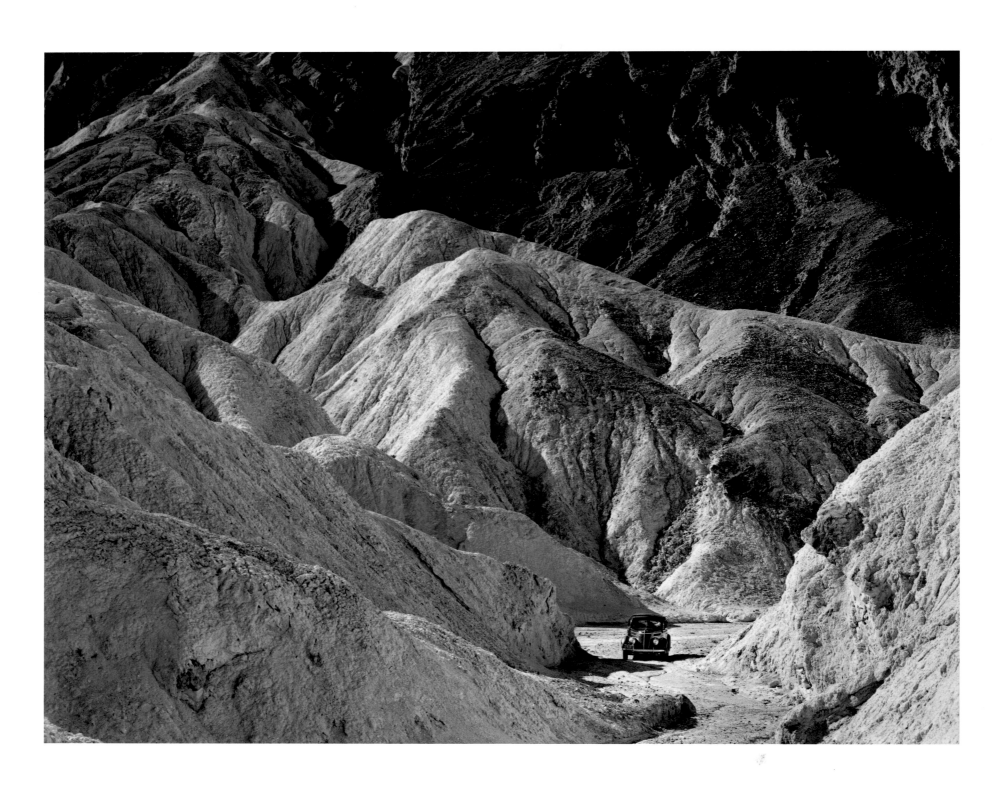

WESTON'S WESTONS

California and the West

KAREN E. QUINN

THEODORE E. STEBBINS, JR.

with a foreword by Charis Wilson

Museum of Fine Arts, Boston

in association with

Bulfinch Press / Little, Brown and Company

Boston · New York · Toronto · London

First Edition

Library of Congress Catalog Card Number 94-76350

ISBN 0-8212-2143-4

Jacket illustrations:
Front: Edward Weston, *Crab Apple Tree,* 1937.
Back: Inscription in Edward Weston's hand on verso of mount of *Crab Apple Tree*, 1937.

Frontispiece:
Edward Weston, *Heimy in Golden Canyon,* 1937.

Printed by Acme Printing Co., Wilmington, Massachusetts

Bound by Acme Bookbinding Co., Charlestown, Massachusetts

Tritone negatives by Thomas Palmer

Text edited by Troy Moss

Typeset in *Univers* and designed by Carl Zahn

"Weston's Westons: California and the West" was organized by the Museum of Fine Arts, Boston. The exhibition was held in Boston, July 22 to October 23, 1994; at the Museum of Art, Toledo, March 20 to May 28, 1995; and at The Phillips Collection, Washington, D.C., January 2 to March 10, 1996.

Bulfinch Press is an imprint and trademark of Little, Brown and Company (Inc.)
Published simultaneously in Canada by Little, Brown & Company (Canada) Limited

CONTENTS

FOREWORD by Charis Wilson

5

ACKNOWLEDGMENTS

7

INTRODUCTION by Theodore E. Stebbins, Jr.

9

WESTON'S WESTONS: California and the West by Karen E. Quinn

19

MAP of Weston's Travels: 1937–1939

38

PLATES

39

CHECKLIST

126

CHRONOLOGY

144

SELECTED BIBLIOGRAPHY

145

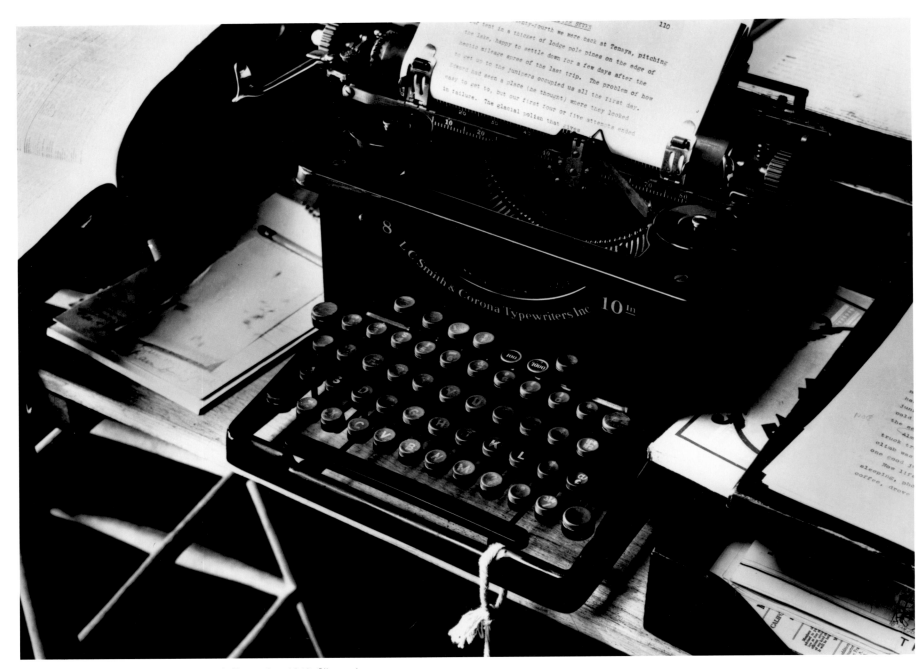

Fig. 1. Beaumont Newhall. *Charis Weston's Typewriter*, 1940. Silver print
(Chapter seven of *California and the West* is in the typewriter.)

CHARIS WILSON

In his early days as a photographer, Edward Weston felt it necessary to offer sartorial proof he was an artist — a flowing tie, a swirling cape, a jaunty walking stick. By the time we met, in 1934, the tricky costuming had been left behind along with the signature — "Edward Henry Weston" — that trailed down the side of those early soft-focus portraits. Now his photographs were sharply focused and printed on glossy paper, and his clothing consisted of flannel shirts, denim pants, and *huaraches*, the woven leather sandals he had discovered while living in Mexico in the mid-1920s.

Edward now believed it was better for an artist to be inconspicuous. He preferred that viewers react to the photographs rather than the photographer. However, his notion that he could blend into the background was unrealistic: his high dome of suntanned forehead, his large, alert brown eyes, and the poise of his lean body in motion and at rest, made him stand out in any group or place. He always seemed more alive and aware, more keenly focused, than the people around him.

When Edward and I first became acquainted, we were surprised to discover how many views and attitudes we had in common. Our opinions of movies, art, and literature usually coincided, as did our rejection of middle-class dress, manners, and morals. For a twenty-one year old and a forty-eight year old to have such similar outlooks seemed to us nothing short of miraculous.

The portraits and nudes Edward made of me that first year changed my whole image of myself, and although I suspected I was neither as fascinating to look at nor as handsomely formed as his photographs suggested, I could see that I was not as structurally defective as I had always imagined. This revelation gave me a great boost in self-confidence, augmented by my growing understanding that Edward was as much in love as I was. No matter how we laughed at our increasing attachment and told ourselves it could never last, our mutual hunger to find out everything about each other did not diminish.

The fact that I had fallen in love with Edward's photographs along with their maker probably did much to cement our union. I had never seen photographs like these before, and they overwhelmed me. I was dazzled by their depth and clarity; they seemed to communicate eloquently to an inner eye that had never been addressed. I marveled especially at the power of these images to fix themselves in my mind. Even when he photographed something backyard familiar — the radiating rows of a Salinas lettuce field or a

part of the Point Lobos whale skeleton my brother and I had climbed about on as children — it was Edward's vision that almost immediately replaced my own mental snapshots.

Years later, writing an essay for a Weston centennial volume, I came up with an explanation of Edward's special kind of vision that seems apt:

> …He often said, "When I find myself stopping to think, I know I'm on the wrong track." When Edward photographed, he tuned out the thought processes — the judging, comparing, weighing and studying that usually mediate our relations with the world — and simply opened his eyes to all that lay before him. If his picture was there, he usually saw it instantly, almost as if it leapt out at him and demanded to be photographed. In the absence of such compulsion, he either pointed his camera elsewhere or put it away.

I have difficulty believing that more than half a century has slipped by since Edward and I were criss-crossing the state of California as he sought out subjects for his portrait of the West. He had made it clear in his application for a Guggenheim Fellowship that "the West" did not refer to the tourist's vacationland of orange groves, old Spanish missions, and snow-capped Sierra peaks, but *his* West, which he said "might include the feather of a bird as well as the furrows of a plowed field."

But the fact is when we set out on our travels, in the spring of 1937, we were almost as ignorant of the varied territory of California as any tourist and most natives. We looked forward with intense excitement to getting off the beaten track and finding out what really lay on "the other side of the mountain." We asked Edward's friend Phil Hanna, editor of *Westways* magazine and a devoted traveler, to lay out six model trips for us, three in southern California and three in the north. The routes mostly kept away from well-travelled roads and took us into the unfamiliar country we were seeking. Hanna also gave us a contract: Edward would supply *Westways* with 8 to 10 photographs a month for $50, and I would furnish captions for the pictures and a paragraph or two about their location for an additional $15. This windfall paid for the new Ford V8 we christened "Heimy" and soon subjected to blistering sandstorms on the Mojave Desert, steep frozen grades in the High Sierra, and hubcap-swallowing mudholes in the hinterland of Modoc County.

I later described our traveling style from the viewpoint of a fictitious tenderfoot — F. H. Halliday — whose reactions

echoed those of real friends who had accompanied us on occasion:

> Anyone believing that all artists are impractical dreamers would be shocked to meet Weston, an eminently practical man. I don't know a businessman who could have done as much with a year of freedom and $2000. Weston and his (second) wife Charis planned the project of photographing the West in such a way that every possible cent would go for photography and travel. I made one trip with them, and if I ever saw living reduced to essentials, that was it.
>
> It was a week without radio, newspaper, or mail, without anything I would formerly have called a regular meal or a possible bed. The Westons didn't even carry a watch. For the first two days, during which we touched no settlement, I suffered sugarless — and creamless — coffee and saltless food. But even when these deficiencies were remedied, life was rough enough. In the morning — and I mean morning, four or five A.M. — we rushed into clothes, swigged down fruit juice and coffee, packed up the car, and were on the road before sun-up.
>
> After that the order of the day was dictated by the surroundings. Charis was chauffeur. She piloted Heimy (the travel-scarred Ford sedan) along at fifteen mph when the scenery was good, raced along at thirty-five if the going was dull. When Weston saw something he wanted to work with or investigate further, Heimy was halted, and the 8 x 10 camera was fixed to its heavy tripod. With that hoisted on one shoulder, the holder case in his free hand, Weston trudged off to examine his find. Meanwhile Charis pulled out her portable typewriter, set it up on the front fender, and pounded away at the daily log. If Weston made but a single negative, fifteen minutes would see us packed up and driving on. If he found several things to do we might stay half an hour or half the morning. There was no destination, no routine. One day we would cover a hundred miles, another day less than ten. One day would net two negatives, another day, eighteen.
>
> After a week of this itinerary I was not unhappy to return to the decadence of apartment-dwelling, as represented by hot bath, frigidaire, radio, tables and chairs...

Edward was in his early fifties on the Guggenheim; when I reached that age, I looked back with amazement at the rugged aspects of our travels, and at Edward's remarkable toughness. No air mattress to cushion the sleeper, no Coleman lantern to hold back the night, and, as Halliday says, "no tables or chairs." When we stayed in one place for a while, or in an official campground, a little more comfort was possible, but even with the tent up, a camp table and cupboard and a washroom handy, the going was pretty spartan.

What made this tolerable for Edward was his continuous excitement over the negatives he was producing. He knew he was doing new and important work, and that conviction sustained him through whatever difficulties and discomforts the journey imposed.

Time has proven him right. The Guggenheim years can now be seen as a pivotal point in his development as an artist, a period in which he created more than a thousand indelible images. More than 50 years after seeing the exposures made and viewing the freshly developed prints, my memory can call up a procession of these images, bringing them into sharp focus and present reality.

But, of course, present reality is entirely different. Much of California has undergone the kind of "improving" that tends to make all landscapes interchangeable: a proliferation of freeways, interminable strips of ugly commercial buildings, and the leveling of natural grades that once called for a shift down to second or even first gear. Gone are the sway-backed barns with their giant ads for flapjack flour and chewing tobacco; gone are the two-lane roads with their suspenseful verses about Burma Shave. Open meadows and crop lands, vineyards and orchards, have been squeezed out by housing developments, giant parking lots, and clusters of multi-storied buildings.

California of the 1930's is gone forever. Yet the state is vast, varied, and resilient, and it is still possible to get off the beaten track if that is one's intention.

The unique vision and extraordinary generosity of Mr. and Mrs. William H. Lane have made this exhibition and book possible. All of the photographs in the exhibition have been lent from the unequalled resources of the Lane Collection, whose holdings include about one-half of all the surviving vintage prints by Edward Weston. The vision of Bill and Saundra Lane has benefitted countless admirers of American art.

Charis Wilson has been our special guide to Edward Weston's "Guggenheim years," 1937-1939. She has provided us with rare insight into the photographic adventure she shared with Edward Weston, and we are deeply grateful for her help with every aspect of the project, including reading both of our essays and contributing her own elegant foreword to this book. Carl Zahn, Director of Publications at the Museum of Fine Arts, has been our collaborator on every detail of this exhibition. He assisted in the selection of the photographs, made thoughtful suggestions on the text and brought his talents as a designer to the production of this beautiful volume. Kelly Wise generously reviewed our selections and pointed out several outstanding prints that we had previously overlooked that are now included as plates. We are truly indebted to Deanna Griffin for her excellent research assistance throughout the project. In addition, we offer sprecial thanks to Jacqueline Dugas, Henry E. Huntington Library and Art Gallery, G. Thomas Tanselle, John Simon Guggenheim Memorial Foundation, as well as to Jane Funk, Rachel Harris, James Johnson and Ellie Rubin. We would also like to acknowledge the students in our 1993 graduate seminar on Edward Weston at Boston University: Marcella Beccaria, Loren Ferré, Deanna Griffin, MaryLouise Hoss, Kathryn Koslowski, Grayson Lane and Maura Lyons. Research on this project was significantly aided by an Aimée and Rosamond Lamb/Andrew W. Mellon Foundation Curatorial Research Grant awarded to Karen Quinn.

The quality of reproduction of Weston's subtle prints is due in large part to the expert photography of Richard M.A. Benson and Thomas Palmer, who made the tritone separations from the original prints, and to the craftspeople at Acme Printing Co. and Acme Bookbinding Co. who made the book a reality. We are also grateful to Eliza McClennen, cartographer, who designed the map illustrated herein.

At the Museum of Fine Arts, we received enthusiastic support for this project from Alan Shestack, former Director, and then from Morton Golden, Acting Director. We are indebted to many others for making this exhibition and catalogue possible: Harriet Rome Pemstein diligently prepared the manuscript through its many revisions and Troy Moss skillfully edited the text. The Department of Prints, Drawings, and Photographs has once again been enormously helpful, and we are grateful to our colleagues Clifford S. Ackley, Curator, and Roy Perkinson, Conservator, for all of their assistance. Gail English, Exhibitions Preparator, matted every print, and, with Tim Coultas and Norene Leddy, framed them beautifully. At the Museum we also thank Janice Sorkow, Director of Photographic Services, and Gary Ruuska, photographer; Michael Rizzo in the Design Department; Gilian Wohlauer in the Education Department; Rickie Harvey in the Publications Department; Marci Rockoff in the Paintings Department; Patricia Loiko, Associate Registrar; Désirée Caldwell, Assistant Director, Exhibitions, and Joshua Basseches, Jennifer Wells and Katie Glaser in the Exhibition Planning Department; and Nancy Allen and her staff in the William Morris Hunt Memorial Library.

Finally, we express our heartfelt thanks to Susan C. Ricci, Mike, Zoë and Molly Quinn, Norma and Joseph Quinn and Ellen and Paul Funk for their support.

K.E.Q. and T.E.S.

Fig. 2. Edward Weston. *Cypress Detail*, 1929
(Log no. 10T). Silver print

Fig. 4. Edward Weston. *Rocks*, 1930
(Log no. 39R). Silver print

Fig. 3. Edward Weston. *Rock Erosion, Point Lobos*, 1929
(Log no. 24R). Silver print

Fig. 5. Edward Weston. *Wood and Adobe*, 1933
(Log no. 33A). Silver print

INTRODUCTION

THEODORE E. STEBBINS, JR.

In 1989 the Museum of Fine Arts had the privilege of organizing an exhibition devoted to the figurative work of one of the most admired of all American artists, the photographer Edward Weston. That show and its accompanying catalogue, *Weston's Westons: Portraits and Nudes*, were made possible by the extraordinary generosity of Mr. and Mrs. William H. Lane, who shared with us the unequaled resources of the Lane Collection. It is our pleasure now to present the second in our series of exhibitions devoted to Weston's work, once again drawn wholly from the Lane Collection. This exhibition celebrates Edward Weston's work between April 1937 and April 1939, the two-year period when, having won a Guggenheim Fellowship, he found himself for the first time in his life with time and money enough to do whatever he wanted. As Karen Quinn explains in her essay that follows, these two years were perhaps the most productive of his life, not only in terms of numbers (roughly one-quarter of his total oeuvre was made during this brief time), but in terms of creativity as well. In these works, we see Weston concentrating on landscape for the first time in his career; in the process, he redefined his own style, and he produced an astonishing body of work which continues to influence photographers today.

The title of the present book, *Weston's Westons: California and the West*, recalls that the unparalleled holdings of beautifully printed vintage photographs in the Lane Collection were acquired directly from Weston's heirs, his sons Chandler, Brett, Neil, and Cole Weston, and his grandson Edward ("Ted") Weston.[1] These were Weston's own prints, the ones he would show to visitors to Wildcat Hill, and many still bear the photographer's personal inscriptions and notations. In addition, our title pays homage to *California and the West* by Charis Wilson and Edward Weston; that engaging volume, first published in 1940, tells the story of Weston's two "Guggenheim years," and it remains an essential source for his work of this period.

In 1922, Weston wrote that "some day photographs by the masters of the craft will be prized and valued as a Rembrandt or Whistler etching is now."[2] This prophecy, which would have seemed outlandish at the time to almost everyone, has come true. Not only are the works of Weston, Sheeler, Stieglitz, and others as highly valued — by critics, collectors, and the public — as great master etchings and engravings, but we now study and judge photographs in the same way that we examine older prints; students of photography now realize that every print made by a photographer from a given negative is unique, just like each impression pulled from an etched plate. Weston's extraordinary vision allowed him both to see, or "prevision," as he called it, the potential for a great photograph while looking into his camera's groundglass, and to print remarkably subtle, telling prints from his negatives. In a typical Weston print, every square centimeter has life; there are no dull areas. Moreover, in most of his prints he achieved a phenomenal variety of tones and textures, in much the same way that a great painter does; Weston's prints often evoke a feeling of color without using it. In the Lane Collection, one can see the real Weston as nowhere else, for on occasion we can examine up to a half-dozen Weston prints from the same negative. In addition, the collection includes enough "Project Prints" and prints from portfolios so that we can see what happened when Edward's negatives were printed by others.

As is now well known, Dick McGraw funded the so-called "Project," the printing of 838 of the best Weston negatives. The work took place during 1952 and 1953, at a time when the photographer was gravely ill, with the printing being done by Edward's eldest son, Brett Weston, who was assisted by his then-wife, Dody Weston, and his brother Cole. Between five and eight complete sets were made, only one of which remains intact today.[3] The ailing Edward Weston supposedly supervised, but the resulting prints are not vintage works, but rather represent collaborations of a sort between the father and his photographer sons. In them, one recognizes Edward's vision and subject matter, but if one looks closely and comparatively, one also finds Brett's own aesthetic in the print quality as well as Cole's eye in the selection. Though Edward was unwell, and writing was laborious for him, he did manage to sign many of the Project Prints with his initials.[4] In general, the Project Prints look flatter and less modeled than Edward's, with fewer subtleties and less life in the darks. In the present exhibition, we show four Project Prints (cats. 30, 39, 76 and 110) alongside vintage Westons of the same subjects (cats. 29, 38, 75, 109), in order to make these points clear (see figs. 6 and 7).

During the years before 1937, Weston had been eking out a living from commissioned portraits along with occasional sales of what he called his "personal work" at fifteen dollars a print. When he won the Guggenheim in 1937, he found himself miraculously free; what he now wanted to do was, in the words of his application to the foundation, "to continue an epic series of photographs of the West, begun about 1929." Thus before he began, he knew that he would give up both the slow, painstaking style and the still-life and figurative subjects which had enabled him to produce his classic modernist works of the preceding decade, the iconic nudes,

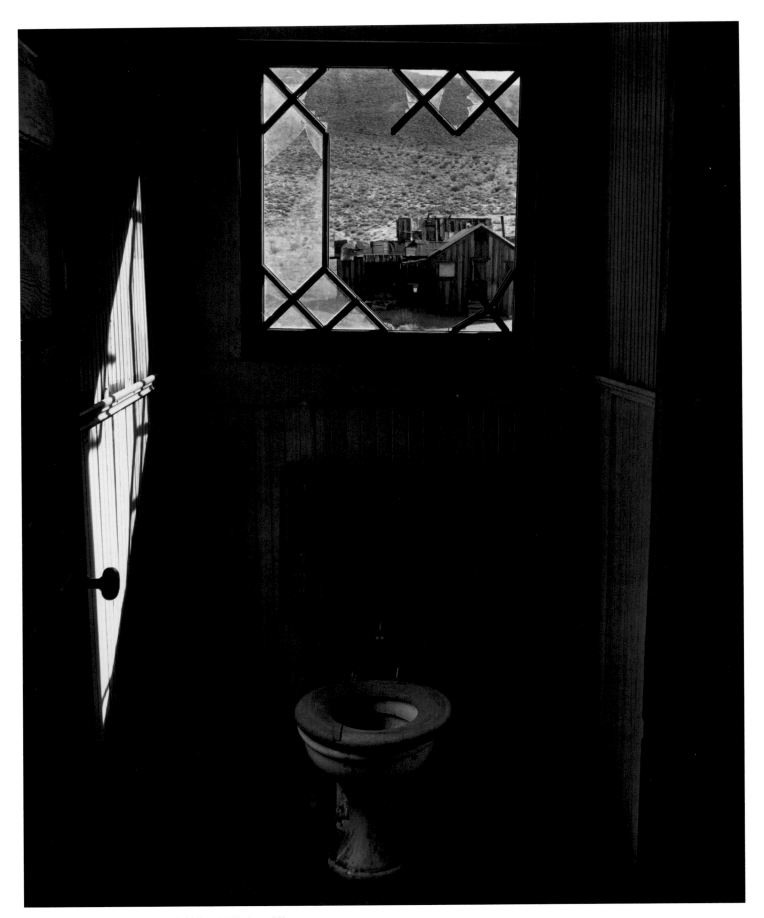

Fig. 6. *Golden Circle Mine, Death Valley*, 1939. (cat. 38).
This is the original Weston vintage print.

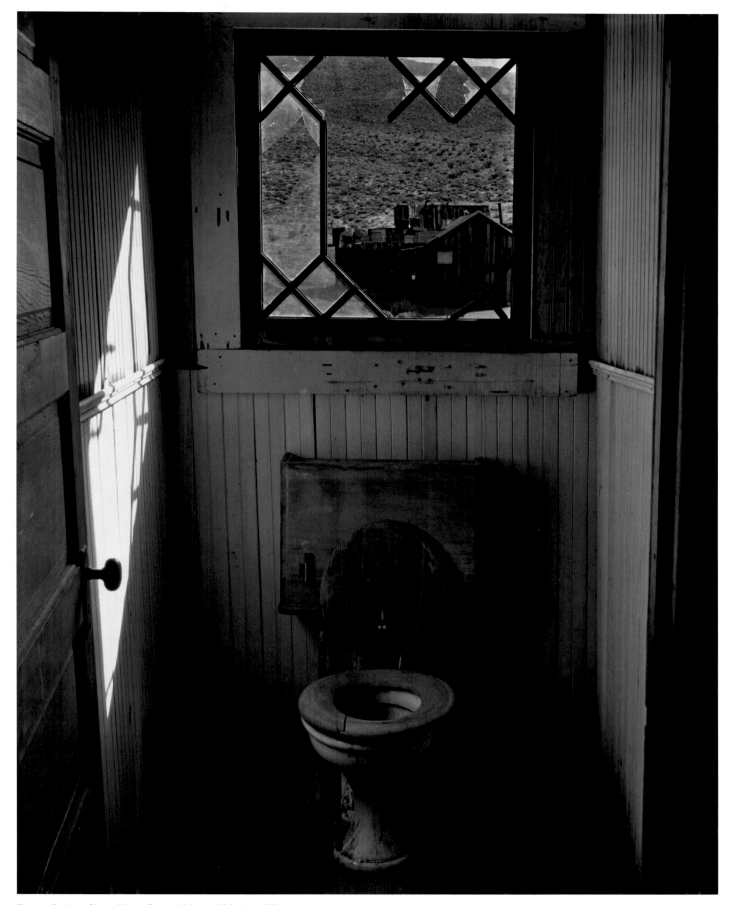

Fig. 7. *Golden Circle Mine, Death Valley,* 1939. (cat. 39).
This is the Project print.

peppers, and shells. The Weston who would spend days setting up a pepper or shell arrangement preparatory to making a three or four minute exposure, was forgotten; in his place there appeared a landscape photographer who worked quickly and "omnivorously," as he said, and as a result was able to produce some fourteen hundred negatives during his two years of "liberated, mass-production seeing."[5]

Weston had always been interested in landscape as a subject for his camera; he made landscape photographs from the time he first used a camera in 1902, and then took the motif up seriously during his years in Mexico (1923-1926). Some of the Mexican landscapes foreshadow the Guggenheim ones of 1937–1939 in the way they combine modernist style with an interest in the prosaic. Interestingly, however, as one reads in his Guggenheim application, Weston saw the beginning of his "epic series" of western landscapes as beginning with his work at Point Lobos, California, in 1929. He first applied the full strength of his rigorous vision to landscape subjects during that year, as one sees in the series which he made of abstracted, fragmentary cypress trees and roots (fig. 2, Log no. 10T). However, Weston's occasional forays into landscape during the early thirties show him working in two different styles. On one hand, he was making many of his best high-modernist still lifes during this time, the famous pictures of shells, peppers, artichokes, cabbages, and the like, and he naturally applied the same approach to landscape subjects. His 1929 and 1930 close-ups of eroded rocks at Point Lobos, with their simple biomorphic shapes, look like flattened versions of the peppers (fig. 3, Log no. 24R). Continuing to work in the same vein a few years later, he made his quintessential modernist landscapes with the series of several dozen pictures of the dunes at Oceano, California, in 1936. Yet on the other hand, during the same years he was producing landscapes of a quite different kind; they were often more panoramic in composition, and they pictured weather-beaten structures, broken fences, and peeling paint. The picture of a dead bird in the sand from 1930 (Log 1Bi), the brilliantly abstracted, evocative composition of boulders (fig. 4, Log no. 39R), and one called *Wood and Adobe* (fig. 5, Log no. 33A), made in New Mexico in 1933, all suggest a different, more pensive, side of Edward Weston. The high modernist Weston made sculptural photographs that emphasized the three-dimensionality of their centrally placed, highlighted subjects. But in these other, often more vernacular, works, the photographer tends to deny three-dimensionality; foreground merges with background, rocks with sea, and the viewer has to strain to distinguish one dark form from anoth-

er. These non-modernist works, and this dual style, have been largely overlooked, because critics have found it simpler to see a strictly modernist Weston followed (in 1937, or 1940) by a depressed introspective one. But the fact is that all through the thirties, Weston was exploring both modernist, Brancusi-like form, as well as the decayed, discarded, darker side of things. Thus, setting the stage for the Guggenheim years on one hand are the classic nudes and dunes at Oceano of 1936, and on the other, some very different pictures of the accidental and the common, such as the well-known *Cement-Worker's Glove* (Log no. 28Mi), or *Monument on Wilshire Boulevard* (fig. 8, Log no. 30Mi), both of which also date from that year.

Weston's landscapes of 1937–1939 have been little understood, as they have seemed to represent such a departure both in style and subject. Yet in fact Weston during these Guggenheim years only intensified what he had been doing for a decade. He continued to make "pure" landscapes, in which he used his now highly developed formal style to make flattened, abstracted visions of Iceberg Lake, of the sandstone concretions at Salton Sea, and of a number of places in Death Valley including Golden Canyon and Corkscrew Canyon. He also made large numbers of equally powerful pictures about the commonplace and the vulnerable, images that inevitably recall the writing of John Steinbeck, who was then traveling many of the same roads as Weston, or the poignant contemporary work of photographers such as Walker Evans and Dorothea Lange, who have generally been thought to occupy a very different aesthetic camp.

Themes of poverty and plainness are found in Weston's New Mexico landscapes of 1933, and again in his views of a corral at Pismo Beach, California, in 1935. During the Guggenheim years, this realistic imagery was further developed; Weston's views of abandoned buildings at Rhyolite, Nevada, and Leadfield, California, of the forlorn towns of Jerome, Arizona, and Albion, California, and of the detritus along Route 66 in the Mojave Desert all reflect the depressed mood of these Depression years. Weston had transformed a toilet into modern sculptural form in his two versions of *Excusado* in 1925 (Log no. 4M and 5M); now in Death Valley thirteen years later, a toilet remained simply a toilet, broken, dark, and dreary (cats. 38 and 39, figs. 6 and 7).

Other Weston works of this period, particularly the ones that he called "satires," take on the artifacts of contemporary American culture. He loved irony, especially when it allowed him to contrast materialism or phoniness with nature itself.

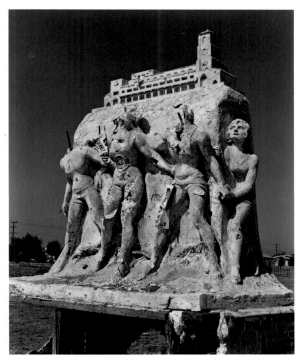

Fig. 8. Edward Weston. *Monument on Wilshire Boulevard*, 1936 (Log no. 30Mi). Silver print

He found perfect foils in the "Hot Coffee" sign in the shape of a cup standing in the middle of the broiling Mojave Desert (cat. 66), the "Yuma Nymph" that he saw in Arizona (Log no. A-Mi-1G), or the disconcerting yet compelling stage sets that he worked with at the MGM storage lot in Hollywood in 1939. Weston loved nature, and he hated falsity of all kinds, especially what he referred to as those "excrescences called cities"; he especially lamented the way in which (as he saw it, contemporary America had been "severed from its roots in the soil — cluttered with nonessentials, blinded by abortive desires."[6]

Without question, much (though far from all) of Weston's work in these years has a mournful, elegiac quality. It seems clear that he was thinking hard about mortality and death, whether consciously or not; one recalls not only his many images of animals killed on the highway (cat. 4) and the one of the dead man in the desert (cat. 15), but all the old shoes, the abandoned autos, the graves, and ghost towns in his work of these years. Equally moody and perhaps more pro-

found are the group of pictures of rocks and shore made between 1937 and 1939. These portray typical Weston subjects — rocks, tidal pools, surf, and seaweed — and many of them were made at home, at his beloved Point Lobos. Nature, for Weston in earlier years a source of classic forms, has become largely indecipherable. Bright sunlight now confuses the eye rather than clarifying form and edge. In *Surf, Point Lobos* (cat. 100) ocean and shore become one, and all one sees is undulating dark form. In *Wet Kelp, Point Lobos* (cat. 93) similarly there is no sky, and no relief; the viewer is forced to concentrate on the darkly shadowed, murky forms of grasses and water. Even Point Lobos has become a place of confusion and despair.

Few critics before the 1980s grasped the implications of Weston's Guggenheim work. Ben Maddow, for example, the author of an unfortunate biography of the photographer, wrote of "how little effect the Depression had on Edward Weston's attitude toward his work," and concluded, "I think he simply saw no way to incorporate disasters into his aesthetic."[7] And Janet Malcolm, who is often so observant, misunderstood Weston's late landscape style when she described it as "a kind of Sierra Club realism."[8] This may be true of a few of his Yosemite-in-winter photographs, but not many others. However, Beaumont Newhall and Amy Conger in 1984 remarked that the Guggenheim grants allowed Weston "to express himself to the utmost and to produce a body of work amazing in quantity and quality."[9] These words were used in their anthology of writings about Weston to introduce an article by John Szarkowski, one of fewer than a thousand words, that remains both the most sensitive and the most succinct analysis of the photographer's development. Szarkowski sees Weston's modernist works of the late twenties and early thirties as "tense, muscular, nearly absolutist in the rigor of their formal perfection," while his later work is perceptively described as "more complex, more subtle, less obviously formal, richer (and less clear) in its allusions." Moreover, Szarkowski understood that "in Weston's work of his Guggenheim years this new spirit of ease and freedom became more and more ascendant. . . . A sense of the rich and open-ended asymmetry of the world enters the works, softening their love of order."[10]

Weston, the Californian, admired the great modernist photographers in the east, especially Alfred Stieglitz, Paul Strand, and Charles Sheeler, all his seniors and all artists whose work had reached maturity a decade or more before his own did. In his early years he spoke eloquently, as they had, of photography as being completely objective; his mis-

sion, he wrote in 1929, was "not to interpret in terms of personal fancy . . . but present with utmost exactness."[11] In another statement of the same period, Weston emphasized that "what I record is not an interpretation . . . but a revelation, an absolute impersonal recognition."[12] Like many in his generation, he scorned psychoanalysis and especially the notions of symbolism and of subconscious motivation or meaning in art.[13] Nonetheless, as his own work changed, so did his views. In the early thirties he stated that "recording the objective physical facts of things does not preclude a communication in the finished work of the primal subjective motive," and by the late thirties he could admit, "I never make a negative unless emotionally moved by my subject."[14] Finally, in a letter to his friend Willard Van Dyke in April 1938, Weston reflected his much-changed attitude when he wrote, "I don't give a tinker's damn about being true to nature — more often than not I am untrue."[15]

Critics have mistakenly thought that Edward Weston was both physically and aesthetically isolated from the artistic mainstream of his time. To the contrary, he was keenly aware of the work — in photography, as well as painting and sculpture — of the leading international modernists (especially during the twenties), and of the social realists of the thirties. In Mexico he had worked with Diego Rivera; he made frequent admiring references to Picasso, Kandinsky, Brancusi, Derain, and African sculpture; he knew the Walter Arensbergs well; and he was fully aware of the photographs of Atget in France (once writing, "his intimate interiors . . . are as fine as a Van Gogh; and his store windows a riot, — superb . . . ")[16] and of his American contemporaries both in the east and in California. The more formal of Weston's Guggenheim pictures parallel the achievements of such painters as Georgia O'Keeffe, Mark Tobey, and Arthur Dove just as they prefigure the abstract expressionists. The less formal ones, with their decaying buildings and abandoned cars, come close to the Farm Security Administration photographs of such people as Russell Lee, Arthur Rothstein, and Dorothea Lange, all of whom he knew.[17] His Guggenheim photographs seem to point everywhere: backwards, to Alfred Stieglitz, whose accomplishments they build upon; forwards, to what photographers would do in two succeeding generations; and around him, with their combination of loneliness and formalism that recalls the work of Edward Hopper.

Weston's two justly celebrated Guggenheim years ended in April 1939; during the following months, he photographed only sporadically. In July he made a disturbing, anti-modern series of images of a black woman named Maudelle Bass,

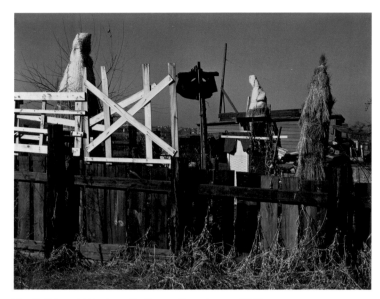

Fig. 9. Edward Weston. *Fig Trees, New Jersey*, 1941 (No Log no.). Silver print

and that summer also produced *Floating Nude* (Log no. N39-C-2), which depicts Charis floating on her back, looking quite dead. In 1940 he also photographed very little; among the successful images are those of graffiti and peeling paint at Hornitos, California, while his works at Twentieth Century Fox in Hollywood are far less compelling than the ones made the year before at MGM. Yet during 1940 he continued to work with great success at Point Lobos, making images of rocks, kelp, and sea that continue his Guggenheim investigations. *Kelp, China Cove* (Log no. PL40-K-4) stands out, but the whole group is remarkable for its charged inscrutability, and for its highly non-objective quality.

The year 1941 was devoted to a grand new project, which Edward and Charis hoped would rekindle their collaborative energies, and would repeat their earlier successes. Weston was commissioned to make fifty illustrations for a new edition of Walt Whitman's poetic celebration of an earlier America, *The Leaves of Grass*, and Charis and Edward drove thousands of miles on their quest, finally reaching Maine in October. Whitman had written, "I hear America singing, the varied carols I hear . . . " but Weston rarely heard the song; he was the wrong photographer, at the wrong time

in his life, to emulate Whitman's optimistic exhuberance. His pictures of countryside and cityscape, of dams and factories, cemeteries and deserted Southern plantations, generally seem forced and empty in comparison with the work of just a year or two earlier. However, some fine photographs did result from this trip including images of the interior and exterior of a Yaqui Indian church in Arizona, several cemetery views from New Orleans, and some wonderfully strange pictures of fig trees in New Jersey wrapped against the cold of winter (fig. 9). The trip ended abruptly, with the Westons hurrying home after the attack on Pearl Harbor; and they were deeply disappointed in the book that resulted, with the photographs reproduced on a strange mint-green paper.[18] Weston was relatively unproductive for the rest of his life. The war years were largely devoted to portraying people, sometimes in satiric compositions, and to photographing cats for the last book he would make with Charis Wilson.[19] After the war, and his divorce from Charis, Weston was ill and largely inactive, though up through 1948 he continued to make the occasional powerful, charged image at Point Lobos. During Weston's final decade, in the years before his death in 1958, he was too sick to do any photography at all.

Between 1929 and 1939 Edward Weston made photographs that surely rank among the most magnificent works in this medium; the Guggenheim pictures representing both a continuation of earlier themes and a departure from them, came as an extraordinary climax to this decade of seeing. Weston's approach to his work developed and matured in unexpected ways; as his demand for absolute formal perfection eased (he wrote of his first Guggenheim year, "The twelve hundred negatives are not all masterpieces"),[20] he was able to find new kinds of beauty and new levels of meaning. As Andy Grundberg writes, "Weston's shift from high Modernist to late Modernist style constitutes a crowning accomplishment in a career remarkable for its sheer number of achievements."[21]

As the Guggenheim Fellowship began, Weston was fifty-one years old, a grandfather, and living happily with the remarkable twenty-two year old Charis Wilson. Weston was probably more at ease during the Guggenheim years than at any other time in his life; at that time, he was willing to take chances, and was able to work in a powerful, prolific manner that he would never attain again. Though he couldn't know it, illness, marital troubles, and World War II, all lay just ahead. This period of artistic exploration and transition, of immense productivity and highly original seeing, build on what the photographer had done earlier, and suggest the direction he

would follow during his last active years. Weston was always an artist who knew himself well and who was his own sternest critic. His own judgment about the Guggenheim work deserves our attention; in April, 1938, he wrote: "My landscapes of the past year are years in advance of any I have done before or any I have seen."[22]

1. The Lane Collection owns about half of all the surviving vintage prints by Edward Weston, including about nine hundred prints from the Guggenheim years (April 1, 1937-April 1, 1939). The next most extensive collection of "Guggenheim" prints is at the Huntington Library, San Marino, California; Weston, beginning in 1940, printed five hundred images for the Huntington, of which about three hundred are from the Guggenheim period. Amy Conger, in her useful but frustrating catalogue of Weston images at the Center for Creative Photography, Tucson, Arizona, lists 458 Guggenheim images there, but the vast majority are Project Prints not made by Weston himself. See Amy Conger, *Edward Weston: Photographs from The Collection of the Center for Creative Photography*, Tucson, 1992.

2. Edward Weston, "Miscellaneous Notes on Photography," 1922, in Peter Bunnell, ed., *Edward Weston on Photography*, Salt Lake City, Utah, 1983, p. 31 (Weston here quotes the remark as having been made originally by J. Nilsen Laurvik.)

3. The intact set was given to the University of California at Santa Cruz by McGraw. With regard to the "Project" Weston wrote to Willard Van Dyke, Feb. 25, 1953: "An unnamed donor put up $6000.00 for the making of several sets of my work — 1000 to a set. He will retain one complete set; the balance, it is hoped, will go to various museums, libraries, etc. Brett is doing all the printing under my supervision . . . ," Leslie Squyres Calmes, *The Letters between Edward Weston and Willard Van Dyke*, Tucson, 1981, p. 47.

4. The majority of Project Prints bear genuine "E.W." initials at the lower right, though they are not vintage Weston prints. Adding to the complexity of the signature question is the fact that a number of genuine vintage prints — made by Edward Weston himself — bear initials "E.W." and a date in hands other than Edward's. In the end, the Project sets included only about 838 prints, rather than the thousand Weston had hoped for. Conger reports (n.p., in the section "How to Use this Book") that the set included 832 prints, but there are 838 on the official Key to the Project, dating from about 1953, at the Center for Creative Photography. It should also be noted that Cole Weston has made prints from Edward's negatives from Edward's death until very recently; these are clearly stamped and identified as such.

5. Weston said that he made some twelve hundred negatives during the first Guggenheim year; the second year was devoted largely to printing, but he also made about two hundred more negatives on three trips.

6. Edward Weston to Willard Van Dyke, April 18, 1938, in Leslie Squyres Calmes, *The Letters between Edward Weston and Willard Van Dyke*, Tucson, 1992, p. 35.

7. Ben Maddow, *Edward Weston: Fifty Years*, Millerton, NY, 1973, p. 105.

8. Janet Malcolm, *Diana and Nikon: Essays on the Aesthetic of Photography*, Boston, 1980, p. 10.

9. Beaumont Newhall and Amy Conger, eds., *Edward Weston Omnibus*, Salt Lake City, 1984, pp. 158-159.

10. John Szarkowski, "Edward Weston's Later Work," in Beaumont Newhall and Amy Conger, eds., *Edward Weston Omnibus*, Salt Lake City, 1984, pp. 158-159.

11. Edward Weston, "America and Photography," in Peter C. Bunnell, ed., *Edward Weston on Photography*, Salt Lake City, 1983, p. 56.

12. *Edward Weston*, "Statement" in Peter C. Bunnell, ed., *Edward Weston on Photography*, Salt Lake City, 1983, p. 67.

13. There is no evidence that Estelle Jussim was correct when she wrote that Weston was in analysis at one time. See Estelle Jussim, "Quintessences: Edward Weston's Seach for Meaning," in Peter C. Bunnell and David Featherstone, eds., *EW 100: Centennial Essays in Honor of Edward Weston*, *Untitled* 41, Carmel, 1986, p. 55.

14. Edward Weston, "A Tyro's Annual," in Peter C. Bunnell, ed., *Edward Weston on Photography*, Salt Lake City, 1983, p. 65 and Edward Weston, "What is a Purist?," *Camera Craft* 46:1, January 1939, p. 7.

15. Edward Weston to Willard Van Dyke, April 18, 1938, in Leslie Squyres Calmes, *The Letters between Edward Weston and Willard Van Dyke*, Tucson, 1992, p. 35.

16. DB II, p. 202.

17. Conversation with Charis Wilson, February 3, 1994.

18. Walt Whitman, *Leaves of Grass*, introduction by Mark Van Doren, New York, 1942, 2 vols.

19. On the late figurative work, see Theodore E. Stebbins, Jr., *Weston's Westons: Portraits and Nudes*, Boston, 1989. Eighteen of the cat photographs were reproduced in Charis Wilson and Edward Weston, *The Cats of Wildcat Hill*, New York, 1947.

20. *Edward Weston*, "Photographing California," *Camera Craft* 46:2, February 1939, p. 59.

21. Andy Grundberg, "Edward Weston's Late Landscapes," in Peter C. Bunnell and David Featherstone, eds., *EW 100: Centennial Essays in Honor of Edward Weston*, *Untitled* 41, Carmel, 1986, p. 199.

22. Edward Weston to Willard Van Dyke, April 18, 1938, in Leslie Squyres Calmes, *The Letters between Edward Weston and Willard Van Dyke*, Tucson, 1992, p. 35.

KAREN E. QUINN

1

In 1937 . . . the award of a Guggenheim Fellowship made it possible for me to spend a year photographing without thought of cost. For the first time in my life I did not have to make professional portraits to support myself and my creative work. The result was that from April, 1937, to April, 1938, I traveled twenty-two thousand miles and made over twelve hundred 8 x 10 negatives. I accomplished more than I would have in ten years under ordinary circumstances.[1]

In October 1936, Edward Weston submitted his completed application for a fellowship to the John Simon Guggenheim Foundation.[2] In his brief "statement of project," Weston proposed "to continue an epic series of photographs of the West, begun about 1929; this will include a range from satires on advertising to ranch life, from beach kelp to mountains."[3] He had applied at the suggestion of friends and was encouraged to carry it out by his companion and model, Charis Wilson.[4] Wilson and Weston viewed the grant not only as a way for Edward to be able to devote himself to creative photography, but also a means for his economic survival. At the time, Weston's livelihood depended on making portraits and selling his "creative work," and the already meager earnings from both of these sources had dwindled alarmingly in the mid-1930s. At the beginning of January 1934 he had written in his Daybooks, "I did not have a single sitting during Dec[ember]. This has been the worst year of the Depression for me."[5] Weston tried several resourceful schemes to augment his income: he worked briefly for the Public Works of Arts Project for Southern California, he would barter a sitting for food and for services such as dentistry, and, with Charis's help, he came up with the short-lived "Edward Weston Print of the Month Club."[6] Then, on March 22, 1937, after a five-month application process, Weston received notification of his Fellowship appointment,[7] the first photographer to win a Guggenheim. With his successful appeal for an extension in 1938 (which he used largely to print the negatives he had taken the first year), the Guggenheim Fellowship allowed Weston two years of artistic freedom.

The John Simon Guggenheim Memorial Foundation had been established in 1925 by former United States Senator and Mrs. Simon Guggenheim to honor their son who had died in 1922. According to its charter, the mission of the Guggenheim Foundation was to "promote the advancement and diffusion of knowledge and understanding, and the appreciation of beauty, by aiding without distinction on account of race, color or creed, scholars, scientists and artists of either sex in the prosecution of their labors."[8]

Fellows were chosen by a Standing Committee of a larger Advisory Board, acting on recommendations made by separate juries in the major fields of interest, including the arts. However, since the names of those who have served on the individual juries has remained confidential, we do not know who was involved in actually selecting Weston.[9] He was one of forty-six new fellows chosen in 1937 (thirteen more were renewed for a total of fifty-nine awards); other successful applicants in the field of "creative work" included playwright Robert Ardrey, poet Sterling Allen Brown, novelist Frederic Prokosch and painters William Gropper and George Grosz.[10]

During the first decades of the award, the choice of Guggenheim fellows was progressive and emphasized emerging and experimental figures rather than established artists, scientists, and scholars. In the arts, for example, fledgling composer Aaron Copland received a fellowship in 1925, the first year they were given, sculptor Isamu Noguchi got one in both 1927 and 1928, as did such modernist figures as Marsden Hartley in 1931, Martha Graham in 1932 and E. E. Cummings in 1933. The choice of Weston paved the way for the recognition of photography at a time when the medium was struggling for acceptance as a "fine" art; subsequent fellows included such photographers as Walker Evans (1940), Dorothea Lange (1941), Brett Weston (1945), Ansel Adams (1946), and more recently Aaron Siskind (1966), Imogen Cunningham (1970), and Minor White (1970).

Over the five months between submission of the Guggenheim application and notification of his appointment, Weston exchanged a series of letters and a package of photographs with Henry Allen Moe, secretary of the foundation. Weston's correspondence included an extensive amendment to his original application. Apparently, after a discussion with fellow photographer Dorothea Lange and her husband, Paul Taylor, Weston wrote in a short note to Moe that he realized the "plan for work" he had described was inadequate and that he wanted to rewrite it. Weston's original responses to the questions on the application had been concise and unexpansive, offering the barest minimum of information. In fact,

for his "plan of work" Weston had simply repeated verbatim the two sentence "statement of project" in which he had proposed "to continue an epic series of photographs of the West. . . ." In the lengthy letter in which he expanded on his plan, Weston laid out his vision for the Guggenheim project more completely:

> Now for what I meant by "beach kelp to mountain —." My work-purpose, my theme, can most nearly be stated as the recognition, recording, and presentation of the interdependence, the relativity, of all things, — the universality of basic form.
>
> In a single day's work, within the radius of a mile, I might discover and record the skeleton of a bird, a blossoming fruit tree, a cloud, a smoke-stack; each of these being not only a part of the whole, but each, — in itself, — becoming a symbol for the whole, of life. So, the blossom of the fruit tree becomes more than a blossom; it is the tree itself, — etc.
>
> And the recording of these becomes not just documentation of a given subject matter, but its sublimation, — the revealing of its significance. I have no desire to make a pictorial record of the "Western Scene"; rather I want to photograph MY Western Scene which may include the feather of a bird as well as the furrows of a plowed field. This "theme" of mine could of course be done anywhere from the Tropics to the Arctic. I have chosen the West — By which I really refer to the Pacific Coast — because of the great variety of subject matter it offers, because I know and love it, and because I have an established base here.[11]

In this statement, Weston not only explained his intentions for the Guggenheim project, but he also summed up his photographic philosophy. Weston's determination to reach beyond representation had appeared in his writings by the early 1920s. In his Daybook in 1924, he had resolved, "that the camera should be used for a recording of *life*, for rendering the very substance and quintessence of the *thing itself*."[12] Influenced by the modernist ideology of Henri Bergson and others, Weston's quest to reveal in his work, "the ultimate mystery" as Estelle Jussim has called it, applied to all the subjects he treated, including the landscapes.[13]

During the first year of his Guggenheim Fellowship, from April 1, 1937 to March 31, 1938, Weston made sixteen trips throughout California and one foray into New Mexico and Arizona. Charis Wilson accompanied him on all but one of these excursions. Since Weston did not drive, this duty fell to Charis, or to one of Edward's sons, one of whom occasionally accompanied them.[14] On the Guggenheim trips, Charis and Edward shared responsibilities: Edward photographed while Charis, inspired by Edward's own Daybooks,[15] kept a written account of their travels in a journal in which she described their life on the road, listed expenses, and recorded negatives.

Charis felt that the entries she kept in her journal, which were written in an easy, anecdotal style, might provide ample material for a book.[16] In 1940, her hopes were borne out and *California and the West* was published, with Charis and Edward credited as co-authors (see fig. 1). The book, a much condensed version of her journal, retains Charis's distinctive voice, and the text is accompanied by ninety-six of Edward's Guggenheim photographs. The publisher wanted to include a broader range of Weston's prints, including earlier nudes and still lifes, but Charis and Edward stood firm in their commitment to produce a book based solely on the new Guggenheim material.[17] Although the illustrations reproduced in the publication represent only a small portion of the work of the Fellowship years, *California and the West* is the single source devoted exclusively to this important period of Weston's career.[18]

Weston spent much of the second year of the Guggenheim Fellowship (April 1, 1938 – March 31, 1939) printing the negatives he had made the first year. The small house in Carmel Highlands, called Wildcat Hill, was built that summer by Weston's son Neil as a residence for Charis and Edward; it also provided Edward with his own permanent darkroom.[19] Edward and Charis did make three more trips, finally reaching Oregon, Washington, and across the Canadian border into Vancouver. They ended up the second Fellowship year in Elk, California, where they were married on April 24, 1939 (after the ceremony, Weston photographed the town, cat. 79). Over the two-year period, Weston made approximately 1400 negatives, Charis wrote some 400 pages of journal, and they logged over 20,000 miles on their car.

The Guggenheim Fellowship provided Weston with a $2000 annual stipend which not only paid for living costs, but for photographic expenses as well. As Charis Wilson wrote, the grant "permitted a year of frugal living and of liberated photographing."[20] Her careful records reveal, for example, that before starting out on the first trip they spent $66.86 on equipment which included a tent, a gas stove, three sleeping bags, sundries, and clothes for Charis, Edward, and Edward's son Cole. On this initial nine-day excursion they fed three

people for $13.14 and purchased 66½ gallons of gasoline for $15.05.[21]

The Guggenheim funds were supplemented by income Weston and Wilson received from *Westways* magazine, the publication of the Automobile Club of Southern California. Weston and Wilson asked its editor and general manager, Phil Hanna, to suggest the best routes for their travels. Then, in April 1937, just prior to setting out on their first trip, Hanna contracted with Edward to provide eight to ten photographs a month from his travels, and with Charis to supply captions and a short summary of each set of images, all to be published in the magazine (see figs. 10 and 11). For their efforts they received $65.00 a month — $50.00 for Edward's photographs and $15.00 for Charis's text. With these added funds they could afford the payments on a new black Ford V-8 touring sedan; the car was eventually nicknamed "Heimy," after Guggenheim (frontispiece, Log no. DV-GC-24G).[22]

For two years beginning in August 1937, twenty-one articles entitled "Seeing California with Edward Weston" were published in *Westways* magazine.[23] Each was devoted to one of the geographic areas visited by Charis and Edward during the Guggenheim Fellowship including "The California Coast — San Diego to Monterey," "High Sierra," and "Carrizo Creek and the Southern Colorado Desert." Although Weston had agreed to send in eight to ten images a month, seven to nine actually appeared through 1937, and then the number dropped down to five or six for the remaining articles.[24]

At the beginning of the Fellowship, frustrated with the lack of clarity of Edward's old method of logging his negatives, Charis came up with a code of letters and numbers for identifying each Guggenheim negative.[25] This system identified first the general area, then the specific locale of each image, and finally gave it a sequential number in its series. The negative or print marked "DV-GC-12G," (cat. 32), then, means Death Valley, Golden Canyon, twelfth image in the group. The final "G," added after Charis left Edward and not part of her original formula, stands for Guggenheim.[26] It should be noted that the negatives were numbered in the order they were printed, not the order in which they were taken or developed. Thus, for example, in the Lane Collection "DV-DV-23G" (Death Valley, Dante's View, #23) is known to have been taken on the first trip to Death Valley in April 1937, while DV-DV-13G (Lane Collection) postdates it, for it can be assigned with some certainty to the second trip there in March 1938.[27]

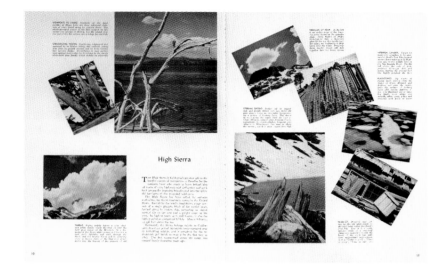

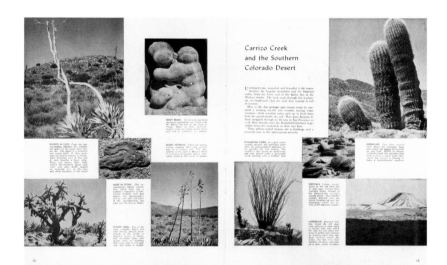

Figs. 10 and 11. Two page layouts of Weston photographs from *Seeing California with Edward Weston*, pp. 10-11 and 12-13. "High Sierra" originally appeared in *Westways* magazine in September 1937 and "Carrizo Creek and the Southern Colorado Desert" in October 1937.

2

On the morning of Friday April 9, 1937, just two and a half weeks after being notified that he had won the grant, Weston departed on the inaugural trip with Charis and his youngest son, Cole, then sixteen. They left from the Los Angeles home of the eldest of the four Weston sons, Chandler; his apartment served as the base for the southern California excursions.[28] The ultimate destination of this first trip was Death Valley. In her unpublished journal, Charis described the pace of "Day 1:"

> In less than an hour Edward calls the first halt and gets out to once-over a sandy vineyard; short black grape stumps lining back to the whip-cream-topped mountains. But there is too much haze, and we hope better vineyards to come. Quarter of an hour later another stop. This time a crab apple tree in full coat of snow ball blossoms alone in a green field. It all unwittingly makes history, becoming the first Guggenheim negative.[29]

When Weston made what is probably the only print from this negative, he also took note of its significance when he wrote on its mount, "This is my first print from my first Guggenheim negative" (see jacket, and cat. 63).

Weston's Guggenheim landscapes build on his earlier accomplishments. By the mid 1920s, as one sees in the series of toys he photographed in Mexico (1924–1926) and the *Excusado* (1926), Weston had begun to experiment with the studies of form that culminated in the still lifes of vegetables and shells at the end of that decade. He continued to explore still life into the early 1930s, using fruit and even flowers in addition to various vegetables and shells. Then, between 1933 and 1935, the human figure largely replaced the inanimate object as Weston's favored subject, as one sees in the small-format portraits and especially in the fragmented, abstract nudes.

Weston's work with still life and the nude was usually executed under tightly controlled studio conditions. With the former subject, he arranged and rearranged his compositions; with both, he carefully calculated the effect of natural light. While experimenting with shells in 1927 he wrote, "I have my work room barricaded, — for there, are two shells deli-cately balanced together awaiting the afternoon light. My first version of the combination was done Sunday: Monday a slight turn of one shell, and I gained strength: Wednesday the second proof decided me to try a lighter ground with the same arrangement."[30]

Weston carried these experiments with natural form to their ultimate resolution in the classic peppers, shells, and small-format nudes of the late 1920s and early 1930s. Then, during the Guggenheim years, he used the lessons he had learned in the studio as one aspect of his approach to landscape.

In the "statement of project" for the Guggenheim application, Weston had asserted his intention to concentrate on landscape, proposing "to continue an epic series of photographs of the West, begun about 1929." In referring to 1929, Weston was alluding to the year he had moved to Carmel and had taken his first close-ups of cypresses and rock formations at Point Lobos and along the Carmel coast. His interest in landscape, however, was lifelong and had actually begun with some of his earliest efforts while still in Chicago in 1902. The achievements of the Guggenheim years follow logically on work he did in Mexico (1923–1926) and his first trip to the Mojave Desert (1928, fig. 12, Log no. 41R), but Weston rightly pointed out the importance of the landscape style he had begun to form at Point Lobos beginning in 1929 (figs. 2, 3, and 4, Log nos. 10T, 24R, and 39R). In his Daybooks, he described the working process used there that would define his approach in the Guggenheim photographs, when he was finally able to concentrate on landscape:

> It (the kelp) lay there unchanged, twisted, tangled, interwoven, a chaos of convulsed rhythms, from which I selected a square foot, organized the apparently complex maze, and presented it, a powerful integration. This was done of course with no manual arrangement, — the selection was entirely my own viewpoint as seen through the camera. I get a greater joy from finding things in Nature, already composed, than I do from my finest personal arrangements. After all, selection is another way of arranging: to move the camera an eighth of an inch is quite as subtle as moving likewise a pepper.[31]

Through the early 1930s, when he could spare the time from his commercial portraiture, Weston experimented with "found" compositions at Point Lobos and along the nearby Monterey coast. He took close-ups of kelp, rocks, and trees and made some views of the shore itself. In addition, he

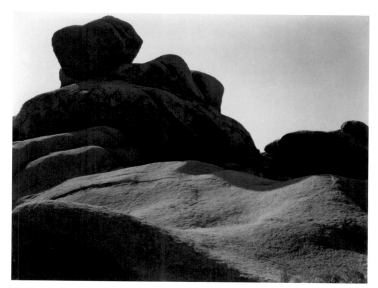

Fig. 12. Edward Weston. *Mojave Desert*, 1928
(Log no. 41R). Silver print

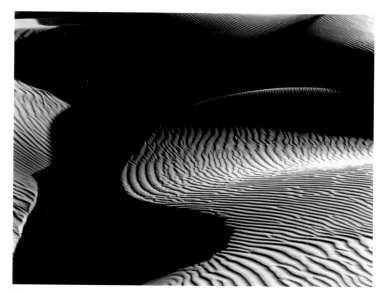

Fig. 13. Edward Weston. *Dunes, Oceano*, 1936
(Log no. 29SO). Silver print

worked with the natural organization of forms in the land-
scape compositions he photographed on the few trips he
was able to take during these years, to New Mexico in 1933
and then on day trips to the Oceano dunes, halfway between
San Francisco and Los Angeles, beginning in 1934 (figs. 13
and 14, Log nos. 29SO and 46SO). But it was the luxury of
the two years of uninterrupted attention to creative work
offered by the Guggenheim Fellowship that allowed Weston
to travel to new sites, to continue to explore compositional
selection, to concentrate on landscape and to produce an
outpouring of highly varied landscapes that equal his great
close-ups of still lifes and nudes of a decade before.

 Death Valley, the first destination for Weston and Wilson
on the Guggenheim, was a place new to both of them. So-
named in 1849 by the first white emigrants to cross it on
their way to the California goldfields, it had become a Nation-
al Monument in 1933. After the initial trip, which served to
break in the routine of travel but yielded few negatives,
Charis and Edward went back in March 1938 at the end of
the award year and remained there to await the results of
their appeal for an extension to the grant.[32] This second trip
was highly productive; from it came over 150 negatives.
Finally, there was a third trip to Death Valley late in 1938, dur-
ing the second year of the fellowship. Over the course of the
three visits to Death Valley, Weston made more than 250

Fig. 14. Edward Weston. *Dunes, Oceano*, 1936
(Log no. 46SO). Silver print

negatives, well over twice as many as at any other location in the Guggenheim years.

The vast array of natural forms in Death Valley provided a perfect workshop for Weston. Far from being a barren wasteland, Death Valley boasts an amazing variety of topography and form — from expanses of salt beds and gentle mesquite-covered sand dunes to endless rugged canyons carved into rock, mile-high mountain ranges, and vast alluvial fans spilling out onto the valley floor. In addition, ruins of manmade structures, mostly from late nineteenth- and early twentieth-century mining ventures, are scattered across the desert, and these, too, appealed to Weston. Weston called Death Valley "the most exciting place in the world."[33]

Surprisingly, Dante's View was the photographer's first stop in Death Valley, for it would seem to be an unlikely Weston subject. A lookout about a mile above the valley floor and one of the most popular sights there, Dante's View affords a panoramic 180-degree vista of the desert below. Photographs of it in contemporary guidebooks and histories emphasized its enormously impressive view.[34] In *California and the West* Charis reported, "Two of our friends who had been there had told Edward he probably wouldn't like it because everything was so far away." But she went on, "The picture reproduced in the official Death Valley folder was by no means inspiring, but it suggested possibilities."[35]

Unlike the guidebook photographers who aggrandized the vista at Dante's View, Weston recognized the inherent abstraction in the topography spread out across the valley, and he made a compelling yet enigmatic series of images. In fact, Weston treated Dante's View as he would virtually all of his landscapes: he found abstract form where others had seen only scenery. In his most successful landscapes, Weston created a taut dialogue between the real and the abstract, between the recognizable and the suggestive.

On each trip to Death Valley, Weston went to Dante's View and worked with the changing configurations of the desert topography below him. The patterns of the salt beds Weston photographed were sometimes delicate calligraphic ribbons of light, but on other days they had blurred contours similar to a wet on wet watercolor, depending on the amount of rainfall collected on the valley floor. In most of the two dozen negatives he made there (including, for example, *Dante's View, Death Valley* cat. 28), Weston denied the desert's most obvious feature, its expansiveness, by cutting out the sky and the tops of the mountains. He looked down instead onto the amorphous patterns of the salt beds, capturing strange forms which seem to writhe like an amoeba under a

Fig. 15. Arthur Dove. *Clouds*, 1927
Oil and sandpaper on sheet metal
Museum of Fine Arts, Boston. Gift of the William H. Lane Foundation

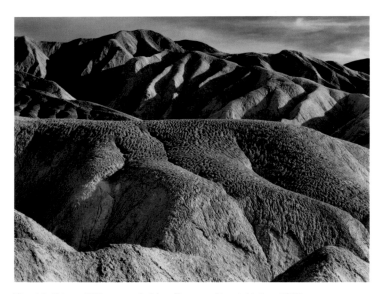

Fig. 16. Edward Weston. *Golden Canyon, Death Valley*, 1938
(Log no. DV-GC-41G). Silver print

microscope. And even when he allowed sky into a composition, as in *Floor of Death Valley from Dante's View* (cat. 29), the vastness of the vista is tempered by his choice of viewpoint, and the viewer's eye becomes drawn to the highlighted serpentine shapes snaking across the desert floor. In all the Dante's View photographs Weston included at least a bit of recognizable topography: an alluvial fan, foreground outcroppings of rock, or the foothills of the Panamint Mountains across the valley. These recognizable features give his images some topographical grounding, and they underscore an essential visual tension, which he is always exploring, between abstraction and reality.

Weston went on to make some of his signature Guggenheim images in the ravines and crevices of Death Valley at Corkscrew Canyon, Twenty Mule Team Canyon, Golden Canyon, and Zabriskie Point, which all lie within a short distance of one another to the north of Dante's View (see cats. 22-23, 31-37, 49-50, 52). In *California and the West*, Charis stressed the importance of this region to Edward's work:

> *There is almost unlimited variety of shape, pattern, texture, and color. Each hill you climb gives a new accounting of the complex intertexture of cliffs, hills, ridges, gullies, sumps, and dry falls. About half of all Edward's Death Valley negatives were made in that comparatively small section; half all our Death Valley days were passed in clambering up and down the puffy clay hills, cutting steps as we progressed along the knife-edged pebbly ridges, looking for new viewpoints, or returning to old ones to see things in different light.*[36]

Like his eastern contemporary, the painter Arthur Dove (fig. 15), Weston revealed order and rhythm in the complexity of the natural landscape. Where Dove worked with color, Weston experimented with the effects of light on rocks and sand, the most barren of landscapes. Both artists came close to abstraction, removing most traditional references to scale and distance; yet both remained allied to representation and created modernist images without wholly departing from nature.

In referring to Golden Canyon, Weston noted, "It is hard work to do this stuff not getting it just picturesque."[37] The best canyon photographs avoid both the picturesque and the sentimental. Scale, which is so important to most photographers, is ambiguous; at times one cannot tell if Weston has taken a picture of square inches or of square miles of terrain. He worked with the natural organization of the topography in the canyons, making tightly ordered, flattened yet rhythmic arrangements of linear patterns, mixing them with curvaceous animalistic forms. In *Corkscrew Canyon, Death Valley* (cat. 23), for example, massive vertical ridges, sculpted by light like great elephant legs, dominate the composition but are contained by the horizontal ridge at the top and bottom of the image.

Weston frequently photographed the same scene at different times of day, thereby producing from it several distinct works of art. At Golden Canyon, for example, he took pictures of an identical series of mud hills and ridges with the sun at varying positions in the sky. *Golden Canyon, Death Valley* (cat. 37) and *Golden Canyon, Death Valley* (fig. 16, Log no. DV-GC-41G) portray almost exactly the same topography.[38] The light, however, creates virtually the opposite effect on the terrain in each picture: areas cast in shadow in the first are highlighted in the second, and vice versa. The greater contrast of light and shadow in the first composition makes a more graphic image, whereas the subtler tones of the second photograph tend to emphasize volume and space. Then Weston changed the position of his camera; in *Golden Canyon, Death Valley* (cat. 31) he shot a skyless close-up of the same ridges in diffused light, resulting in a flatter, more abstract image than either of the first two.

Both *California and the West* and Charis's journal describe the often trying conditions under which Weston worked. Charis discusses the accessibility of various locations (the Dante's View photographs were taken within a short and fairly easy walking distance of each other and the car, but reaching many of the canyon sites required serious hiking); she notes the weight of Weston's camera and supplies (fifty pounds that he insisted on carrying himself), and she details their difficulties with the weather (especially wind and even rain). In addition, a few rare Weston images such as *Heimy in Golden Canyon* (frontispiece, Log no. DV-GC-24G) provide some anecdotal documentary data about their travels.

Initially, Weston had no interest in Death Valley's dunes, which must have seemed, at first sight, to have much less to offer than the superb Oceano dunes he had photographed in 1936. At Oceano, in addition to the well-known nudes (for which Charis had posed), Weston had produced taut, lyrical images of the sweeping forms created by the dunes and their shadows (fig.13, Log no. 29SO), and he also did close-ups of the patterns the wind had made in the sand (fig. 14, Log no. 46SO). On the second trip to Death Valley, however, Charis reported, "Edward decides the dunes may be worth a look after all."[39] The resulting pictures lack the compositional

boldness and dramatic abstraction of either the Oceano dunes or, indeed, of the Guggenheim work done at the canyons. Instead, as seen in three prints all titled *Dunes, Death Valley* (cats. 24, 25, and 27), the new dune pictures are brooding, complex images.[40] Where the Oceano pictures celebrate clarity and line, these are moodier. Weston's subject here becomes the scraggly growth of mesquite that covered the dunes. The subtle tonal range of the overcast sky blends with that of the sand, and in the soft light the forms of the hills are flattened. Sky and sand merge to make a backdrop for the complex composition of scrub and detritus, which, in its twisted disorganized forms, prefigures the overall, gestural quality of the paintings made by the Abstract Expressionists just a few years later.[41]

Weston also photographed the remains of manmade structures at the Harmony Borax Works, Golden Circle Mine, Leadfield, all in Death Valley, and at the ghost town of Rhyolite, Nevada (cats. 38-41, 43, and 46-48). One of Weston's favorite sites was Rhyolite, where he made about a dozen negatives. When Charis and Edward arrived there in 1938, only a handful of the original buildings from the former boomtown were left.[42] In *Ghost Town of Rhyolite, Nevada* (cat. 46), Weston matched the similar shapes but contrasted the different materials of two of the ruins in a foreground/background dialogue, and in *Rhyolite, Nevada* (cat. 48), he juxtaposed the stark flat forms of a crumbling building with the gentle volumes of the hill behind, like a stage set deposited in the desert.

At Rhyolite, Weston also continued to explore abstraction. In *Rhyolite, Nevada* (cat. 47), he concentrated on an inside corner of a roofless building, cropping out ground and sky. Rather than taking only wall and excluding the corner, which would have created a flatter and even more abstract (but perhaps too easy) composition, Weston made the corner the focal point; the result was an image that forces a confrontation between the abstract and the real. *Rhyolite, Nevada* is related to Weston's attic portraits of the early 1920s, as well as some of his architectural studies done in Mexico, including the stairwell picture, *San Pedro y San Pablo* (fig. 17, Log no. 15A). In the earlier photographs, however, Weston included recognizable reference points: the figures in the attic compositions and the parts of a window and a balustrade in the stairwell. In his Rhyolite abstraction, Weston pared away any extraneous details, leaving only the corner itself and the shapes of the patterns on the walls (including light and shadow) as subject matter.

Weston avoided Rhyolite's two most popular attractions:

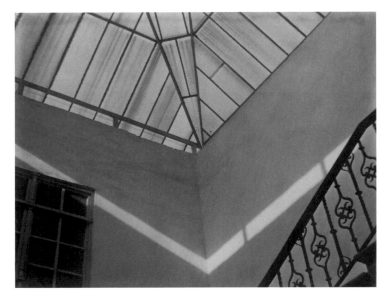

Fig. 17. Edward Weston. *San Pedro y San Pablo*, 1924 (Log no. 15A). Platinum print

the odd little bottle house (made of beer bottles embedded in adobe walls), and the ornate Victorian casino, which was still operating when Charis and Edward visited the ghost town.[43] In general, Weston eschewed the most famous tourist sites in Death Valley such as Artist's View Drive, the Natural Bridge, and Scotty's Castle, and as evident in his work at Dante's View, the images he did produce at well-known sites are usually very different from the typical souvenir shot. Instead, Weston treated Death Valley, like all his Guggenheim subjects, as a challenge to his unique vision of modernist landscape.

3

Desert subjects make up the largest number of Weston's Guggenheim negatives. In addition to Death Valley, during the Fellowship years Weston photographed the Colorado Desert, the Borrego Desert, Joshua Tree National Monument, and the Mojave Desert, all in southern California. Each place has its own peculiar topography and flora which underwent Weston's keen examination: the sandstone concretions in the Colorado Desert, burnt tree trunks in Palm Canyon in the Borrego Desert, Joshua trees and rock piles in the Mojave Desert (cats. 12-14, 16-18, 70-74).

When Weston first visited the Mojave Desert in the southeastern California in 1928 with his son Brett, he had exulted about it:

No mighty mountain, snow-capped, touching the heavens ever stirred me as did these amazing rocks. Stark naked they rose from the desert, barren except for wisps of dry brush: belched from the earth's bowels by some mighty explosion, they massed together in violent confusion, in magnificent contiguity. Pyramids, cubes, rectangles, cylinders, spheres, — verticals, obliques, curves, — simple elemental forms, convex convolutions, opposed zigzags, at once chaotic and ordered, an astounding sight.[44]

Weston said that the negatives he made on this trip "have all the forms I felt and revealed in shells and vegetables plus greater strength and vitality,"[45] and on the Guggenheim grant he returned to work in the Mojave Desert on five different occasions.[46] In the Mojave, Weston was especially drawn to the isolated granite formations and spindly Joshua trees. In *Victorville, Mojave Desert* (cat. 72), for example, Weston photographed a shadowed parabola-shaped boulder accented by two circular highlights at its base and a third almost at the top. Together, the highlights mimic the arc of the rock, in a harmony of parallel curves. At a nearby site, Weston worked with a pile of granite, taking it under two very different light conditions, as one sees in *Wonderland of Rocks, Mojave Desert* (cat. 73, Log no. MD-W-13G and fig. 18, Log no. MD-W-12G). In one of these Mojave pictures (cat. 73), the group of rocks at the upper left descends diago-

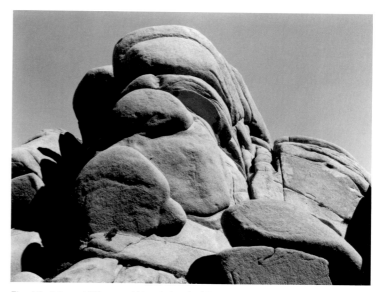

Fig. 18. Edward Weston. *Wonderland of Rocks, Mojave Desert*, 1937 (Log no. MD-W-12G). Silver print

Fig. 19. Edward Weston. *Granite, Mojave Desert*, 1937 (Log no. MD-W-3G). Silver print

nally in a steady march from the top, like steps, lit by the midday sun directly overhead. In the other (fig. 18), longer shadows distort the regularity of the shapes; the upright rocks now seem tilted to the left, resulting in a more fluid, wavelike form.

Also at Wonderland of Rocks, Weston worked with another unusual granite formation, adjusting his camera position to make several different compositions. In *Wonderland of Rocks, Mojave Desert* (cat. 74), Weston pointed the camera up at the granite and isolated the powerful shape of the rocks against the sky, looking like a huge stone fist.[47] *Granite, Mojave Desert* (fig. 19, Log no. MD-W-3G) is shot from farther back and includes a shadowy foreground. The curves of the foreground shadow echo the curve on which the rock fist rests, creating a composition that emphasizes pattern more than sculptural form. In the best-known (and most traditionally pictoral) version of this group of rocks, *Yucca and Rock, Mojave Desert* (Lane Collection, Log no. MD-W-1G),[48] which was published in *California and the West*, Weston pits two slight stalks of yucca in the foreground against the massive granite behind in a contest of opposites.

In the Mojave Desert Weston also took on the Joshua tree, challenged by what he called "the most difficult tree to photograph," finding it, like Golden Canyon, "hopelessly picturesque."[49] He cropped off the bottom of the tree in *Joshua Tree, Mojave Desert* (cat. 70), thereby severing it from any relationship with its surroundings, and he filled the composition to the edges with the "double-elbowed arms gesturing emphatically in every direction."[50] The volumes created by the highlights on the spiky Joshua leaves, though, contrast to the agitated graphic abstraction. In another *Joshua Tree, Mojave Desert* (cat. 71), the repeating forms of two branches make a rhythmic figural pattern, like two space creatures engaged in an extraterrestrial dance.

Along Route 66 in the Mojave, Weston worked with the scattered remains of manmade objects. In a satiric mode, one he would pick up again in his work at the Metro Goldwyn Mayer movie storage lots (cats. 61-62) and elsewhere, his *"Siberia," Mojave Desert* (cat. 66),[51] explores the irony of American throw-away culture. Here he photographed a sign in the shape of a huge cup and saucer, which advertised "Hot Coffee," against the expanse of the arid desert ("Siberia" was the name painted on a nearby abandoned halfway house).[52] In addition to the quirkiness of the subject, the composition has a surreal quality: the scale of the sign makes the vast distances seem impossible and the desert looks like a flat backdrop.

In two other images done near Route 66, Weston found meaning and order in the disorder of manmade refuse. He used debris on either side of the composition in *Highway 66, Mojave Desert* (cat. 67) to frame a view of the remains of a chimney, like a shrine, in the background, and in *Mojave Desert* (cat. 68), two urchinlike Joshua trees stand in poignant counterpoint to the overturned relic of a car in the distance. In Death Valley, too, Weston made sense out of a jumble of odds and ends: in *Leadfield* (cat. 41), the front end of a car frame in the foreground, set at a diagonal, leads the eye back to a shack in the background.

In 1936 Weston photographed some sandstone concretions which a friend had given him.[53] A year later, Weston sought out the concretions in situ in the Salton Sea region of the Colorado Desert. In the resulting compositions, some of the concretions function as sculpture in the round, including those in two photographs titled *Concretions, Colorado Desert* (cats. 16-17). In this series of very Brancusi-like forms, Weston literally backed up his 1932 statement, "I have proved through photography, that nature has all the abstract (simplified) forms, that Brancusi or any other artist could imagine. With my camera I go direct to Brancusi's *source*. I find *ready to use*, — select and isolate, what he has to 'create.'"[54] Throughout his career, Weston denied any associative qualities in his compositions; he and Charis hated that the group of rocks in the first concretion image was called "Teddy Bears" by a copywriter who changed Charis's text in one of the *Westways* articles.[55] Other formations are embedded in the ground, as, for example, *Concretions, Colorado Desert* (cat. 18), in which the rocks look like a Henry Moore reclining figure carved in low relief.

Two of Weston's best-known compositions of the Fellowship period are rare figural works rather than landscapes; these are *Dead Man, Colorado Desert* (cat. 15) and *Charis, Lake Ediza* (cat. 57). In the former, though, Weston went beyond the reportorial or sensational; in the latter, he surpassed personal portraiture. In both compositions, Weston achieved what he had described as his goal in his addendum to the Guggenheim application: "the recording of these becomes not just documentation of a given subject matter, but its sublimation, — the revealing of its significance."[56] In *Dead Man, Colorado Desert*, the tragic subject matter, which so easily could have become melodramatic, is de-emphasized in favor of an amazing range of detailed, subtly highlighted textures. In *Charis, Lake Ediza*, the stability of the sitter's pyramidal form against the rocks, and her evocative look, transcend the specificity of portraiture. In these works

Weston literally makes new objects out of his subjects, as he had promised when he wrote, "So the blossom of the fruit tree becomes more than a blossom."[57]

At Palm Canyon in the Borrego Desert, Weston's favorite subject was a grove of Washingtonia palms, the trunks of which had been burned by fires set by vandals.[58] In *Palm Canyon, Borrego Desert* (cat. 12), Weston again made order out of natural chaos; he centered the curve of a white granite boulder in the foreground, creating a base for four blackened tree trunks which seem to grow out of it. Two drooping palm fronds break up the almost perfect symmetry of the composition. In another *Palm Canyon, Borrego Desert* (cat. 14), Weston did a close-up of palm fronds, creating a dialogue between the linear pattern made by the repetition of their broomlike shapes, and the physical detail of their surface texture.

4

In June of 1937, when warm weather arrived and desert travel became impossible, Charis and Edward headed north. Weston voiced the concerns he had had about the places yet unvisited:

> *Most of the next five months I worked in territory entirely new to me. I had thought I would find little to do in the mountain country because I felt its subject matter to be too confused and undefined compared with the stark and simplified forms of the desert. But the High Sierra and the northern Coast Range proved just as rich in subject matter that appealed to me as the deserts had been.*[59]

In July, Charis and Edward made their first of three trips to Yosemite. Edward's friend Ansel Adams, whom he had met in 1928, served as their guide, and his house became their Yosemite Valley base (figs. 20-21). Although Adams introduced Weston to sites he himself photographed, Weston's work in Yosemite and the High Sierra has little in common with Adams's. Adams, in both his well-known views of the scenic mountains and pristine waterways of Yosemite and the High Sierra, as well as in his close-ups of trees, grass, flowers, and other native flora, celebrated the uniqueness of the place in the nineteenth-century romantic tradition established by painters such as Albert Bierstadt, and by photographers beginning with Carleton Watkins and Eadweard Muybridge. Weston, on the other hand, avoided the famous sites in Yosemite; he could have been working anywhere. He did not, for example, photograph Half Dome, Cathedral Rocks, or any of the dramatic waterfalls, and when he worked with the cliff El Capitan, he did not shoot its characteristic sheer face. The friendship of Weston and Adams, which was a generous and meaningful one on both sides, seems remarkable in retrospect, especially as we become aware of how different their approaches to landscape were, with Edward always critical of what he called the "ain't nature grand" school of which Ansel was the chief practitioner.

As in the desert, the topography and vegetation of Yosemite and the High Sierra provided Weston with the tools to continue his inquiry into landscape. Again, he organized the natural patterns he found; he made compositions both of

Fig. 20. Ansel Adams. *Winter, Yosemite Valley,* about 1936
Silver print. The Lane Collection

Fig. 21. Edward Weston. *El Capitan, Yosemite,* 1938
(Log no. YS-C-126). Silver print

rock formations, such as those done at the Alabama Hills (cat. 58), for example, and of trees, including the powerful series of juniper trunks and branches (cats. 60, 114-115). At Lake Tenaya, Weston photographed groups of tree roots; especially successful is *Roots in Water, Lake Tenaya* (cat. 112), with its close-up of a gnarled tangle of roots. Weston's aim, as always, was to reveal order in unruly forms: the centered vertical root both stabilizes the large sweep of the curved form at the top, and it organizes the smaller roots in sections around it.

Yosemite and the High Sierra offered Weston his first chance to work with ice and snow.[60] On the initial trip to Yosemite, in July 1937, on the same day he later photographed *Charis, Lake Ediza* (cat. 57), Weston made a group of about seven negatives of melting ice on the water at Iceberg Lake. In *Iceberg Lake* (cat. 56), Weston cut out the sky and shot the patches of snow and rocky terrain on the steep far bank of the lake reflected in the water. Islands of ice float on the surface; photographed in flat light, the volumes of the abrupt slope are flattened, creating a compelling two-dimensional composition of its mirrored image. The floating ice gives the image depth, but at the same time makes a complex abstract pattern of black and white land, snow, and reflection.

In February 1938, after two days of snow in the Yosemite Valley, Charis reported that "Edward went berserk. Everywhere he looked there was something to photograph: trees top-heavy with snow, buildings mantled with thick white over-roofs, wires built up with snow till they looked like tree branches."[61] Weston worked the snow-covered landscape as he did any other, experimenting with the rhythm and order of the forms he found, fascinated with the snow that had made new, sometimes unrecognizable objects out of trees, rocks, and manmade structures. In *Tent Frames, Yosemite* (cat. 117), dollops of snow highlight the geometry of a tent frame which Weston photographed at an angle and set against a dense weave of snow-edged trees. Space is condensed by the point of view and the limited range of blacks and whites, making an abstract, linear image.

Weston found the muted light of the northern California coast disconcerting when he went there for the first time in August 1937:

Coming from the strong contrasts and brilliant sunlight of the southern deserts, I found the muffled shoreline flat and uninteresting at first. But soon I realized that fog was as much a part of this country as sunlight of the desert.[62]

Instead of the rigorous sculptural forms of the rocks and canyons of the deserts, a quieter mood pervades Weston's north coast work, an introspective quality also present in the series of Death Valley dunes and the work he did at Point Lobos during the Fellowship years. In *Point Arena* (cat. 83), the reflection of the white overcast sky in the water creates a flat pattern with the gray sand. The image is brought back towards the representational by the scattered driftwood in the foreground. *Driftwood and Auto, Crescent Beach* (cat. 78) is a variation on Weston's Leadfield and Mojave Desert compositions that made order out of detritus. As in *Mojave Desert* (cat. 68), Weston used a natural object as a foil to the manmade, but here, the decaying automobile seems all the more melancholy, half-buried in the sand and photographed in soft light. In *Little River, North Coast* (cat. 80), a great hoof of a stump is softened by diffused light into a study of tonality rather than iconic form, creating a contemplative object instead of a powerful physical presence.

While in northern California, Weston made about five negatives at the abandoned lumber mill town of Albion. As in his images of the ruins in Death Valley, Weston was interested in formal arrangements, not documentation. In *Albion* (cat. 75), the diagonal of the road is anchored by the house and shack at the lower left. In another print titled *Albion, North Coast* (cat. 77), a diagonal deteriorating timber bridge in the foreground, punctuated by the crossbeams of its understructure, is countered by the zigzagged roofline of the houses in the background. Weston also plays with pattern and spatial tension in his photographs of buildings still in use, including, for example, *Embarcadero, San Francisco* (cat. 111) and *Jerome, Arizona* (cat. 3). Yet even in images that come close to contemporary documentary photography, Weston, more than Dorothea Lange or even Walker Evans, for example, still concentrated on his pursuit of formal order. In *Clear Lake, Coast Range* (cat. 20), he shot a lone farm house and its scraggly vineyard, a typical subject for the Depression photographers. Rather than make a statement about the plight of rural communities, however, Weston positioned his camera both to flatten the volume of the house and to deny the perception of space in the landscape; the resulting image has the artficial look of a backdrop.

During the Fellowship years, Charis and Edward made only two trips out of California: one to Arizona and New Mexico and the other to Oregon and Washington.[63] In December 1937, they set out for New Mexico and Arizona, "and after a summer and fall in the north it was good to be once more in the simplified geography of the desert."[64] Weston had visit-

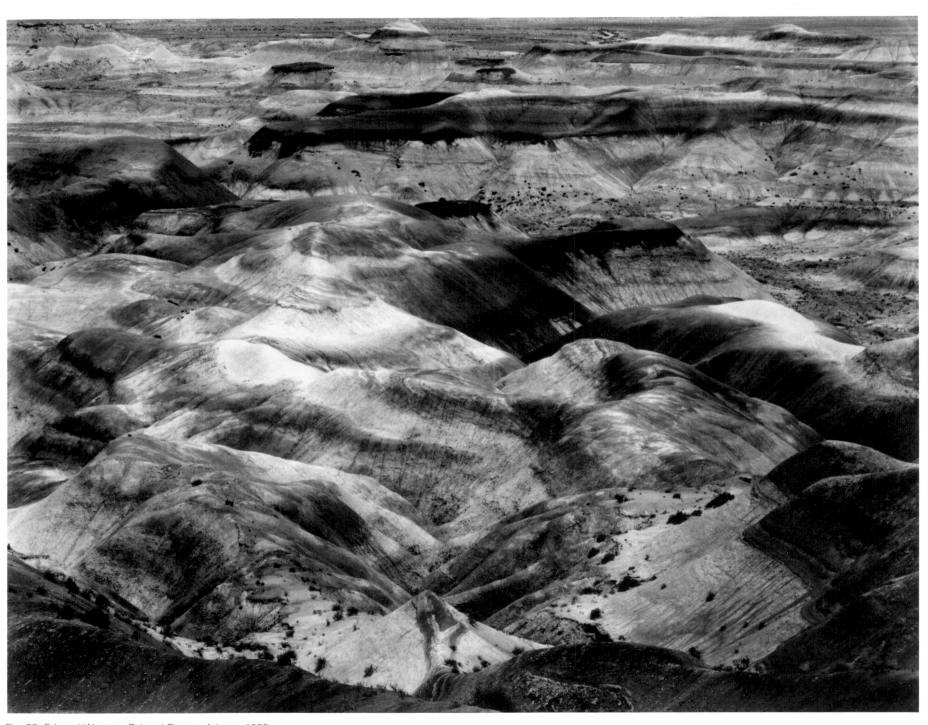

Fig. 22. Edward Weston. *Painted Desert, Arizona*, 1933
(Log no 32L). Silver print

Fig. 23. Edward Weston. *Oregon*, 1939
(Log no. O-Mi-5G). Silver print

ed Arizona in late December 1929 and January 1930, but apparently did not take any photographs on that trip.[65] In 1933, he again traveled to Arizona and New Mexico, and in his Daybooks had written about "the visual memories brought back of a magnificent country — Arizona, New Mexico and my own California."[66] Weston's subjects on this trip included the Painted Desert in Arizona (fig. 22, Log no. 32L) and in New Mexico, the Taos Pueblo, several churches, details of rocks, and a juniper, "but mostly open landscape, — for in N. Mexico the heavens and earth become one."[67] The looser, more painterly style of these southwestern images prefigures Weston's Guggenheim photographs of Dante's View or Point Lobos.

Near Albuquerque, Charis and Edward stayed in an adobe house in which their friend Willard Nash, a painter, had been living. The building was included in about a dozen images which vary in abstraction and show, with a single subject, Weston's range of compositional approaches. In *Old Adobe, New Mexico* (cat. 84), Weston made sense of an interior strewn with junk. A broken rocking chair tilts to the left; in the background a huge wardrobe lists to the right. The instability of these forms is balanced, though, by the vertical line created by the corner. In two other images, called *Albuquerque, New Mexico* (cats. 85 and 88), Weston concentrates on the wall itself. In the first photograph, he made a composition of the stark simplicity of geometric shapes on

the irregular texture of the adobe. In the second image, the austere abstraction becomes lyrical. The force of the geometric shapes has been subdued but still provides the framework for the vertical composition. Softer light emphasizes the texture of the adobe and hard edges of shadow have dissolved into indefinite forms. Finally, in another *Albuquerque, New Mexico* (cat. 87), Weston took a detail of the adobe alone. In this all-over abstraction, he dispensed with any reference to scale; the dried mud could be an aerial view of a network of canyons or the skin of a reptile magnified a thousand times.[68]

At the same time Weston photographed the adobe walls, he also made four negatives of Charis sunbathing on the patio.[69] In this series, which includes *Nude* (cat. 89), Weston juxtaposed the body and black cape to an adobe oven and its shadowy interior, contrasting light and dark as well as texture. Compared to his earlier nudes, these four compositions are both more real, and far less formal; they have an earthiness not present in either the small-format fragmentary nudes or the Oceano pictures. Except for a group of three images of Charis's legs in a hammock (see cat. 107), these New Mexico compositions were the only nudes Weston executed during the Guggenheim years.

In Arizona, Weston did a series of about twenty negatives of Saguaro cacti, photographing them with other landscape elements and in isolation (cats. 7-10). In *Saguaro, Arizona* (cat. 8), the bold trunk of a cactus is contrasted to a pitted, seemingly lunar hill, creating a dialogue between two elemental objects. Both hill and cactus are cut off with no reference to scale, resulting in spatial ambiguity. The mighty vertical thrust of a single cactus in another *Saguaro, Arizona* (cat. 9), is countered by its wild lower limbs which twist and seem to spin like an airplane propeller, creating a clash between stability and movement.

The other Guggenheim foray out of California, to Oregon and Washington and as far north as Vancouver, produced a total of only about two dozen negatives which relate to the North Coast work in both subject and introspective mood. Through the northernmost part of the trip, Charis and Edward drove in a combination of fog and smoke; they were traveling in the spring when land is cleared by burning.[70] Only about half a dozen photographs were taken in Washington (cat. 116). Oregon was more fruitful, and Weston did some effective work on the coast, including the gently abstract *Oregon* (fig. 23, Log no. O-Mi-5G). He also made a small series of negatives of the Columbia River, most of which recall Dante's View, and a stark group of images at the town of Bandon, which had burned in a forest fire in 1937.

5

During the summer of 1938, after their house was finished and Charis and Edward had settled in Carmel Highlands, Weston began to photograph Point Lobos again. He had stayed away from this subject since moving away from Carmel in 1935, "saying he was all through with it,"[70] as Charis reported. However, on Weston's breaks from printing the Guggenheim negatives, his primary objective during the second year of the grant, he and Charis would head to nearby Point Lobos. At first they went just to swim and walk, but, as Charis relates in *California and the West*:

Edward took his camera along in case he might see a cloud or something. He made a few negatives; we went oftener; he made more. Soon we were going out once a week and Edward was making more negatives than ever, most of them quite different from his earlier seeing of the same material. He did tide pools, landscapes, groves of cypress, seaweed and kelp in the water, breaking waves and long views of the rugged shoreline.[72]

Weston's earlier work on Point Lobos had concentrated on monumental close-ups (figs. 2 and 3, Log nos. 10T and 24R), which he had made into carefully organized modernist compositions directly related to the still lifes and nudes he executed in the studio at the same time. In the Guggenheim images, Weston began to distance himself from his Point Lobos subjects. About the cypress, for example, Weston wrote:

When I left Carmel in 1935 I was convinced that I had said all there was for me to say about the Monterey cypress. I returned in 1938, after two years of travel on a Guggenheim Fellowship during which a great part of my work had been open landscapes, and saw the cypress with new eyes. Then, for the first time I treated them as elements of the larger landscape, photographing groups of cypress in their setting of cliffs and sea with fog or sea mist drifting over them.[73]

As with the cypresses, Weston also pulled back from the isolated rock formations he had taken earlier in the decade. In *Pool, Point Lobos* (cat. 96), Weston photographed a random group of rocks in shallow water. He treated the subject much

as he had the vista at Dante's View: he shot down on it at an angle, omitting the sky, but not completely closing off the subject from its surroundings. The haphazard collection of boulders, coastal ledge, and water is anchored, in Weston's composition, by the diagonal shelf of rock at the lower left. Tension is created between the natural abstraction of the resulting pattern and the representation of the objects themselves.

In these new photographs of Point Lobos, Weston relinquished the disciplined clarity of the work he had done there between 1929 and 1935. The difference in approach from the early to the later Point Lobos work in fact parallels what Weston had done with sand dunes, first at Oceano in 1936 (figs. 13 and 14, Log nos. 29SO and 46SO) and then in Death Valley on the Fellowship: classic and restrained images give way to freer, more personal ones (see cats. 24-25, and 27). Not only did he distance himself from familiar stable objects, such as rocks, trees, and the precisely arranged kelp he found, but Weston turned his camera on fugitive subjects, too, photographing ocean and the coast directly interacting with one another. In *Surf, Point Lobos* (cat. 101), for example, the foam left by two receding waves creates an easy loose abstraction which has the relaxed gesture of two great overlapping brushstrokes. Even in close-ups in which he shot directly down on the subject in his old way, as in *Rocks, Point Lobos* (cat. 99), Weston emphasized the accidental and fluid arrangement of rock formations and seaweed in his selection of the composition, creating a Kandinsky-like abstraction.

Edward Weston's Guggenheim photographs represent both a remarkable creative surge for the artist and, at the same time, forge a link between his earlier and later work. Weston moved from the studio, where he manipulated the conditions under which he took pictures, to the outdoors, where he exercised compositional selection on a broader and more complex subject. He sought always to reveal the inherent order in nature, whether photographing the rhythmic ridges of Golden Canyon or the jumbled discards along Route 66. The powerful images from the canyons of Death Valley, for example, retain the distinct organization of the peppers, shells, and nudes of the early 1930s. The poetic photographs executed at Point Lobos, on the other hand, are more subtle, looking forward to the compositions of the 1940s. Rather than commit himself to a single way of seeing, Weston opened up a freer exchange between the subjects he chose

and his approach to them. With this masterful anthology of varied work, Weston not only created his "epic series of photographs of the West," but he exceeded his own expectations in ways he perhaps could not have predicted.

I am most grateful to Charis Wilson, Rachel Harris, and Carl Zahn for their constructive criticism of this manuscript, and I am especially indebted to Ted Stebbins for his tireless guidance and thoughtful comments on this essay.

1. Edward Weston, "Photographing California," *Camera Craft* 46, February 1939, no. 2, p. 56.

2. As "Date of Mailing" on the Fellowship Application Form Weston wrote "10-22-'36." A copy of the application is in the archives of the Huntington Library, San Marino, California (the original is in the archives of the Guggenheim Foundation).

3. As submitted by Weston in the Guggenheim Fellowship Application Form as his "statement of project."

4. Conversation with Charis Wilson, November 30, 1993.

5. Nancy Newhall, ed., *The Daybooks of Edward Weston*, vol. II, California, p. 279 (henceforth DB I and II).

6. The "Edward Weston Print of the Month Club" offered a limited number of subscribers a Weston print a month (chosen by the artist) for $10.00 each instead of his usual $15.00 or $20.00 ($100.00 for the year if paid in advance). This project lasted about a year. Eleven "EWPOMC" prints are designated in Weston's subject log. Weston chose the prints from recent work (1935-1936) and the subjects varied. According to Charis Wilson, there were only about eight or nine subscribers.

7. Charis Wilson, *Journal of the Guggenheim Year 1937-1938*, unpublished manuscript in the collection of the Huntington Library, San Marino, California, p. 1. The letter from the Guggenheim Foundation itself is dated March 18, 1937.

8. John Simon Guggenheim Memorial Foundation, *Charter, Letter of Gift, Constitution and By-Laws*, New York, 1925, n.p. Final approval of the selection was given by the Board of Trustees. Henry Allen Moe, who served the foundation for thirty-nine years in a variety of roles, carefully supervised the whole process. In 1937–1938 the Foundation's Advisory Board (also called the Committee of Selection) included painter Gifford Beal, sculptor James Fraser, musician Thomas Surette and poet Edna St. Vincent Millay. See Gordon N. Ray, *Guggenheim Fellowships A Preprint from the Report of the President, 1978*, New York, August 1979, pp. 7-8; Milton Lomask, *Seed Money*, New York, 1964, pp. 259-264 and letter, G. Thomas Tanselle, Vice President, John Simon Guggenheim Memorial Foundation to Deanna Griffin, Department of Paintings, Museum of Fine Arts, Boston, July 27, 1993, in Museum files. I am grateful to Deanna for all her invaluable research assistance on this project.

9. Letter, G. Thomas Tanselle to Deanna Griffin, July 27, 1993, in Museum files. On his application, Weston included Carl Zigrosser, Charles Sheeler, Merle Armitage, Walter Arensberg, Rockwell Kent, Alfred Barr, Jean Charlot, and Karl Nierendorf as his references.

10. For the list of fellows for 1937 see John Simon Guggenheim Memorial Foundation, *1937 and 1938 Reports of the Secretary and of the Treasurer*, New York, 1939, pp. 16-31.

11. Letter, Edward Weston to Henry Allen Moe, February 4, 1937 (a copy is in the archives of the Huntington Library, San Marino, California. The original is in the archives of the Guggenheim Foundation). The text of the letter is reproduced in Peter C. Bunnell, ed., *Edward Weston on Photography*, Salt Lake City, 1983, pp. 78-80.

12. DB I, p. 55.

13. Estelle Jussim, "Quintessences: Edward Weston's Search for Meaning," in Peter C. Bunnell and David Featherstone, eds. *EW 100: Centennial Essays in Honor of Edward Weston*, *Untitled* 41, Carmel, 1986, p. 60.

14. Three of Weston's sons went on Guggenheim trips at various times: Cole (b. 1919), Brett (1911–1993) and Neil (b. 1916). Only Chandler (b. 1910), the eldest son, did not.

15. Charis made the connection between her journal to the Daybooks in a telephone conversation, November 30, 1993. Until he became involved with Charis, Weston had been author as well as photographer, writing his own letters and articles, and also entering his personal thoughts in his Daybooks. In 1936, beginning with the Guggenheim application, this changed; Charis became Edward's ghostwriter in article writing. Usually, she would ask him questions, jot down the replies, work them into a more finished form and he would then edit them.

16. Conversation with Charis Wilson, November 30, 1993.

17. Conversation with Charis Wilson, November 7, 1993.

18. A second edition of *California and the West* was published by Aperture in 1978, with a new foreword by Charis but only sixty-four images, ten of which were not included in the original. The Guggenheim work is discussed in a short but insightful article by John Szarkowski, "Edward Weston's Later Work," *MOMA* 2, winter 1974-75 (reprinted in Beaumont Nehall and Amy Conger, eds., *Edward Weston Omnibus*, Salt Lake City, 1983, pp. 158-159), by Andy Grundberg in "Edward Weston's Late Landscapes," in Peter C. Bunnell and David Featherstone, eds., *EW 100: Centennial Essays in Honor of Edward Weston*, Carmel, 1986, pp. 93-101, and also in in James Enyeart, *Edward Weston's California Landscapes*, Boston, 1984, which includes earlier and later California work as well.

19. Wildcat Hill was built on land owned by Charis's father, author Harry Leon Wilson. Charis and Edward also moved to Carmel Highlands because her father was suffering from injuries he had sustained in an automobile accident. He died June 28, 1939.

20. Foreword, Charis Wilson in Charis Wilson and Edward Weston, *California and the West*, 2nd edition, New York, 1978, p. 11.

21. Charis Wilson, *Journal of the Guggenheim Year 1937-1938*, unpublished manuscript in the collection of the Huntington Library, San Marino, California, expense list with first trip (henceforth referred to as Wilson,

Journal). Charis kept a detailed breakdown of their expenses for the duration of the Fellowship, sometimes later annotating the list with explanatory comments. On her account for the second trip, for example, she justified the more expensive purchase of two cans of "vegal" for $.22, in addition to three cans of mixed vegetables for $.25 by noting "(vegal) used to have okra in the mixed veg(etables) so tastier than lesser brands." Or, "1 can klim" was explained with the remark "Powdered milk — ugh! — but you had to put something on cereal."

22. Wilson, *Journal*, April 6, 1937, entry. The car is referred to as "Heimy" in *California and the West*, but in the *Journal* as "the black whore," "puta negra" or "dark gal," all of which Charis later crossed out and replaced with "Heimy."

23. For a complete listing of the articles see the Selected Bibliography. The articles did not appear in April and in June 1938 and in April 1939. Although it was made clear that Edward took the pictures, Charis was never credited with a by-line. Interestingly, in the September 1938 "Point Lobos and Oceano" article, some earlier, non-Guggenheim work was used.

24. The size and placement of the reproductions varied (see figs. 9 and 10). In some instances the photographs were laid out diagonally across the page, or even overlapped. Many were cropped. On the other hand, the reproductions in *California and the West* (1940) are all the same and measure 9 x 7 inches (or 7 x 9 inches for verticals). The original prints average about 8 x 10 inches. In the *Westways* articles Charis's captions were also changed; a copywriter came up with the published text, using her carefully researched material. Although Charis and Edward found the quality of the *Westways* reproductions unsatisfactory, the whole series was later issued as a book in 1939. The book was also called *Seeing California with Edward Weston* and was published by Westways.

25. Conversation with Charis Wilson, December 17, 1993. Charis found Edward's old negative numbering system too vague. He used numbers attached to broad categories of subjects, for example, "A" referred to architecture, but one does not know from the shorthand the type of building represented in the negative or where.

26. Conversation with Charis Wilson, December 17, 1993.

27. "DV-DV-23" was published in the November 1937 "Seeing California with Edward Weston" article in *Westways*, and was therefore done on the first trip. According to the list of negatives included as Project Prints, "DV-DV-13" was taken on the 1938 trip. See also Amy Conger, *Edward Weston: Photographs from the Collection of the Center for Creative Photography*, Tucson, 1992, which puts most of the approximately 500 Guggenheim prints belonging to the Center for Creative Photography in chronological order. The Lane Collection includes almost 900 Guggenheim images.

28. For the northern part of the state they used Brett Weston's apartment; during the second year Wildcat Hill was their point of departure.

29. Wilson, *Journal*, April 9, 1937. This event is also recounted in Charis Wilson Weston and Edward Weston, *California and the West*, New York, 1940 pp. 15-16 (henceforth *California and the West*, 1940).

30. DB II, p. 22.

31. Ibid., p. 146.

32. *California and the West*, 1940, p. 113. Charis only obliquely refers to the application for an extension to the grant in her *Journal* (see entry for November 23, 1937).

33. Edward Weston to Willard Van Dyke, March 28, 1938, reproduced in Leslie Squyres Calmes, *The Letters between Edward Weston and Willard Van Dyke*, Tucson, 1992, p. 34.

34. See, for example, Federal Writers' Project of the Works Progress Administration for the State of California, *California A Guide to the Golden State*, New York, 1939, or the Federal Writers' Project of the Works Progress Administration for the State of California, *Death Valley*, Boston, 1939, or W. A. Chalfant, *Death Valley The Facts*, Palo Alto, California, 1930. Three of Weston's photographs are reproduced in the WPA guide to Death Valley, including one of Dante's View. In 1954, Ansel Adams, with Nancy Newhall, published *Death Valley*, a history and guide illustrated with Adams's photographs.

35. *California and the West*, 1940, p. 18. This information is not included in Charis's *Journal*.

36. *California and the West*, 1940, p. 113.

37. Wilson, *Journal*, March 14, 1938.

38. A third version of the composition is DV-GC-1G and is reproduced in Charis Wilson, "Of the West: A Guggenheim Portrait," *U.S. Camera Annual 1940*, New York, 1939, p. 48. (Also in Amy Conger, *Edward Weston: Photographs from the Collection of the Center for Creative Photography*, Tucson, 1992, figure 1283/1938.)

39. Wilson *Journal*, March 8, 1938.

40. There are two other Guggenheim Death Valley dune pictures in the Lane Collection specifically related to these three. Weston did about two dozen negatives at the dunes.

41. The relationship between Weston's work and Abstract Expressionism is also discussed by Andy Grundberg in "Edward Weston's Late Landscapes," in Peter C. Bunnell and David Featherstone, eds., *EW 100: Centennial Essays in Honor of Edward Weston*, Carmel, 1986, p. 96 (he sees the Oceano dunes as prefiguring Abstract Expressionism) and Amy Conger in *Edward Weston: Photographs from the Collection of the Center for Creative Photography*, Tucson, 1992, Figure 1173/1937 with regard to *Burned Car, Mojave Desert*.

42. Rhyolite was named for a type of rock existing in quantity in the area and was founded in 1904 after gold was discovered in the nearby hills. The town flourished until 1911, when the capital backing the mine production disappeared and the population, which had peaked at 10,000, gradually emigrated elsewhere. See Kate Graves, *Rhyolite Tour Guide*, Amargosa Valley, Nevada, 1992.

43. Wilson, *Journal*, March 20, 1938, and December 25, 1938.

44. DB II, p. 57.

45. Ibid., p. 58.

46. On some of these trips, Charis and Edward passed through parts of the Mojave Desert on the way to other destinations and stopped for part

of a day or overnight. They spent the first night of the initial Guggenheim trip to Death Valley, for example, camping on the Mojave Desert; that first afternoon and the next morning Edward photographed there. The five trips include those to Red Rock Canyon. Weston also went to the Mojave Desert in 1935.

47. Amy Conger, in *Edward Weston: Photographs from the Collection of the Center for Creative Photography*, Tuscon, 1992, also calls this rock formation a fist. See figures 999/1937 and 1021/1937.

48. This image is also known as *Yucca, Wonderland of Rocks*. A fourth composition of this group of rocks is reproduced in Amy Conger, 1992, figure 1023/1937.

49. Edward Weston, "I Photograph Trees," *Popular Photography* 6, no. 6, June 1940, p. 120.

50. Ibid., p. 121.

51. This image is also called *Hot Coffee, Mojave Desert*.

52. Wilson, *Journal*, December 8, 1937.

53. *California and the West*, 1940, p. 34.

54. DB II, p. 240 and letter to Ansel Adams, January 28, 1932, reproduced in Mary Street Alinder and Andrea Gray Stillman, eds., *Ansel Adams Letters and Images 1916-1984*, Boston, 1988, pp. 48-50.

55. Edward Weston, "Seeing California with Edward Weston: Carrizo Creek and the Southern California Desert," *Westways* 29, no. 10, October 1937, p. 8.

56. Letter, Edward Weston to Henry Allen Moe, February 4, 1937 (a copy is in the archives of the Huntington Library, San Marino, California. The original is in the archives of the Guggenheim Foundation).

57. Letter, Edward Weston to Henry Allen Moe, February 4, 1937. This statement is similar to the often quoted earlier one Weston made about photographing "a pepper that is more than a pepper." Theodore E. Stebbins, Jr., in *Weston's Westons: Portraits and Nudes*, Boston, 1989, p. 32, reached a similar conclusion about the importance of *Charis, Lake Ediza*.

58. Charis reported in her *Journal* that according to Mr. Calvert, the winter ranger in the Borrego Desert, the palms were burned in 1931 "on purpose, by someone who wanted a nice blaze. Wilson, *Journal*, January 30, 1938 and *California and the West*, 1940, pp. 109-110.

59. Edward Weston, "Photographing California Part II," *Camera Craft* 46, no. 3, March 1939, pp. 99-100.

60. He also photographed snow in New Mexico in December 1937, see *Santa Fe, New Mexico* (cat. 91).

61. *California and the West*, 1940, p. 111.

62. Edward Weston, "Photographing California Part II," *Camera Craft* 46, no. 3, March 1939, p. 102.

63. They also made the two day-trips to Rhyolite, Nevada while in Death Valley.

64. *California and the West*, 1940, p. 101.

65. DB II, pp. 139-140. He wrote in the entry dated January 31, 1930, "Some day I may find time to write about our vacation adventures . . . I did no work, but I have no regrets."

66. DB II, p. 275.

67. Ibid., p. 275.

68. Weston did a similar close-up of the ground at Red Rock Canyon (cat. 105).

69. Wilson, *Journal*, December 29, 1937, and *California and the West*, 1940, p. 105.

70. *California and the West*, 1940, p. 121. Weston did make two negatives at Point Lobos on July 3, 1937, according to Charis in her *Journal*.

71. Ibid., 1940, p. 119. Charis does not write about Point Lobos in the journal. In 1950, Virginia Adams, with Houghton Mifflin Company, reproduced thirty of Weston's photographs of Point Lobos in *My Camera on Point Lobos* with quotes from his Daybooks. Eight of the images were from the Guggenheim years.

72. *California and the West*, 1940, p. 120.

73. Edward Weston, "I Photograph Trees," *Popular Photography* 6, no. 6, June 1940, p. 120.

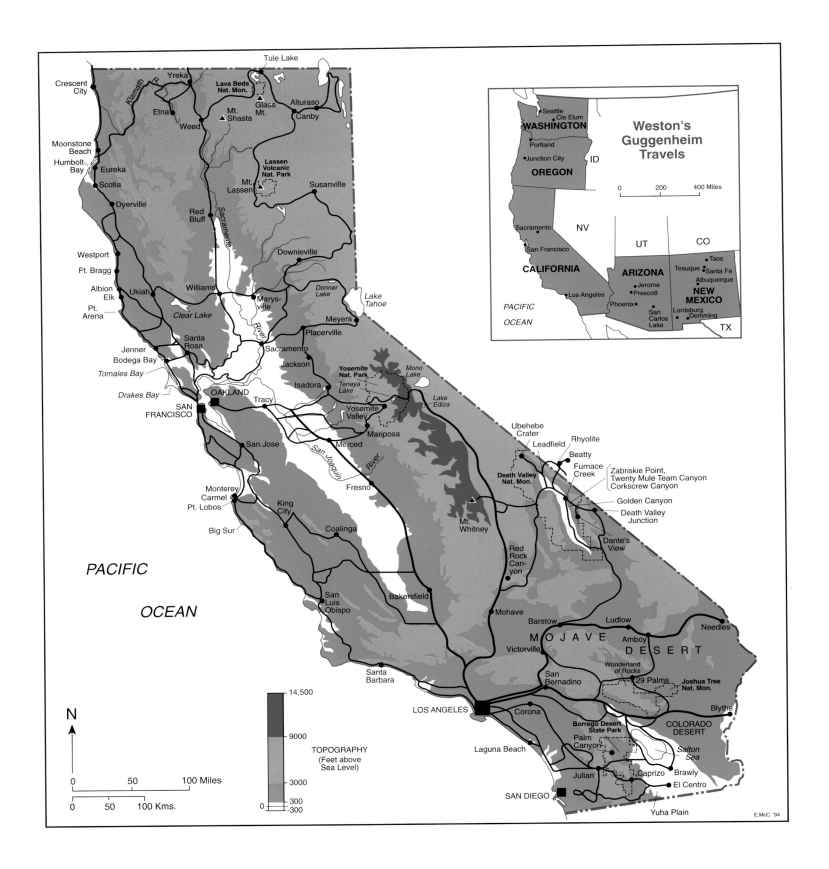

Crescent
City
Yreka
Tule Lake
Lava Beds
Nat. Mon.
Etna
Glass
Mt.
Alturaso
Weed
Mt.
Shasta
Canby
Moonstone
Beach
Humbolt
Bay
Eureka
Lassen
Volcanic
Nat. Park
Scotia
Susanville
Dyerville
Mt.
Lassen
Red
Bluff
Westport
Ft. Bragg
Downieville
Albion
Elk
Ukiah
Williams
Pt.
Arena
Marys-
ville
Donner
Lake
Lake
Tahoe
Clear Lake
Meyers
Jenner
Bodega Bay
Santa
Rosa
Placerville
Tomales Bay
Sacramento
Drakes Bay
OAKLAND
Jackson
Tracy
Isadora
Yosemite
Nat. Park
Mono
Lake
SAN
FRANCISCO
Tenaya
Lake
Lake
Ediza
Yosemite
Valley
San Jose
Mariposa
Ubehebe
Crater
Rhyolite
Merced
Leadfield
Beatty
Monterey
Carmel
Pt. Lobos
King
City
Fresno
Death Valley
Nat. Mon.
Furnace
Creek
Zabriskie Point,
Twenty Mule Team Canyon
Corkscrew Canyon
Big Sur
Coalinga
Golden Canyon
Death Valley
Junction
Mt.
Whitney
Dante's
View
Red
Rock
Can-
yon
San
Luis
Obispo
Bakersfield
Mohave
Barstow
Ludlow
Needles
MOJAVE
Amboy
Victorville
DESERT
Santa
Barbara
Wonderland
of Rocks
San
Bernadino
29 Palms
Joshua Tree
Nat. Mon.
Blythe
LOS ANGELES
Corona
COLORADO
DESERT
Borrego Desert
State Park
Laguna Beach
Palm
Canyon
Salton
Sea
Julian
Caprizo
Brawly
SAN DIEGO
El Centro
Yuha Plain

PACIFIC

OCEAN

N

Weston's
Guggenheim
Travels

Seattle
Cle Elum
WASHINGTON
Portland
OREGON
ID
Junction City
Sacramento
NV
UT
CO
San Francisco
CALIFORNIA
ARIZONA
Tesuque
Taos
Santa Fe
Albuquerque
Los Angeles
Jerome
Prescott
NEW
MEXICO
PACIFIC
Phoenix
San
Carlos
Lake
Lordsburg
Demming
OCEAN
TX

0 200 400 Miles

14,500

9000

3000

TOPOGRAPHY
(Feet above
Sea Level)

300
-300

50 100 Miles
0
0 50 100 Kms.

E.McC. '94

38

PLATES

Plate 1 (cat. 1)

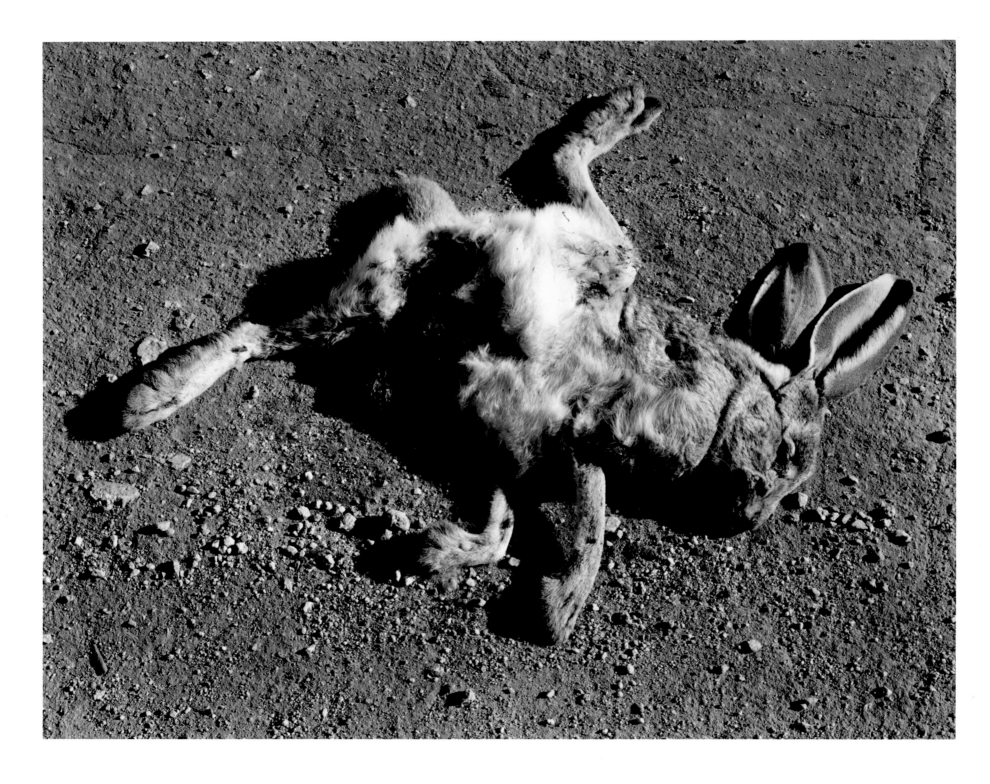

Plate 2 (cat. 4)

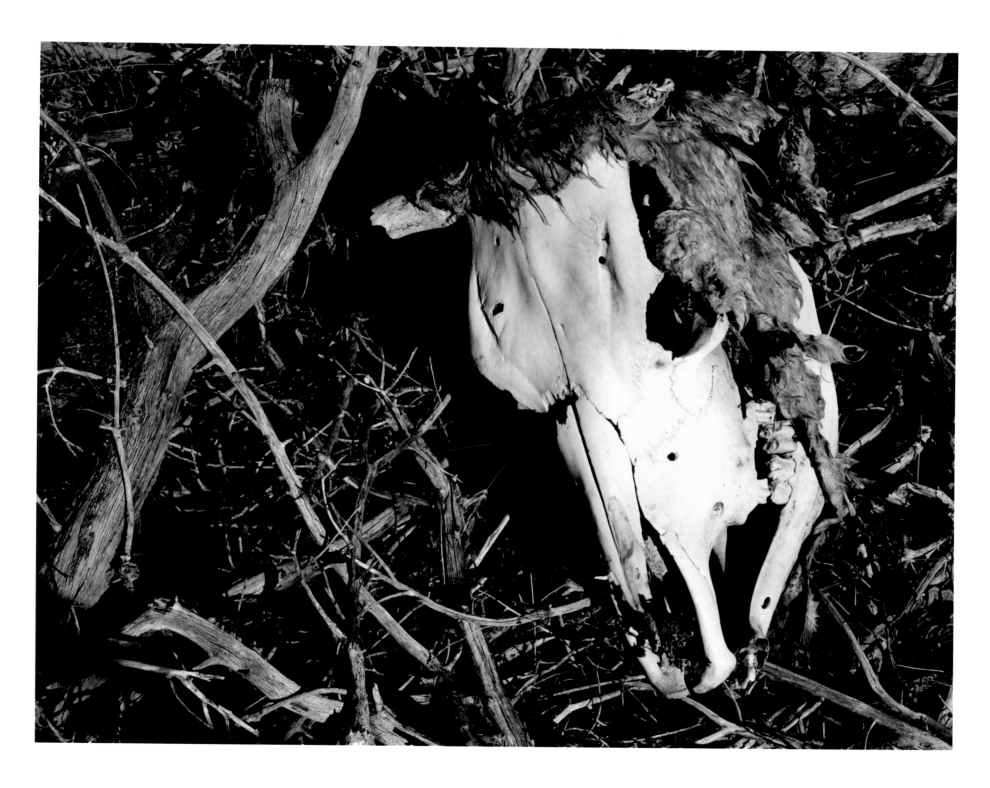

Plate 3 (cat. 6)

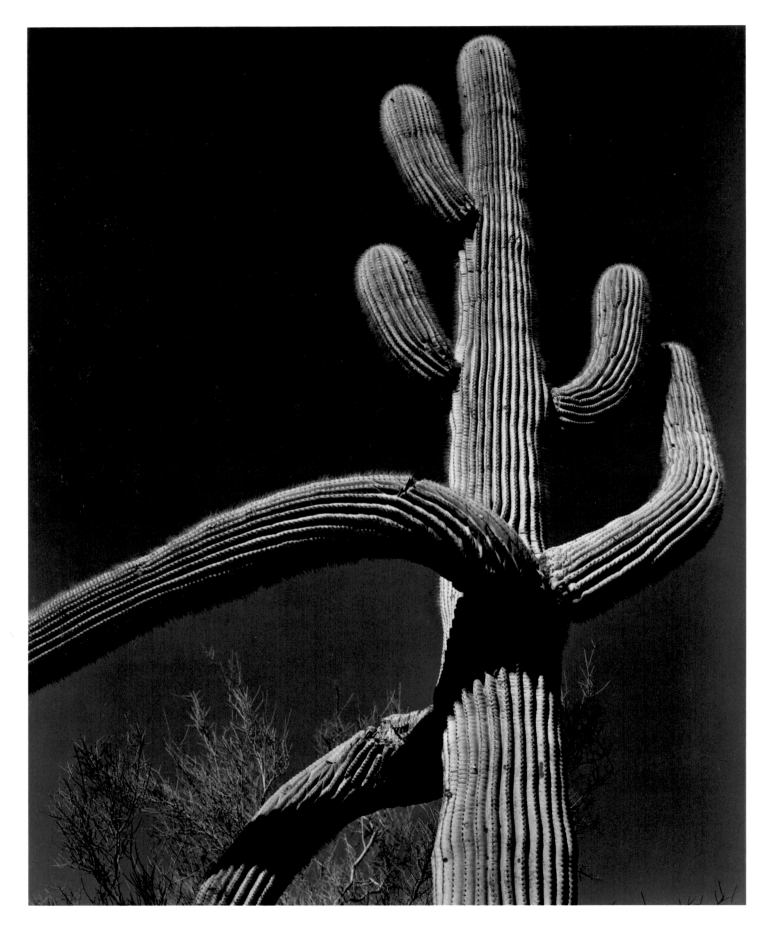

Plate 4 (cat. 9)

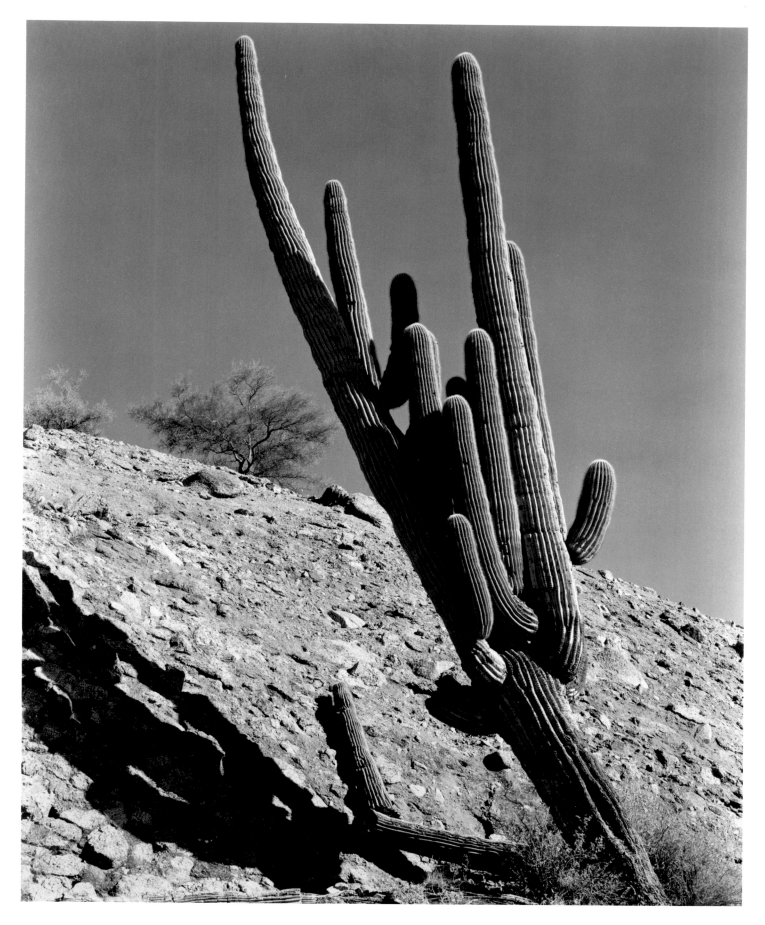

Plate 5 (cat. 10)

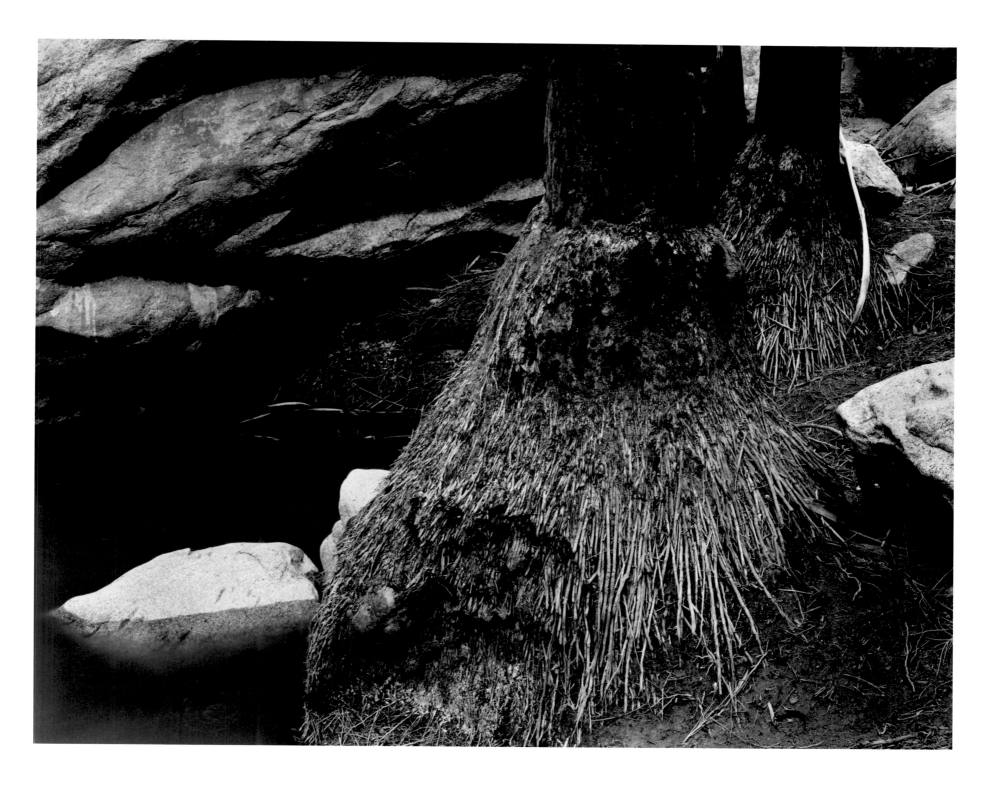

Plate 6 (cat. 13)

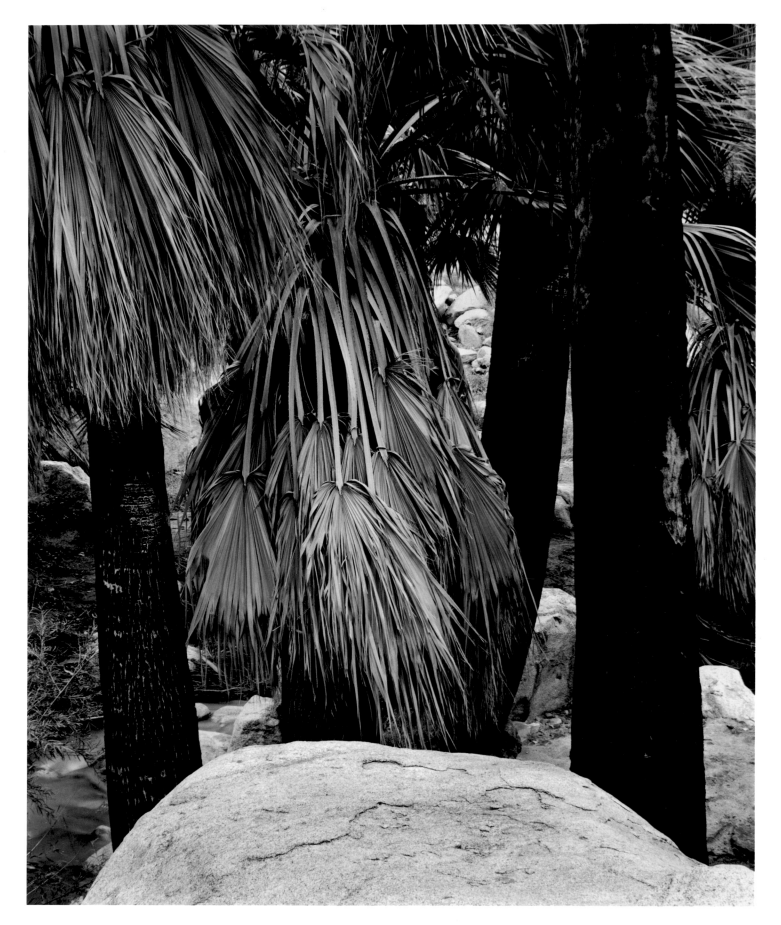

Plate 7 (cat. 12)

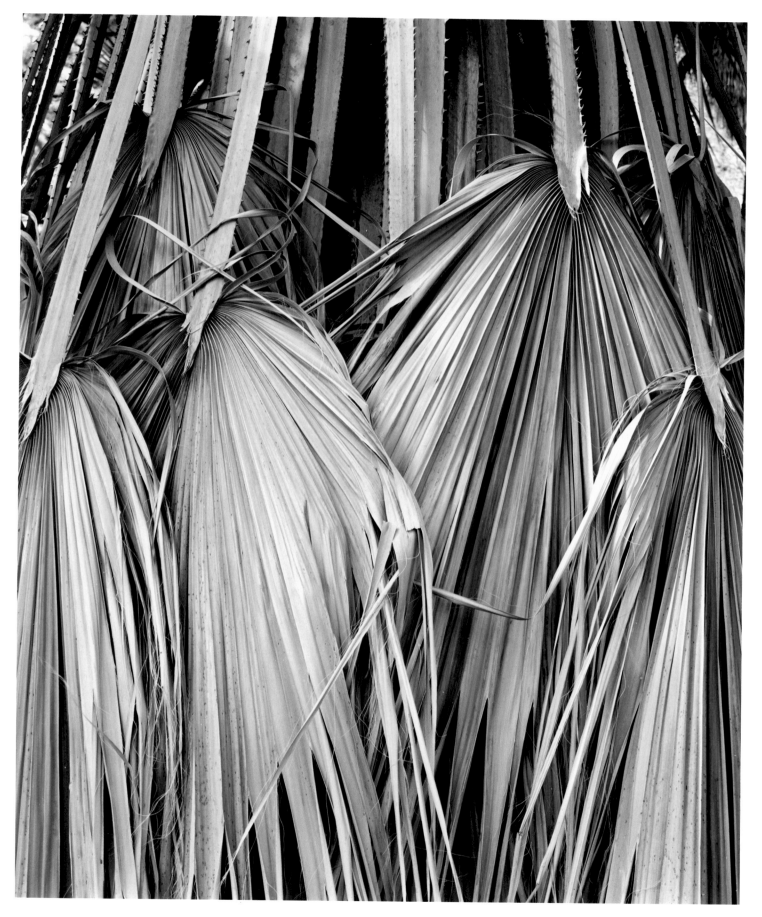

Plate 8 (cat. 14)

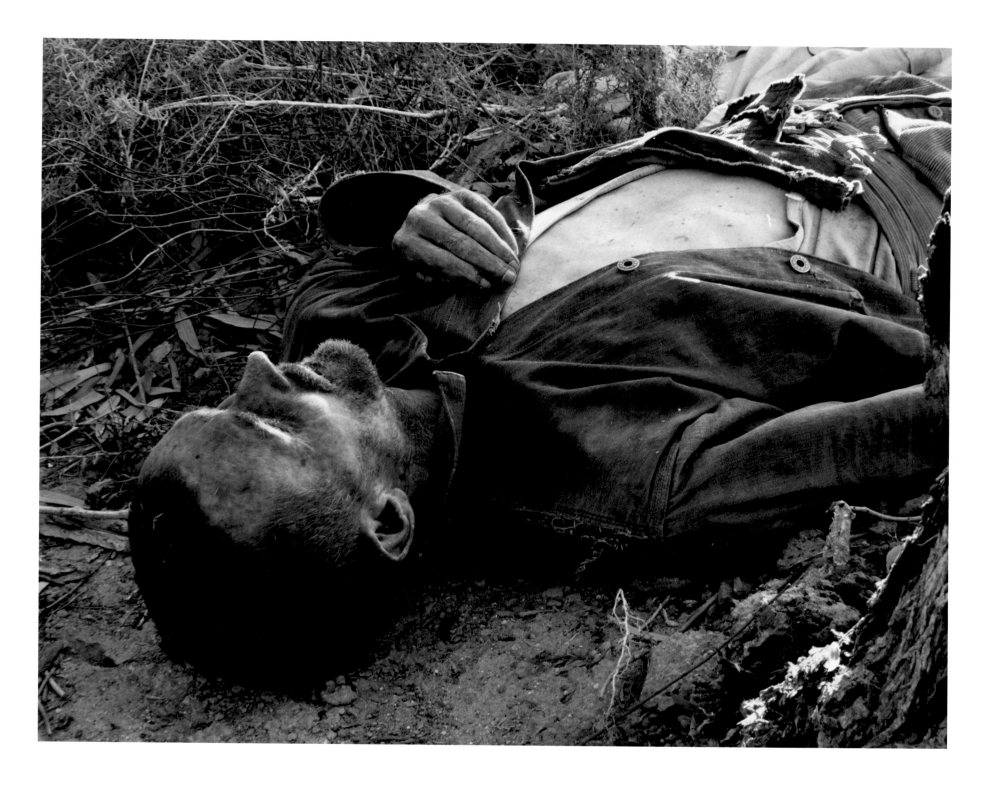

Plate 9 (cat. 15)

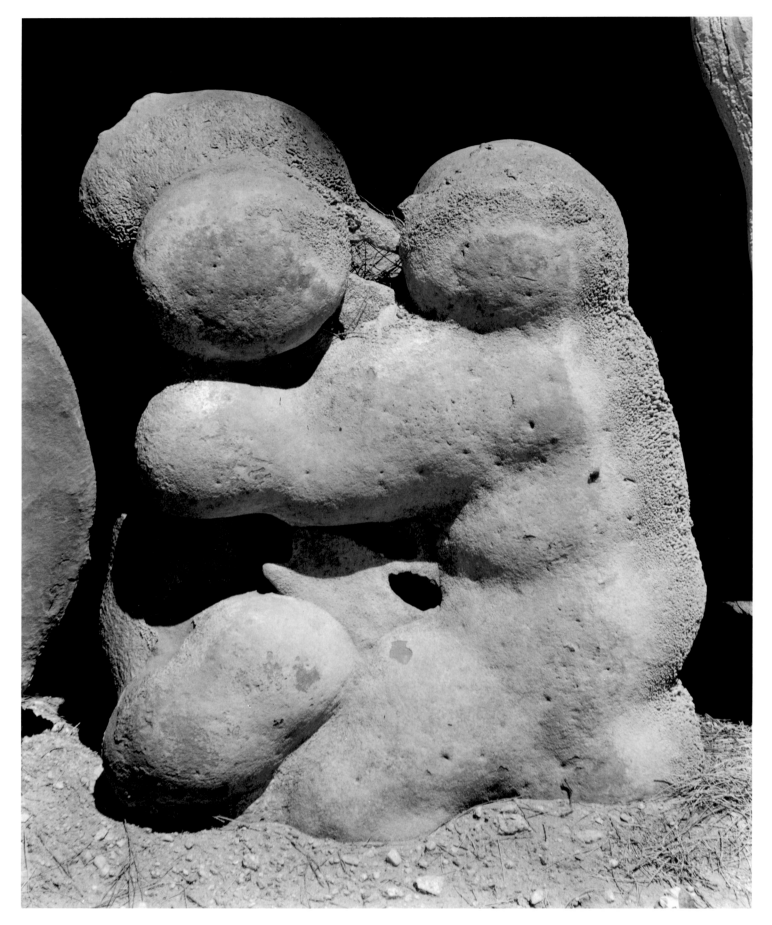

Plate 10 (cat. 16)

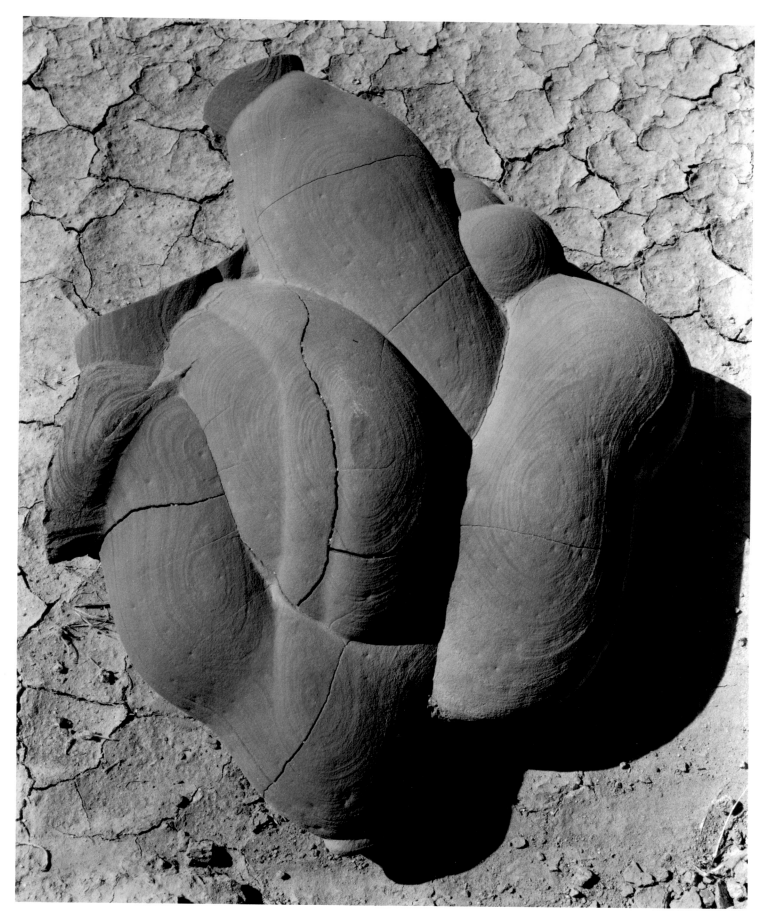

Plate 11 (cat. 17)

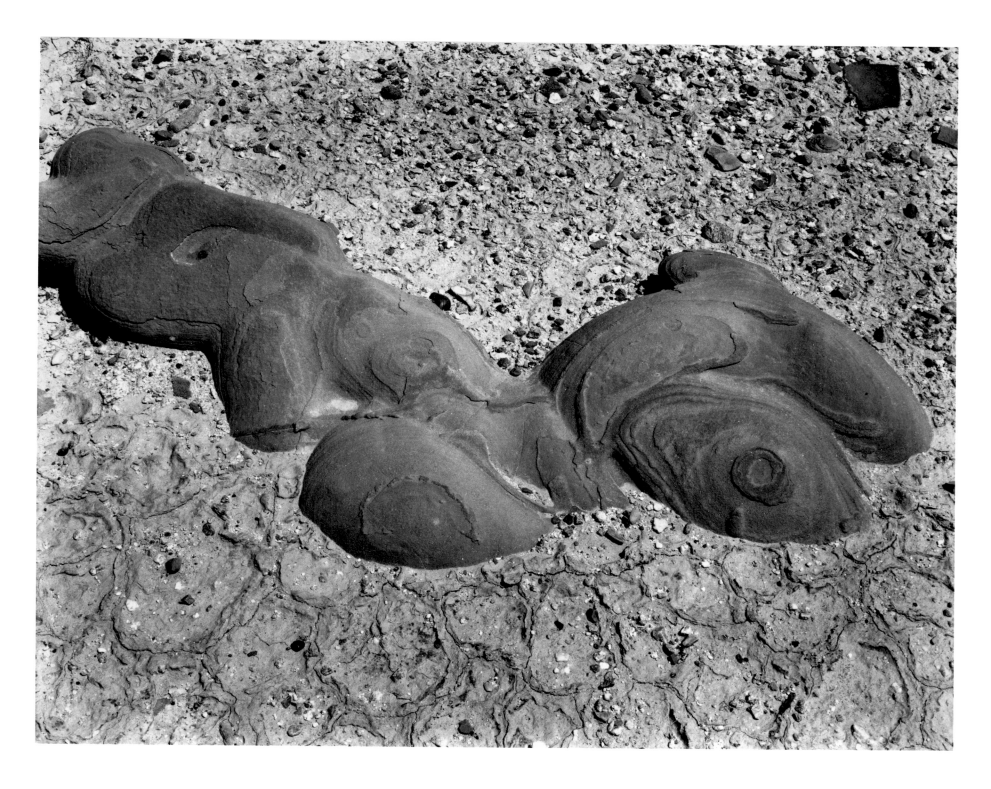

Plate 12 (cat. 18)

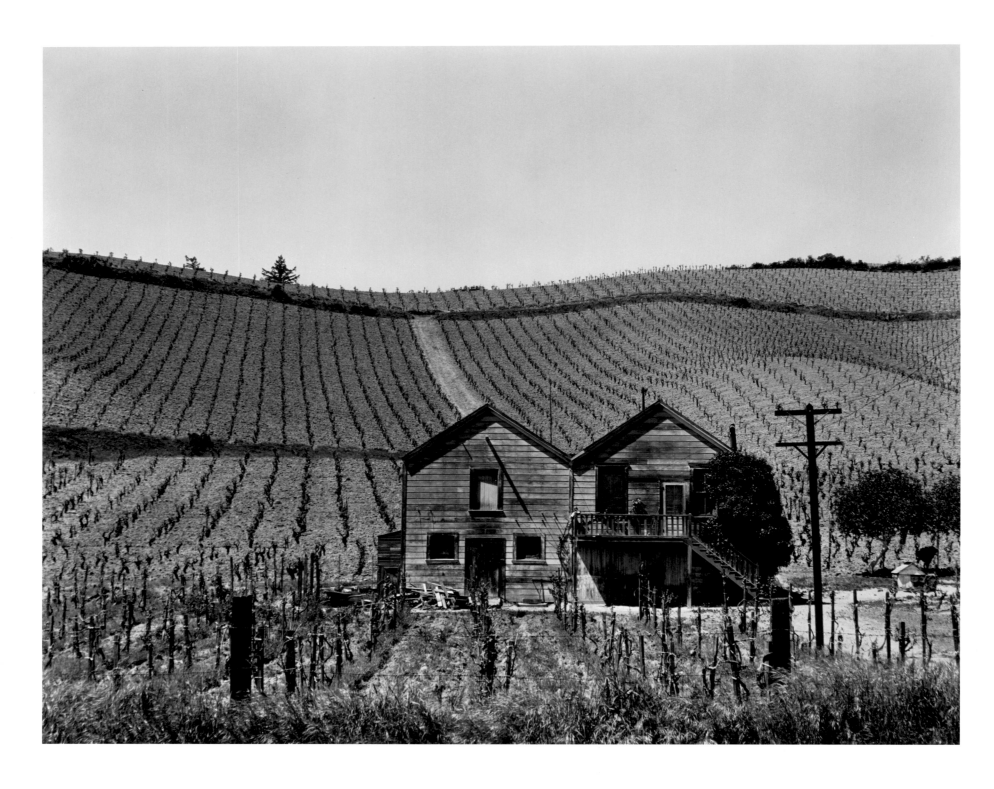

Plate 13 (cat. 20)

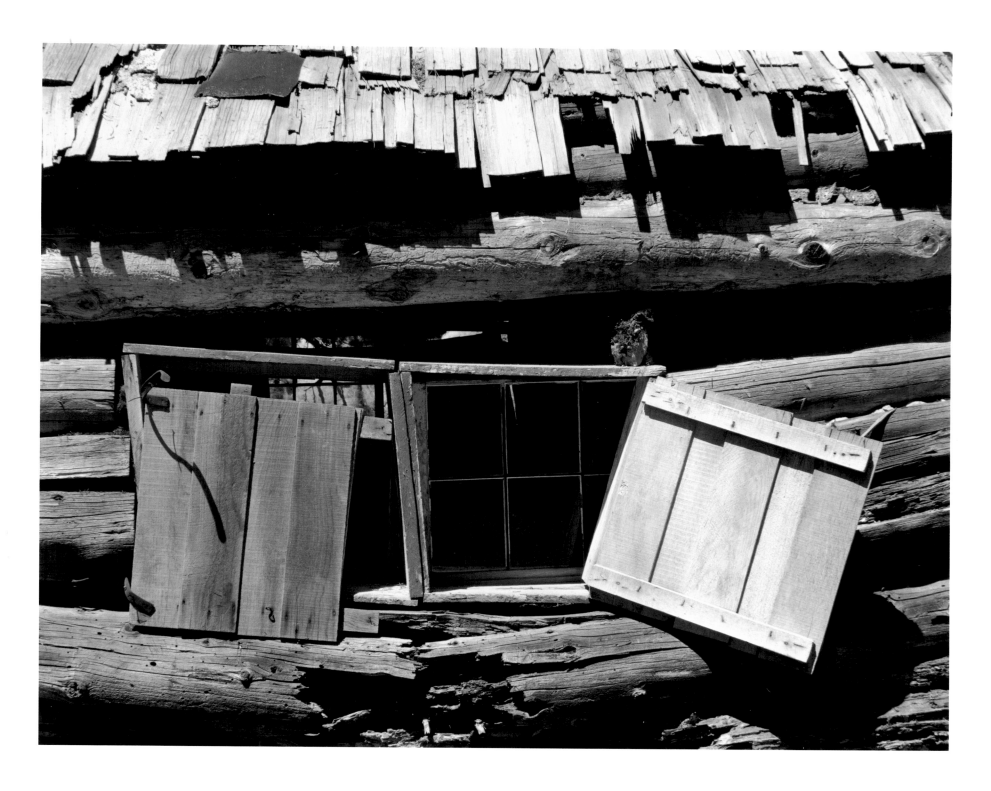

Plate 14 (cat. 21)

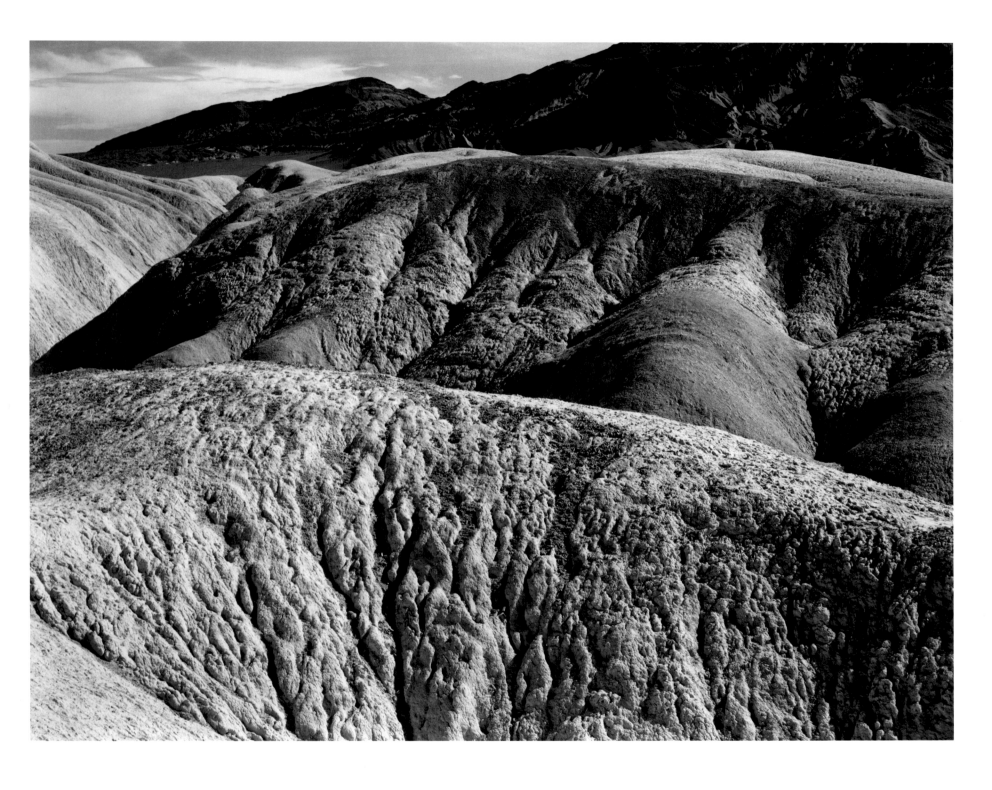

Plate 15 (cat. 22)

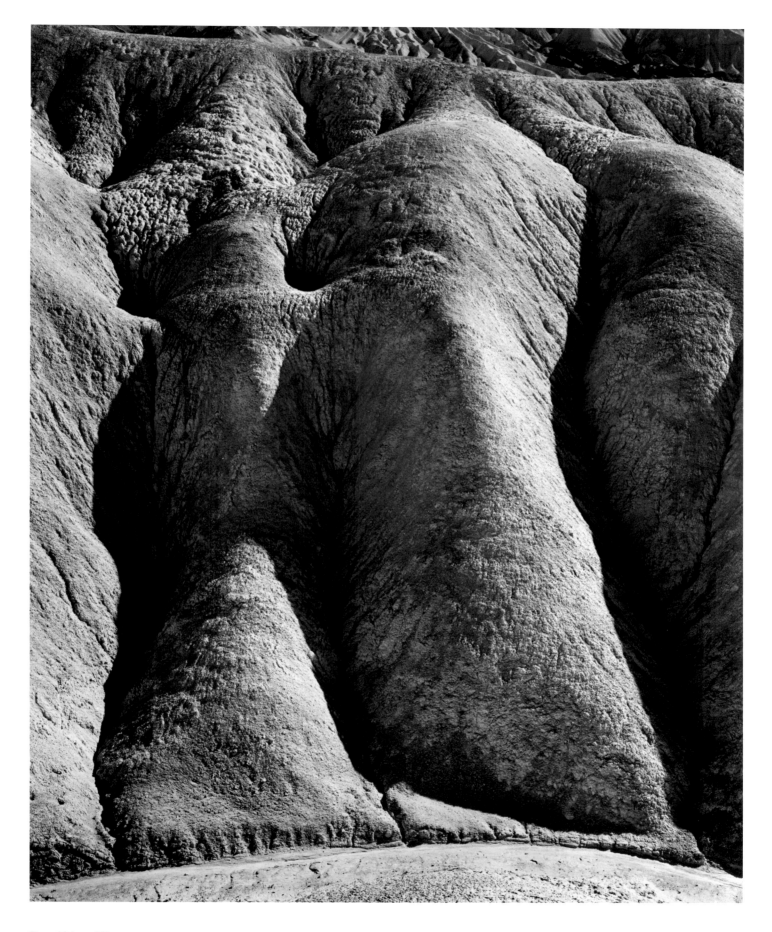

Plate 16 (cat. 23)

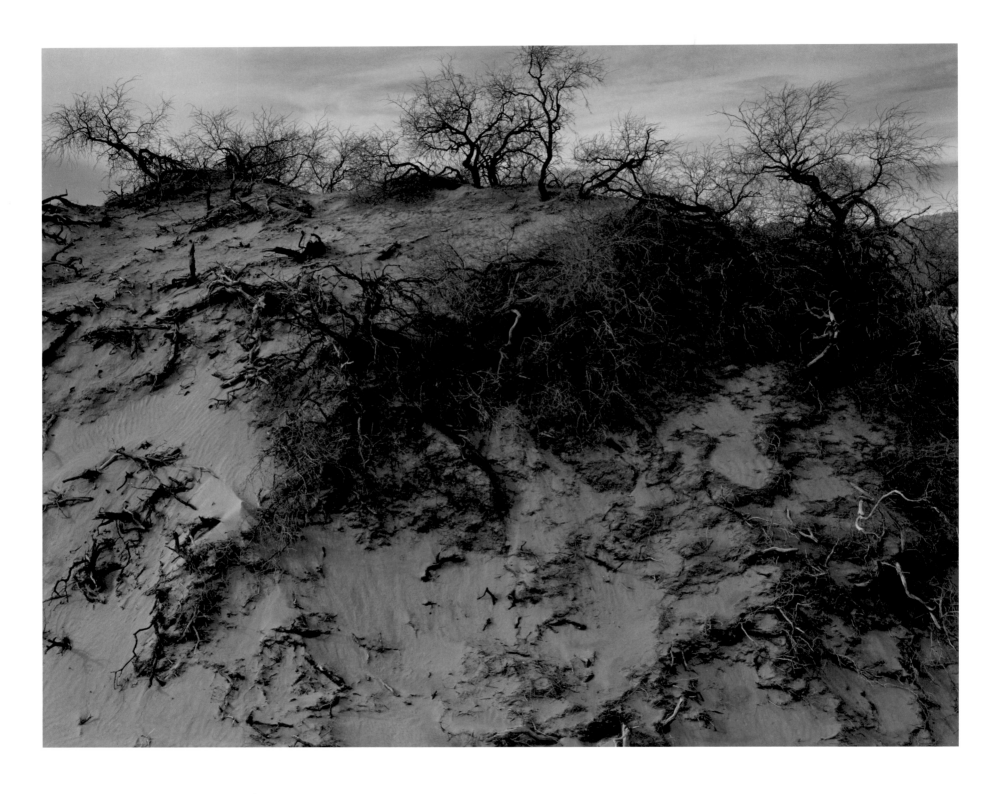

Plate 17 (cat. 24)

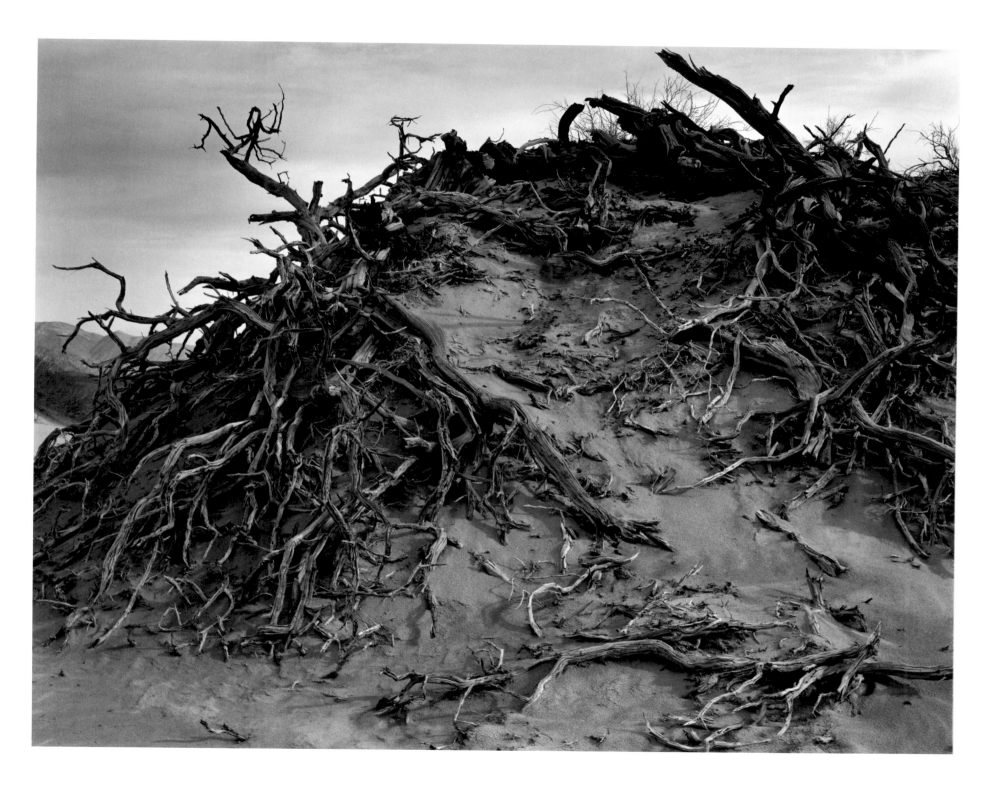

Plate 18 (cat. 25)

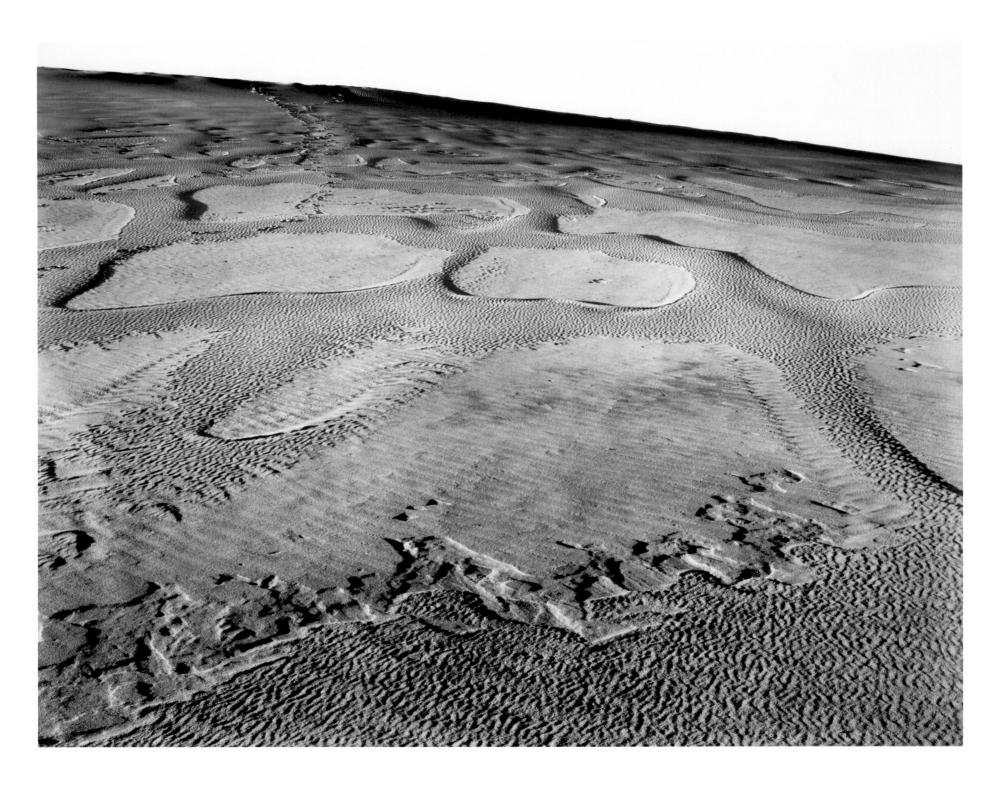

Plate 19 (cat. 26)

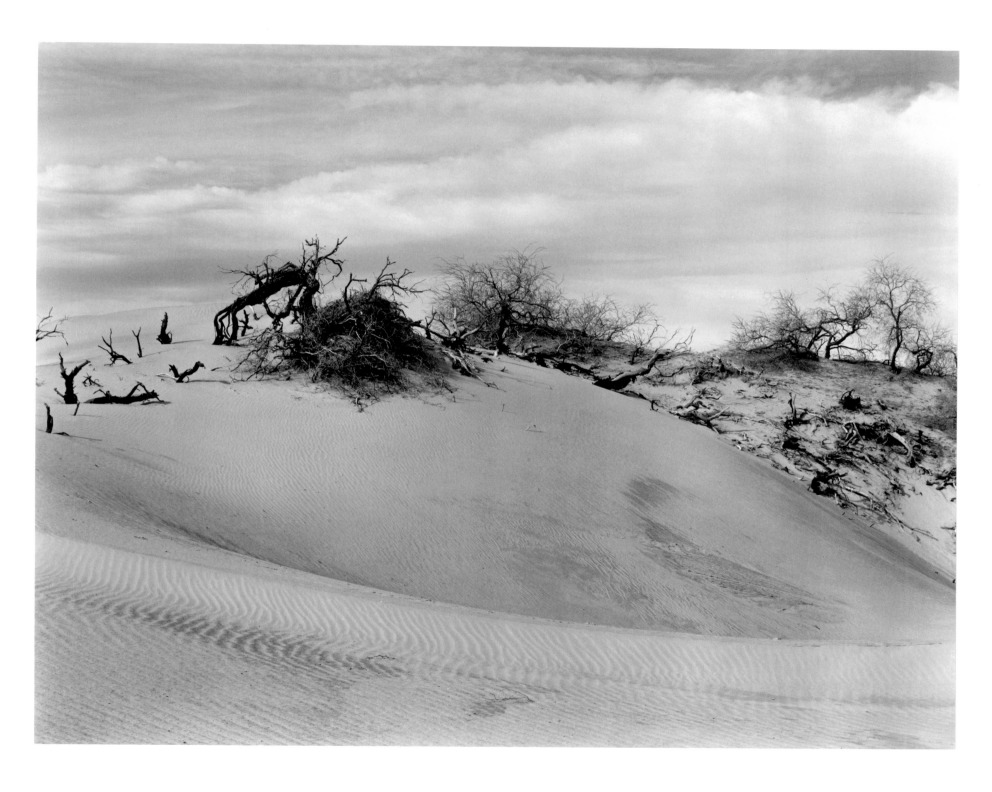

Plate 20 (cat. 27)

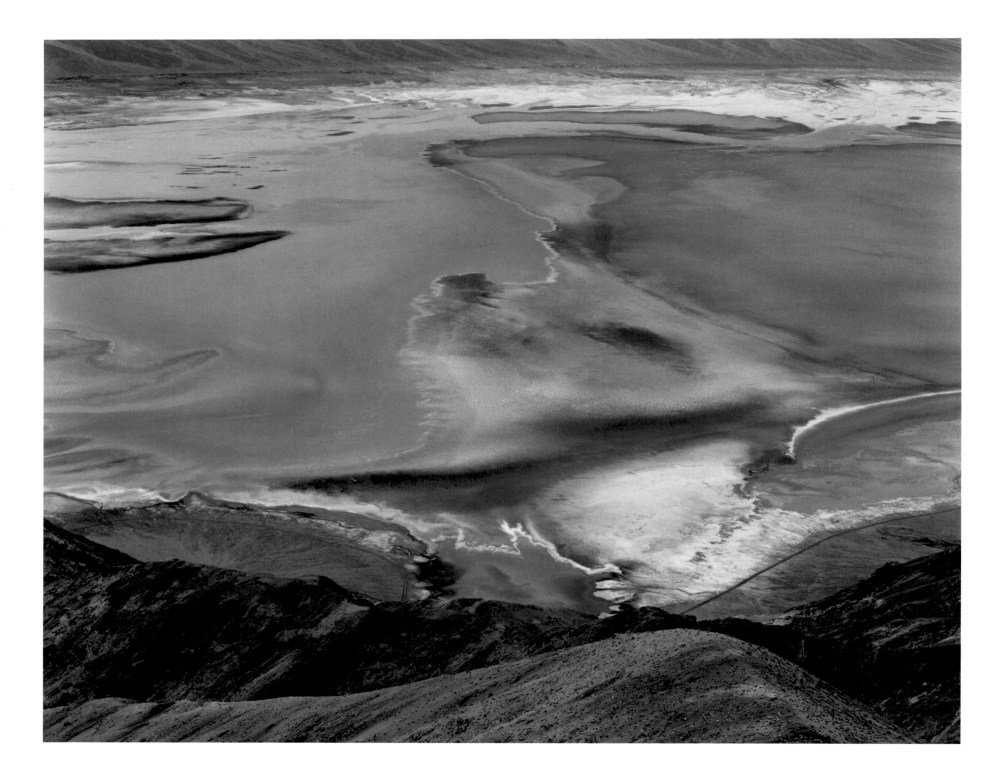

Plate 21 (cat. 28)

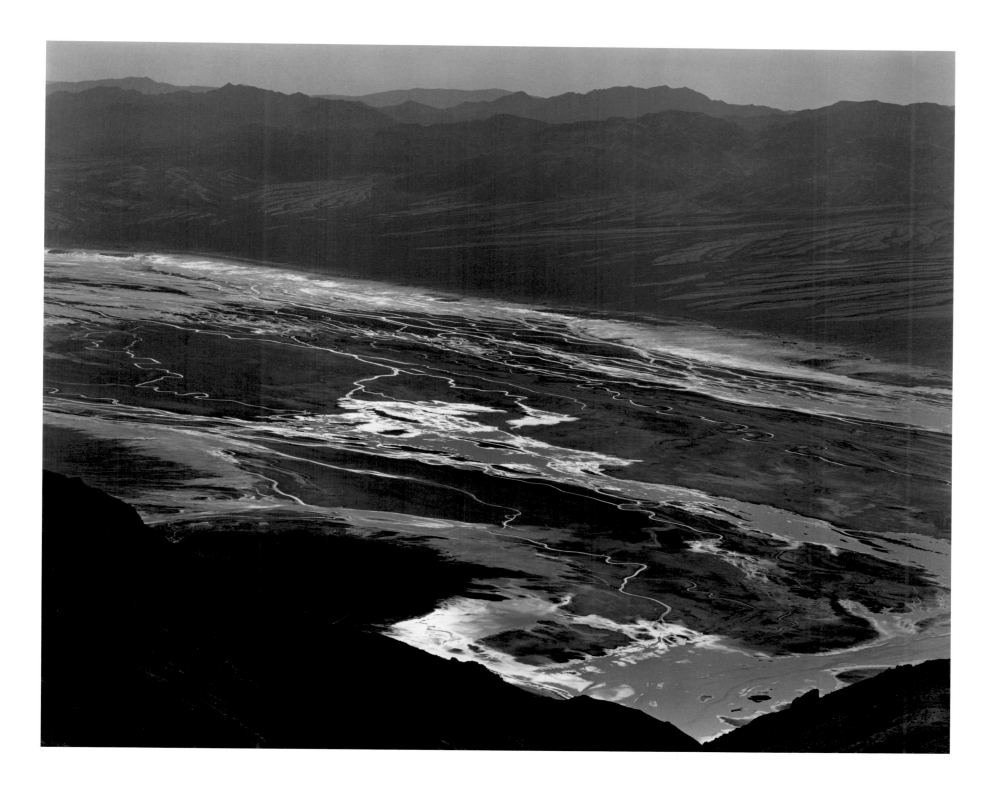

Plate 22 (cat. 29)

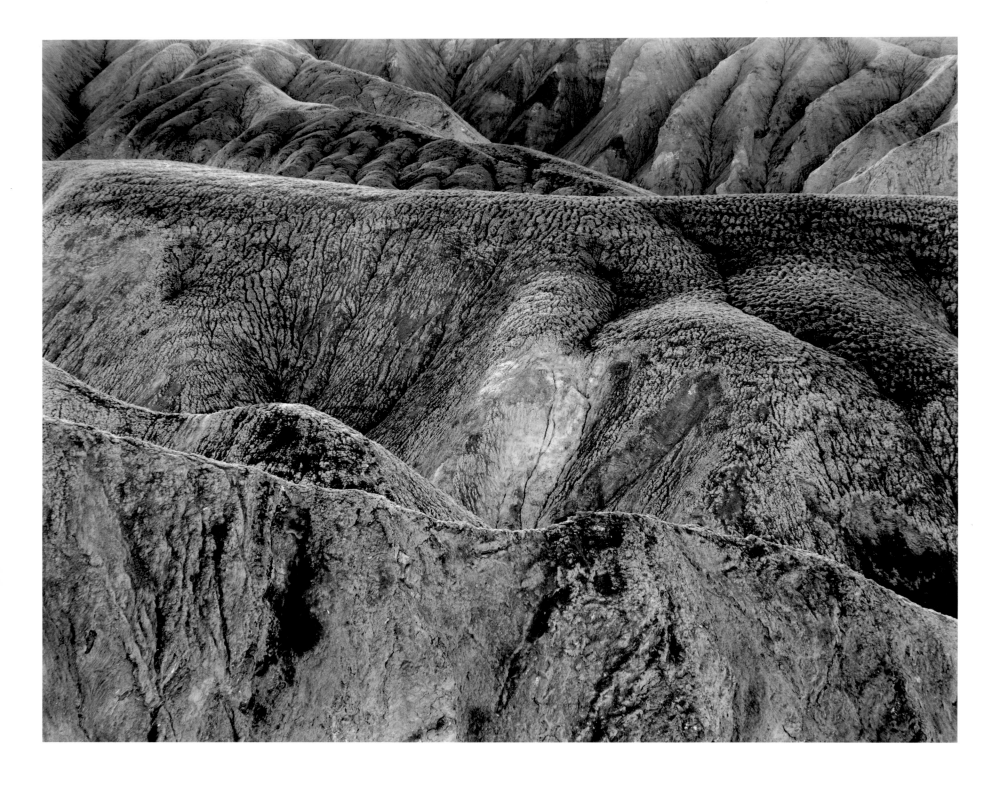

Plate 23 (cat. 31)

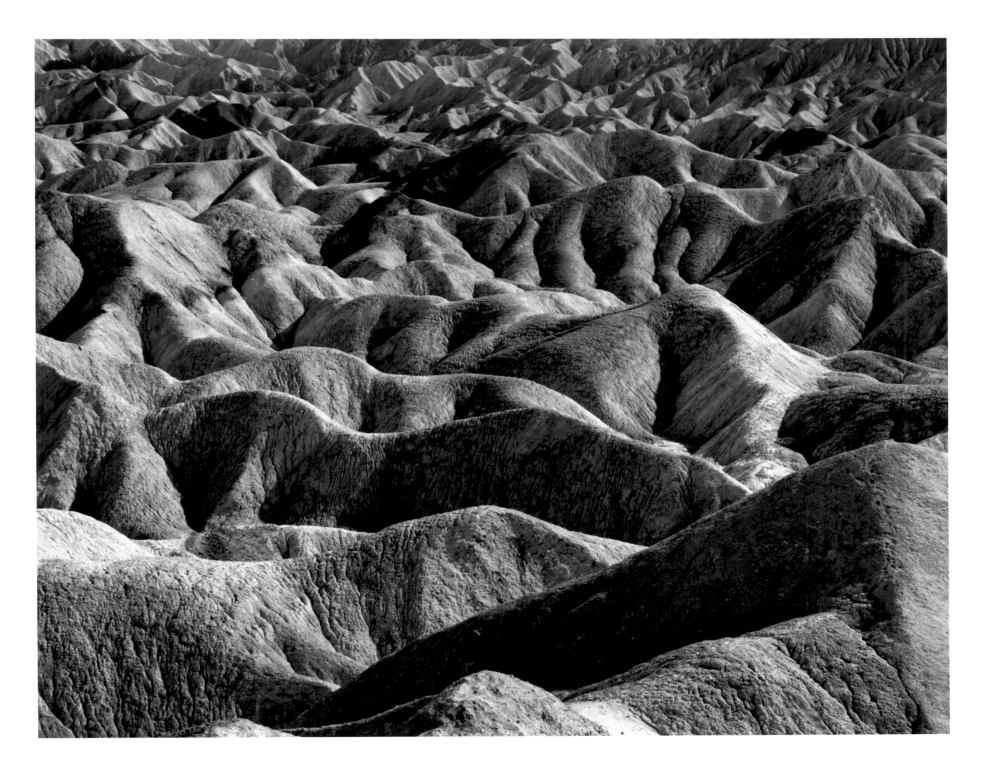

Plate 24 (cat. 32)

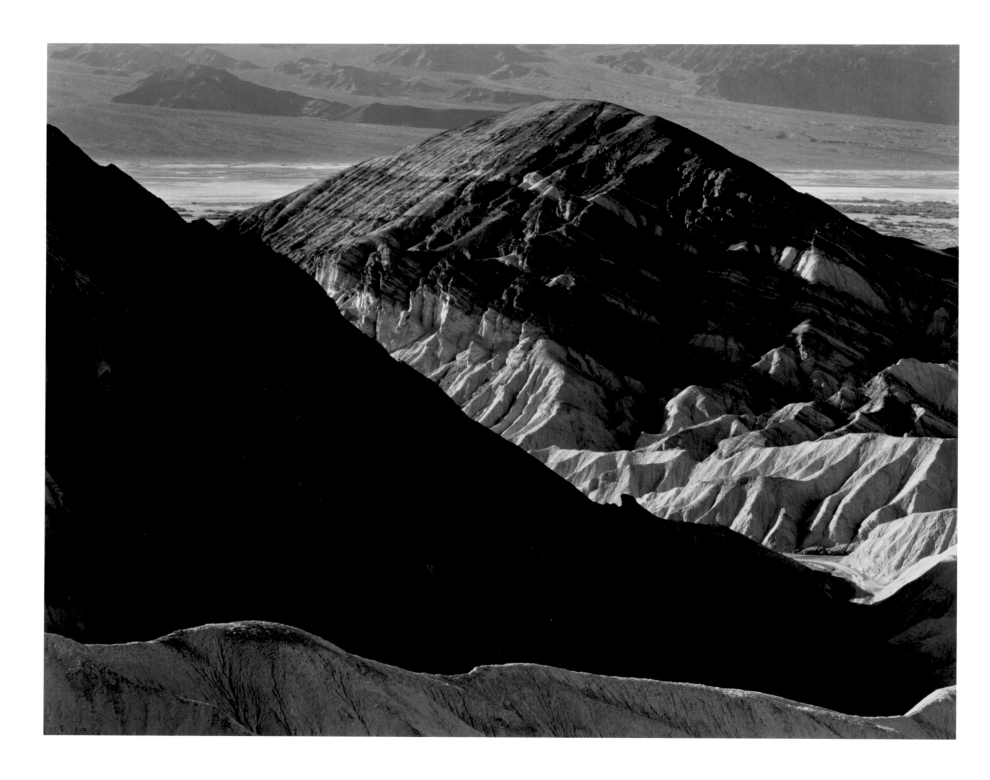

Plate 25 (cat. 33)

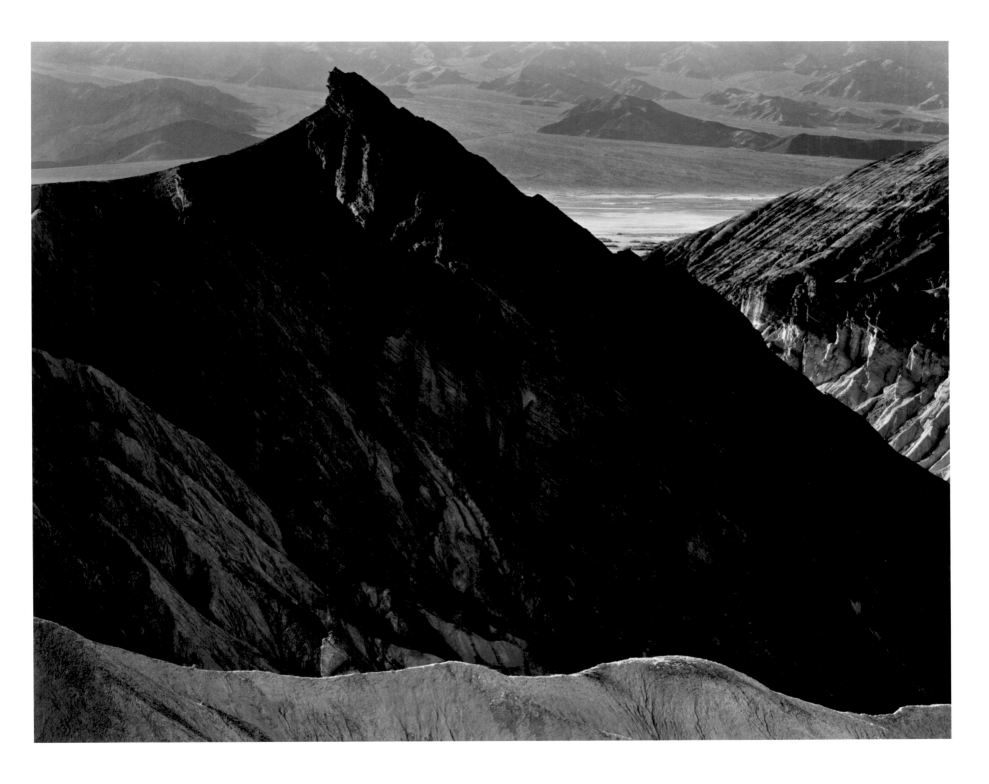

Plate 26 (cat. 35)

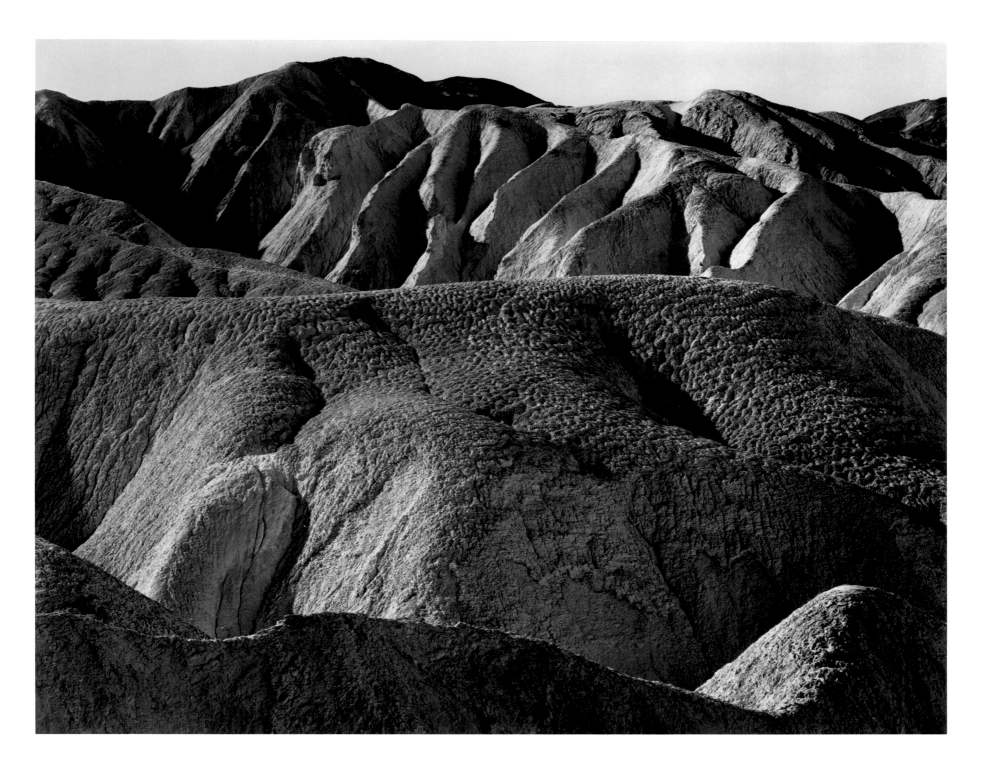

Plate 27 (cat. 37)

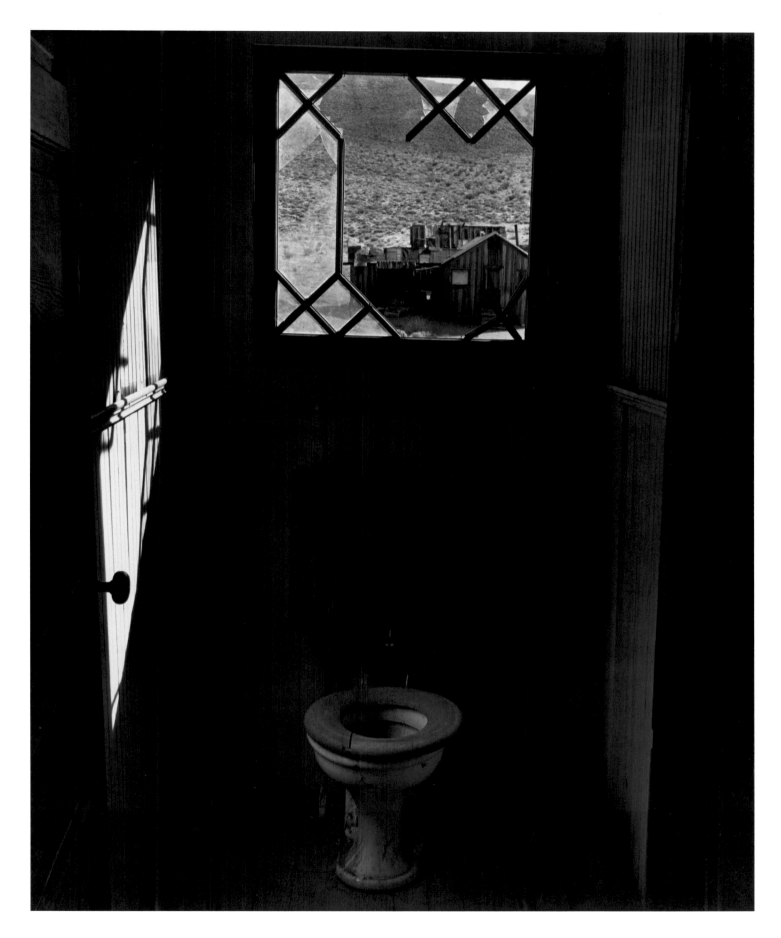

Plate 28 (cat. 39)

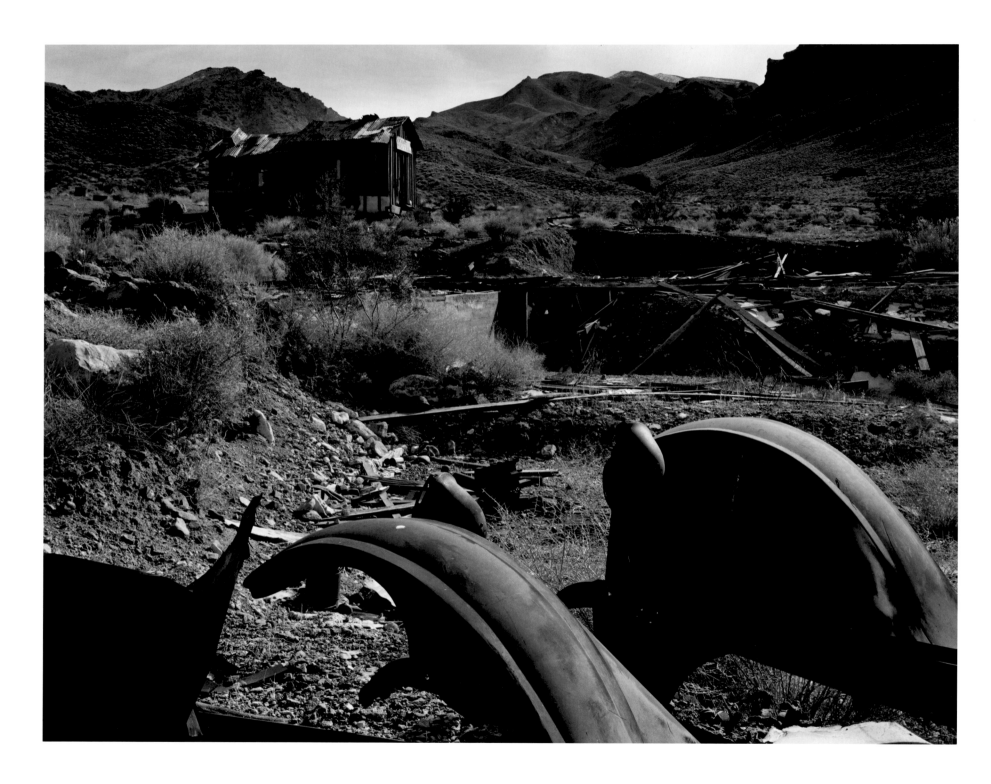

Plate 29 (cat. 41)

Plate 30 (cat. 44)

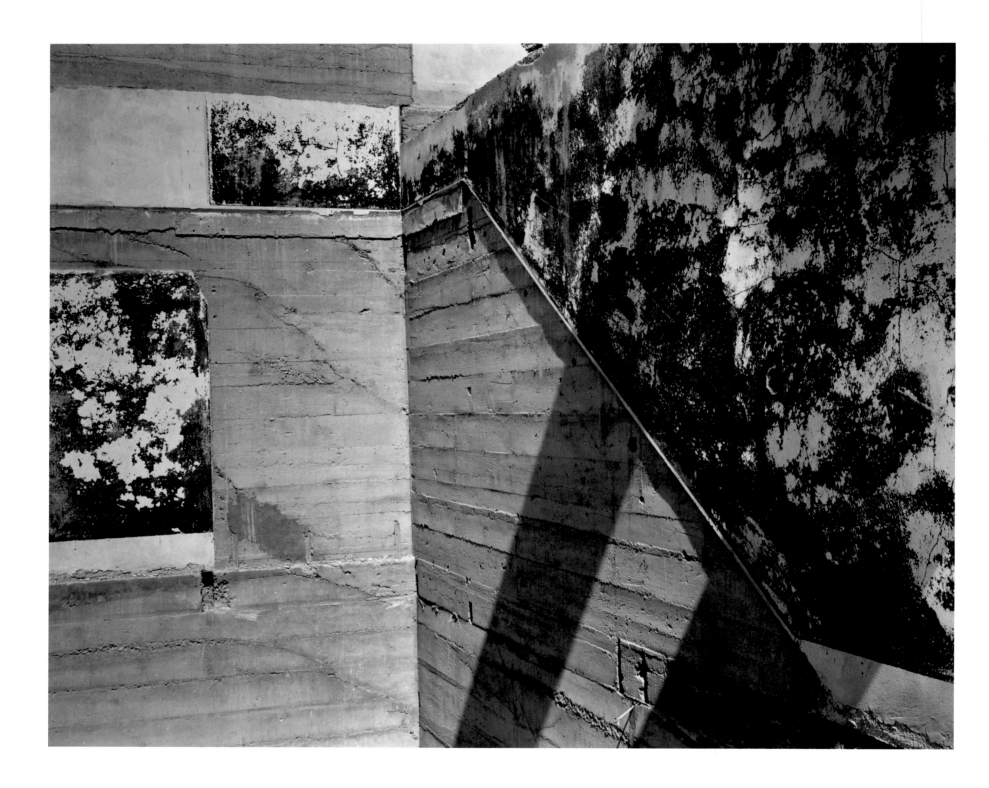

Plate 31 (cat. 47)

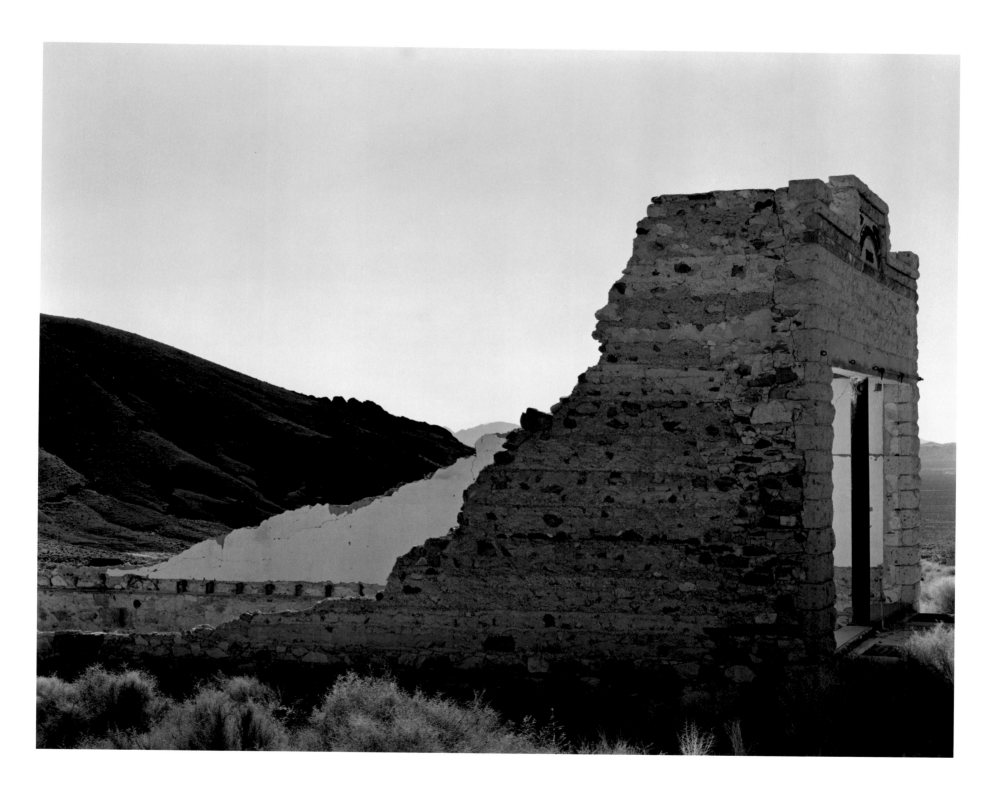

Plate 32 (cat. 48)

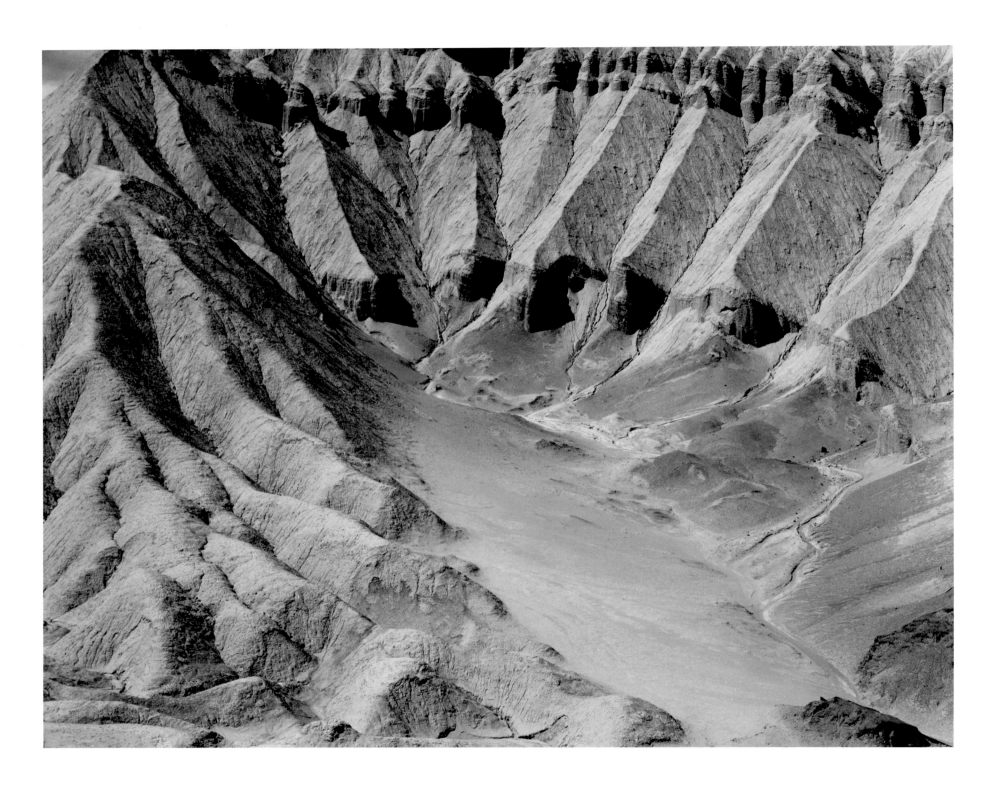

Plate 33 (cat. 50)

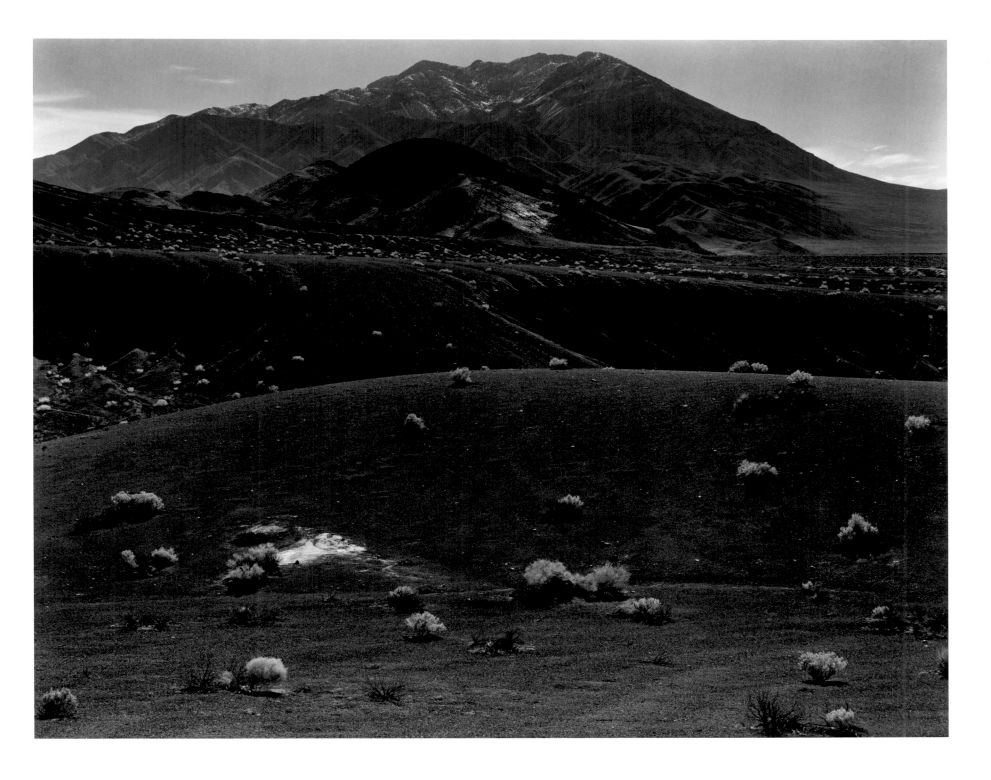

Plate 34 (cat. 51)

Plate 35 (cat. 53)

Plate 36 (cat. 54)

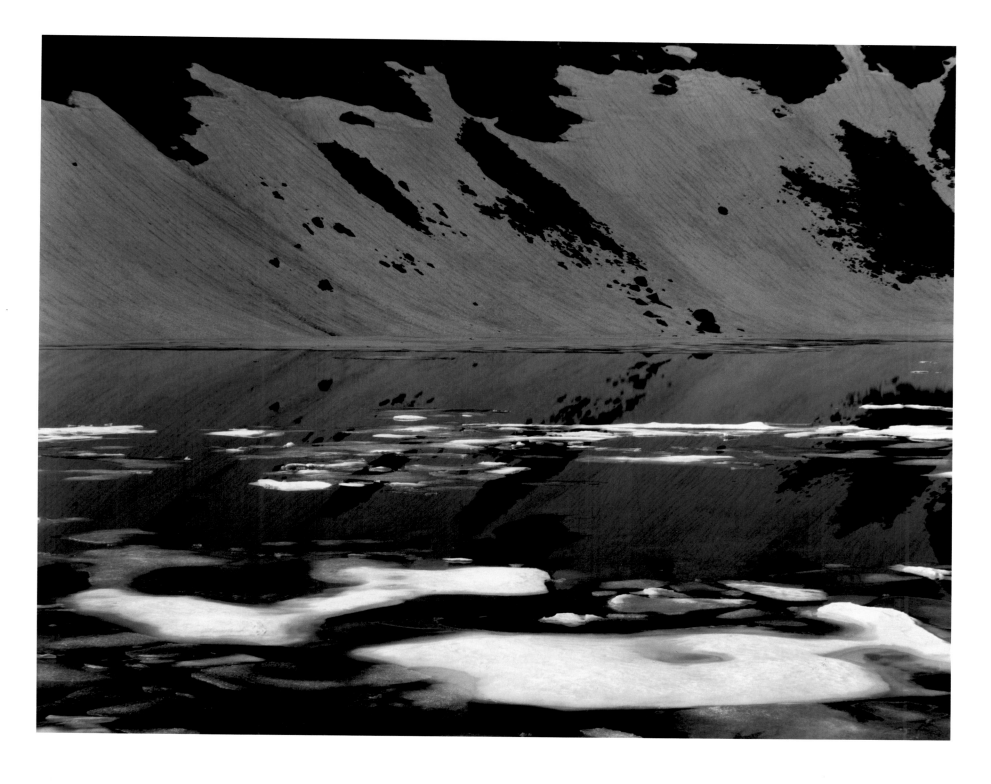

Plate 37 (cat. 56)

Plate 38 (cat. 59)

Plate 39 (cat. 60)

Plate 40 (cat. 62)

Plate 41 (cat. 64)

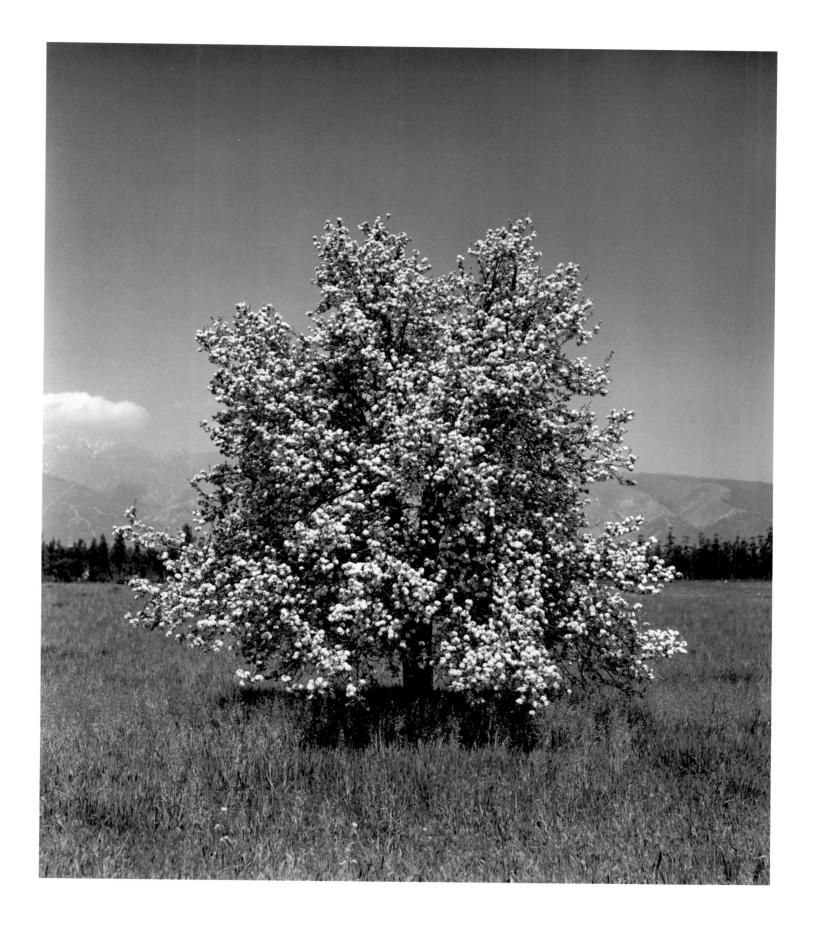

Plate 42 (cat. 63)

Plate 43 (cat. 65)

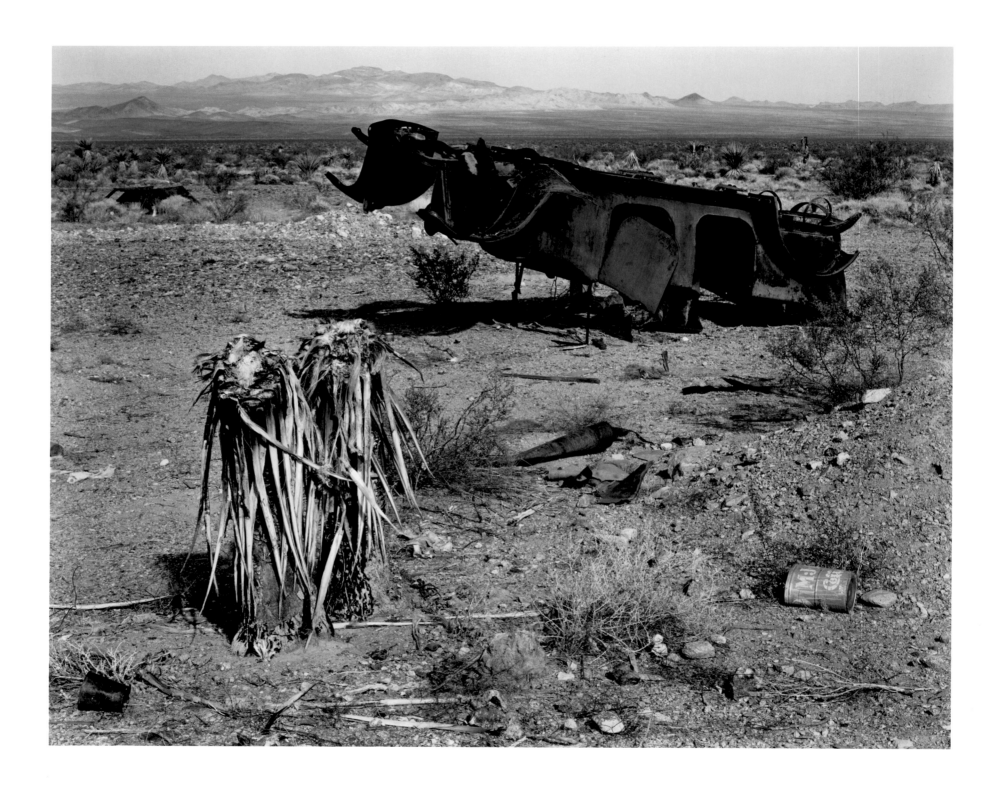

Plate 44 (cat. 68)

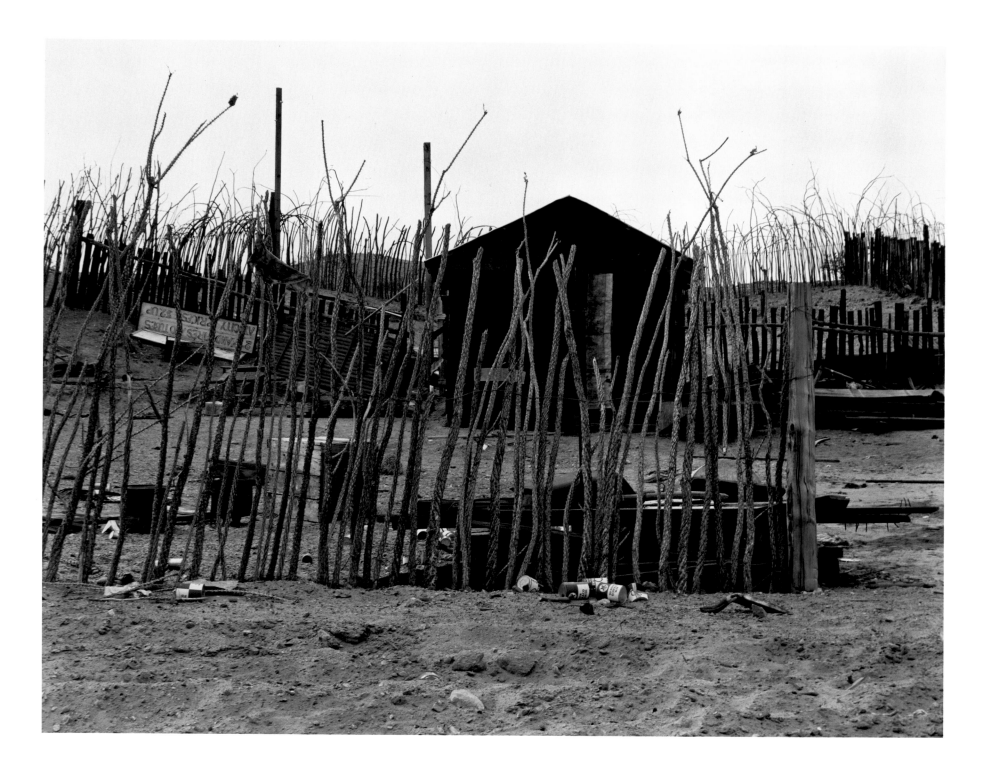

Plate 45 (cat. 69)

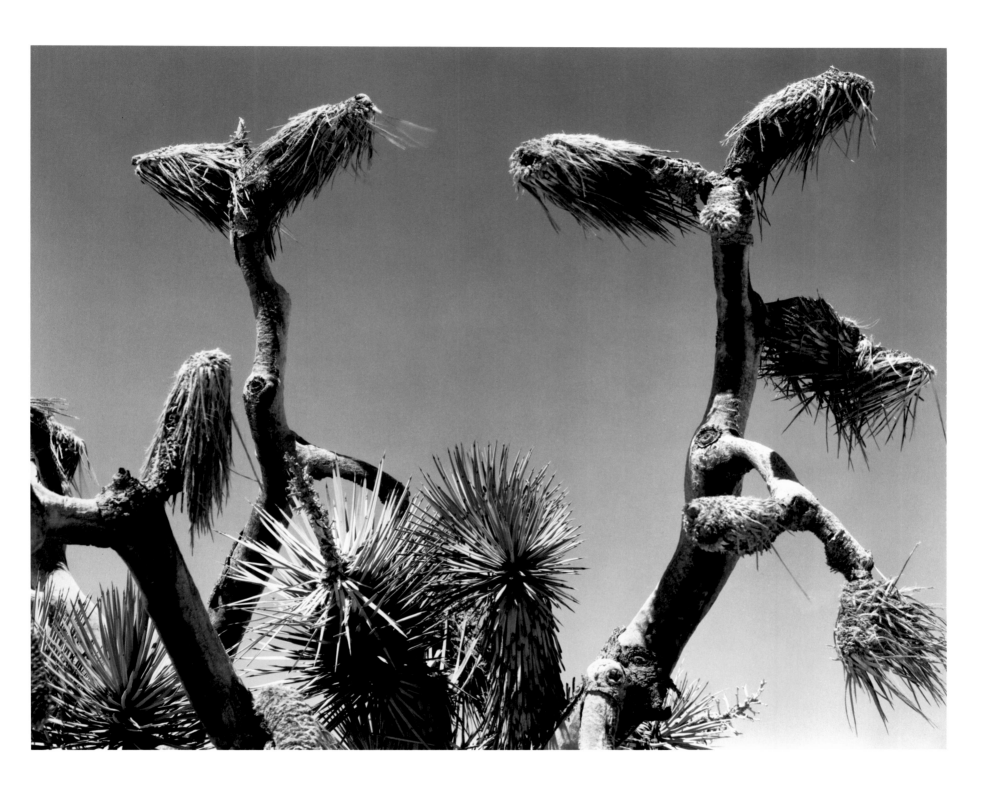

Plate 46 (cat. 71)

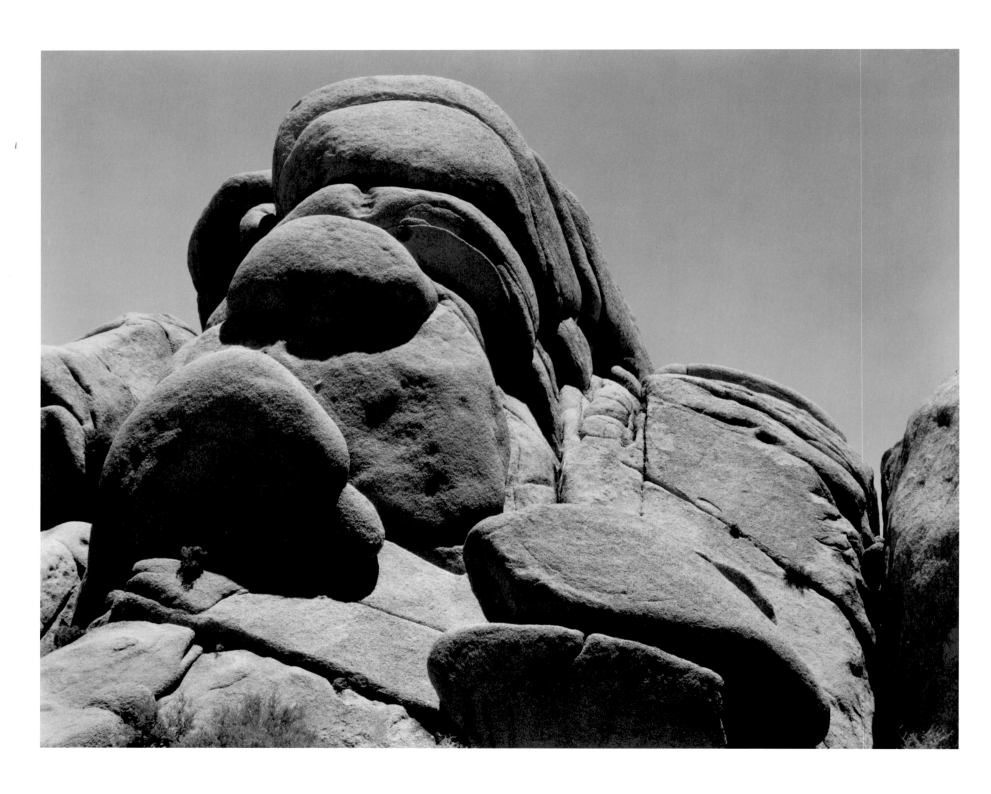

Plate 47 (cat. 73)

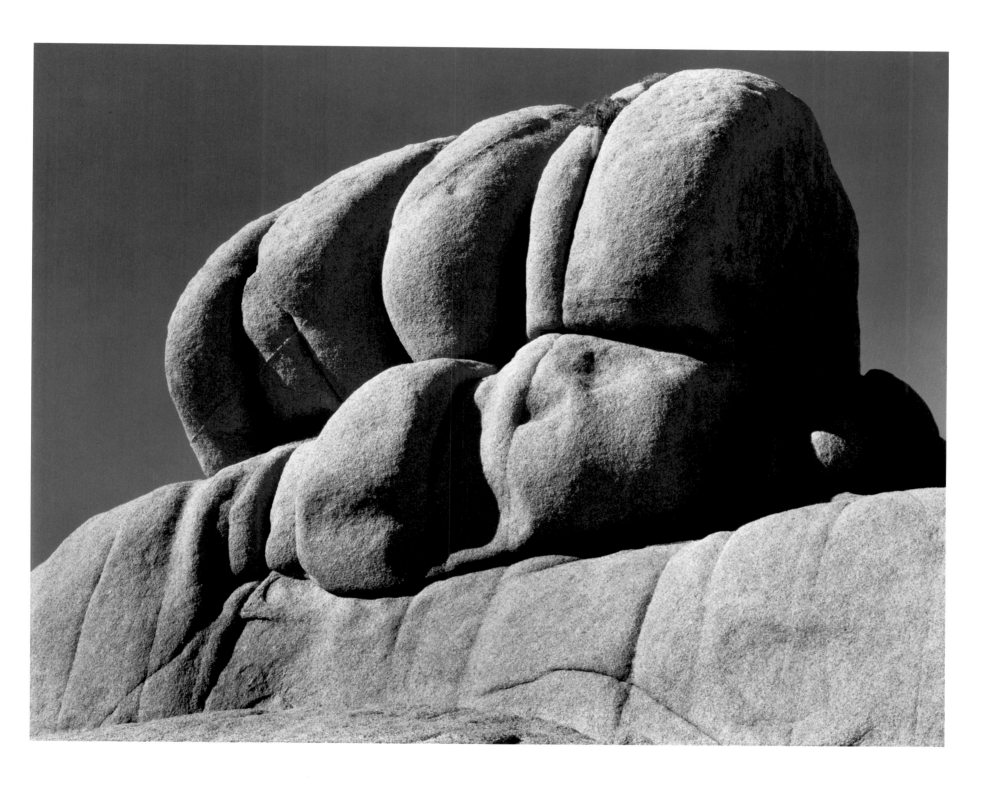

Plate 48 (cat. 74)

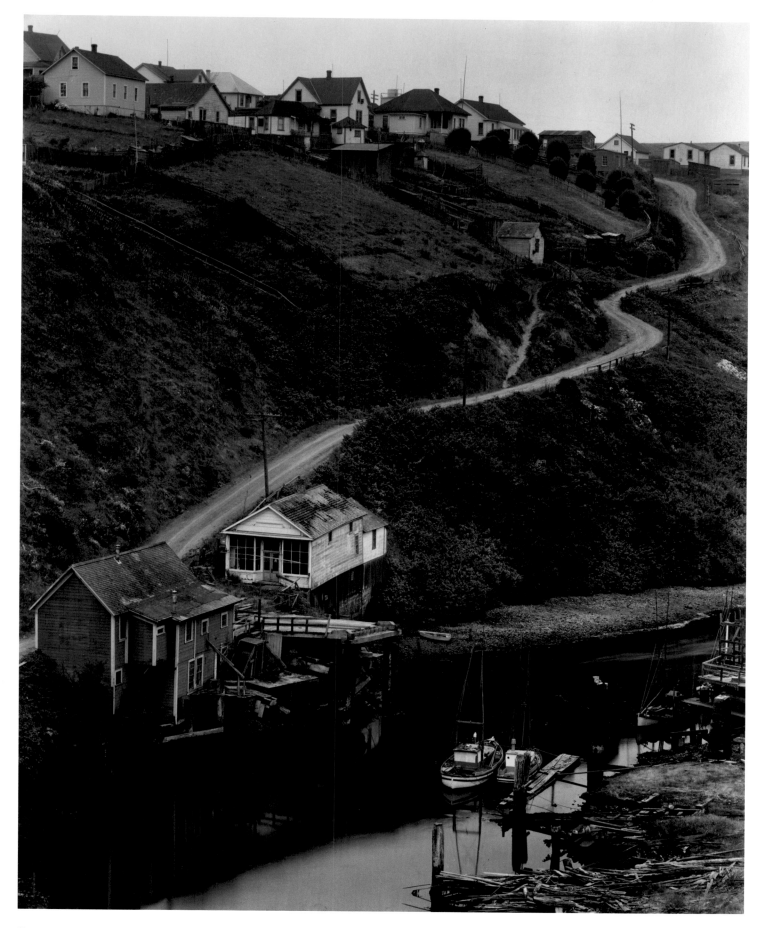

Plate 49 (cat. 75)

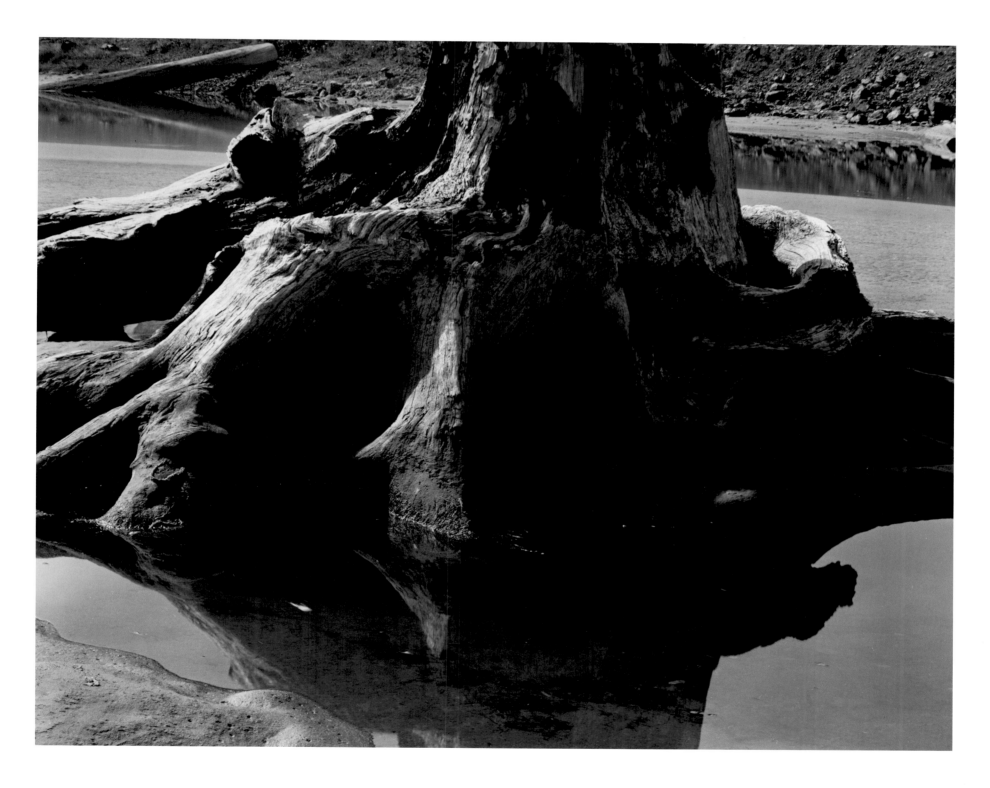

Plate 50 (cat. 80)

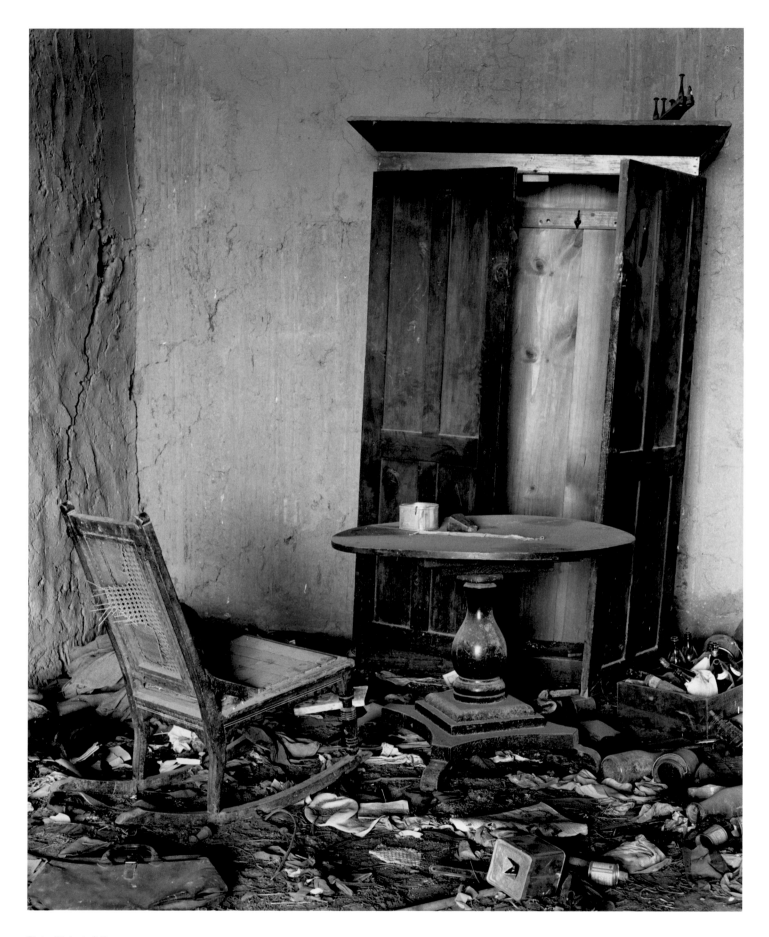

Plate 51 (cat. 84)

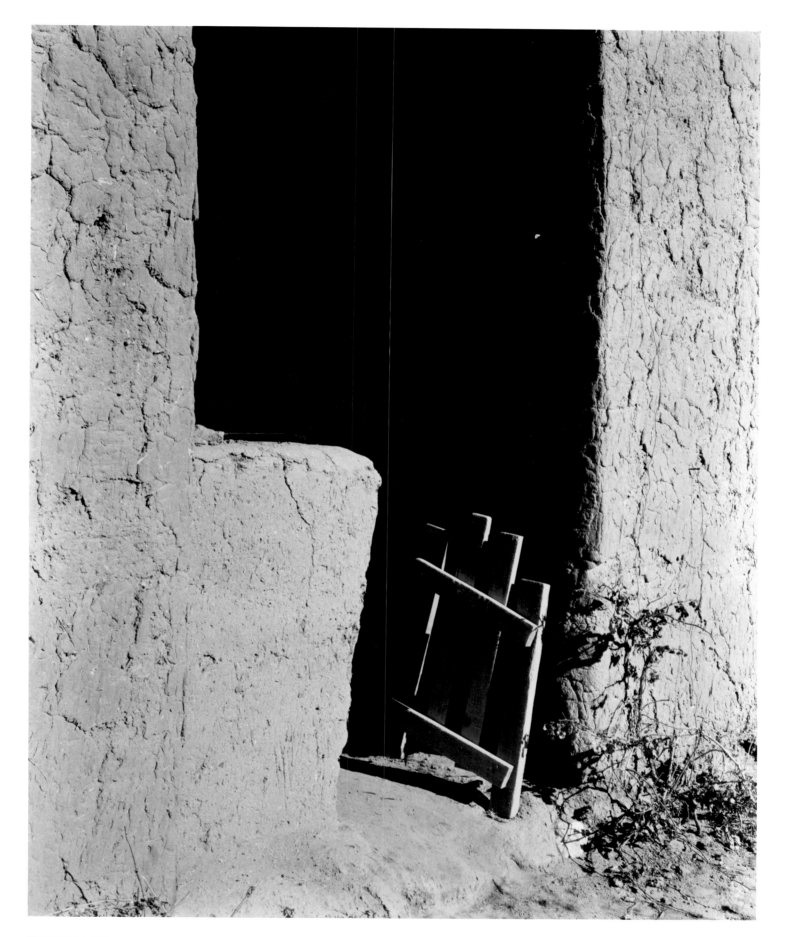

Plate 52 (cat. 86)

Plate 53 (cat. 91)

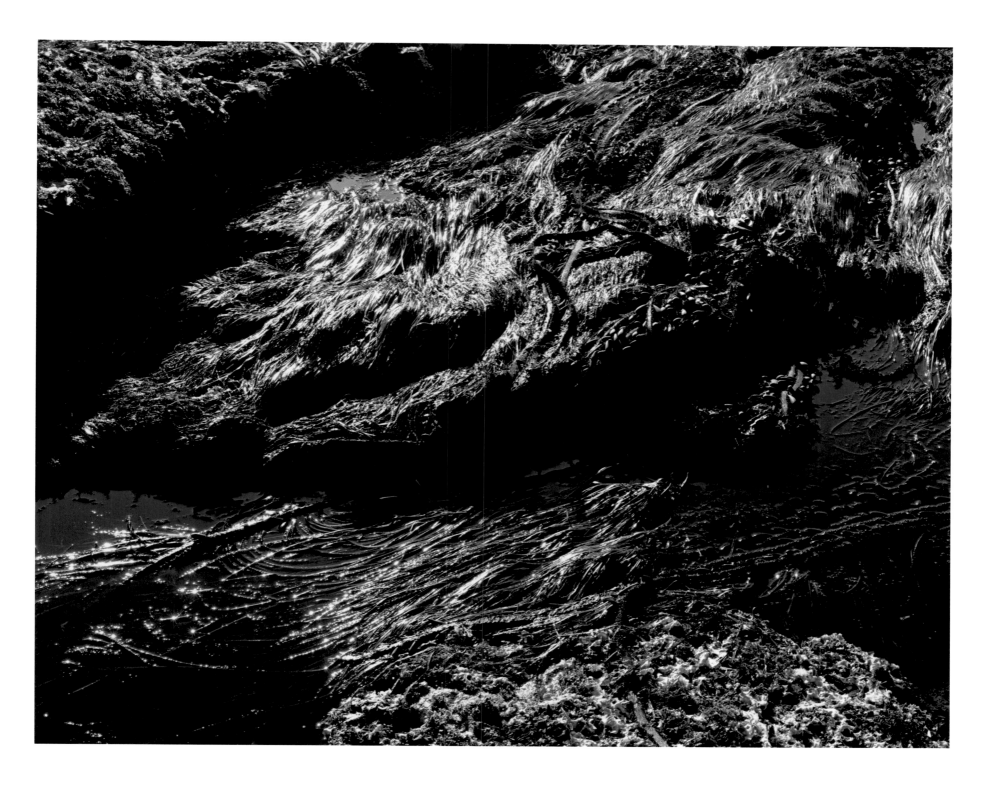

Plate 54 (cat. 93)

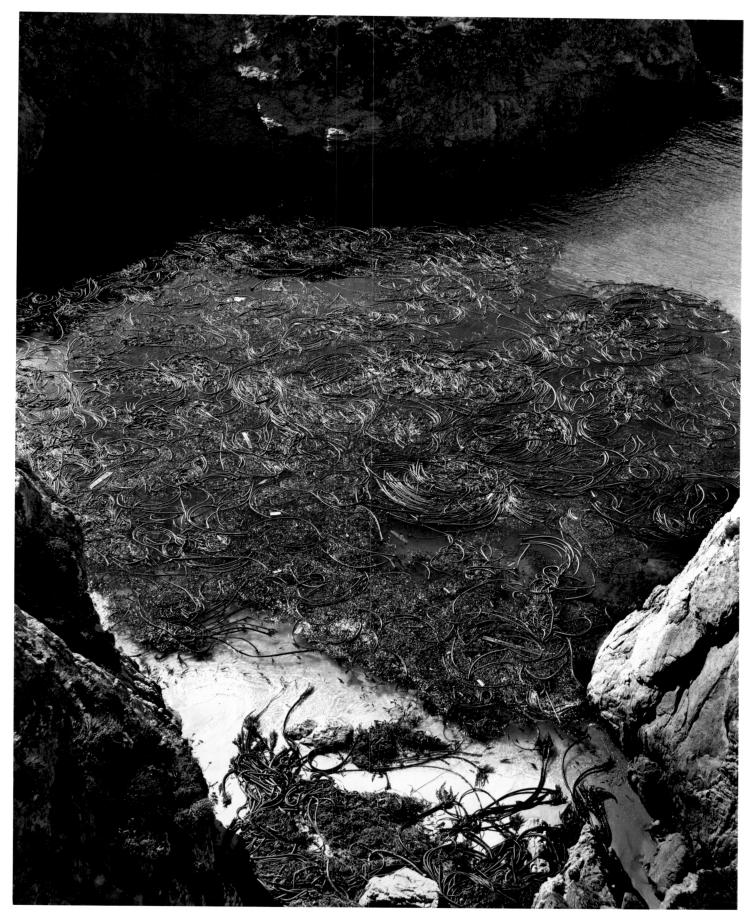

Plate 55 (cat. 94)

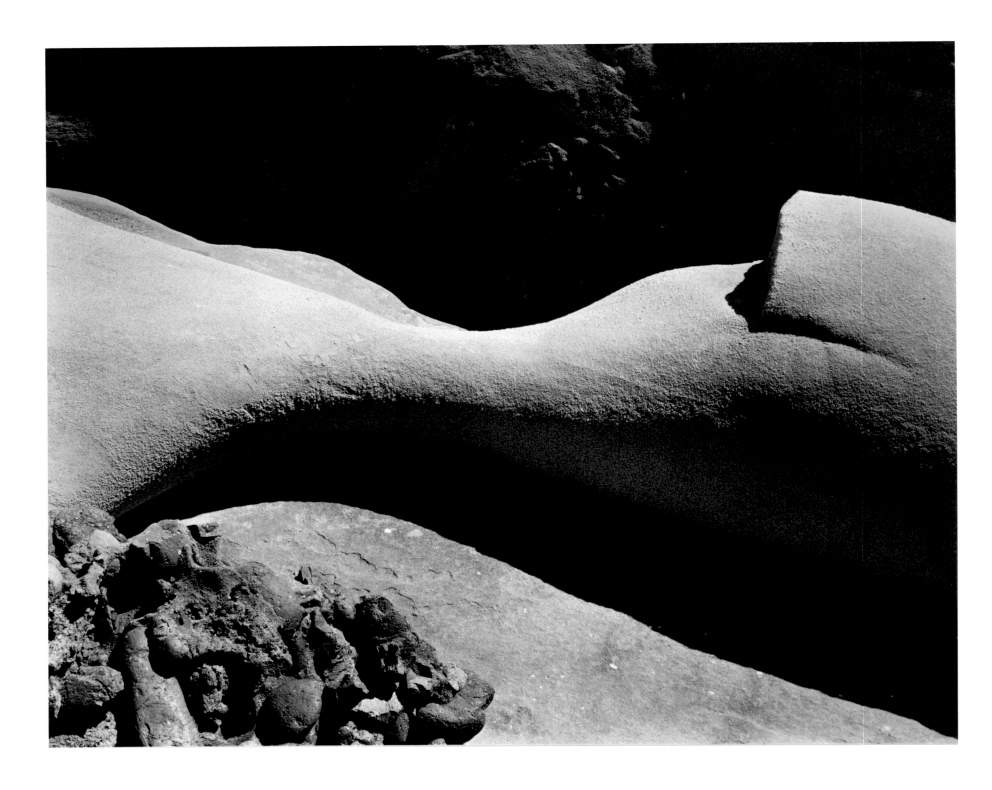

Plate 56 (cat. 98)

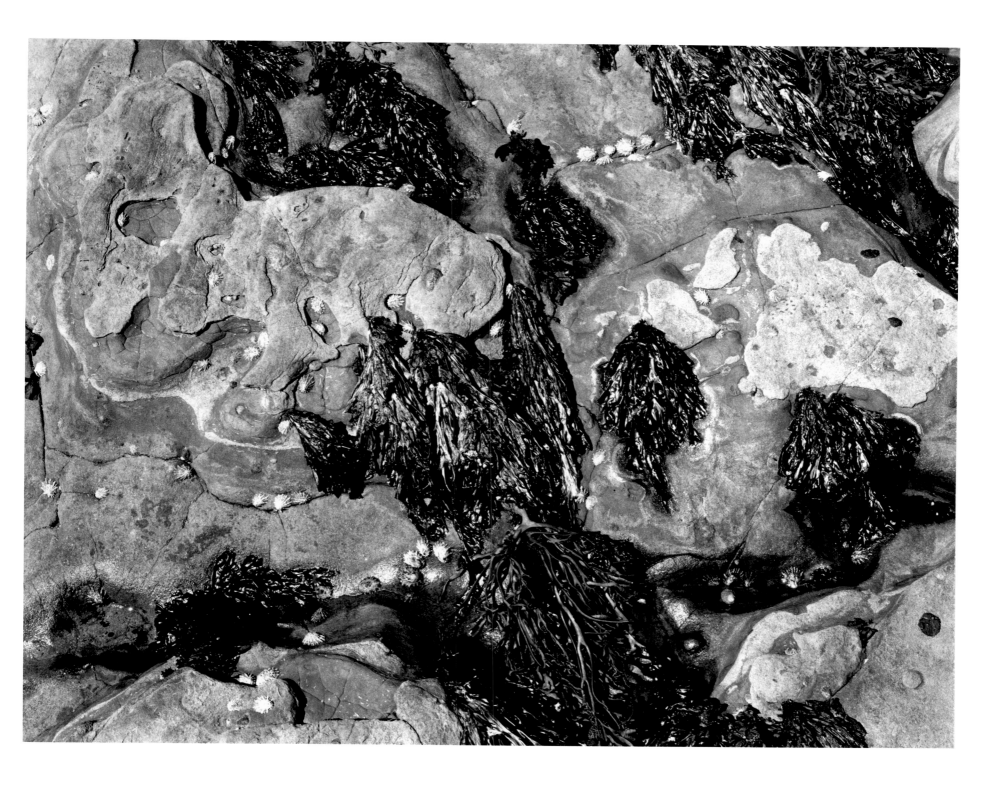

Plate 57 (cat. 99)

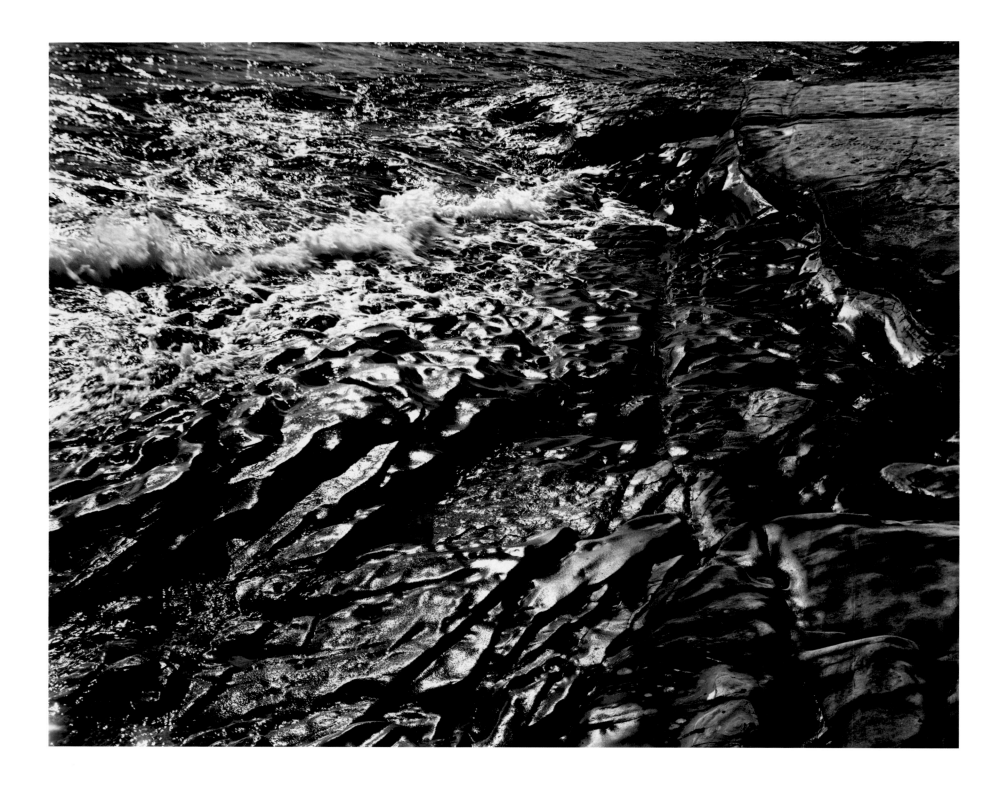

Plate 58 (cat. 100)

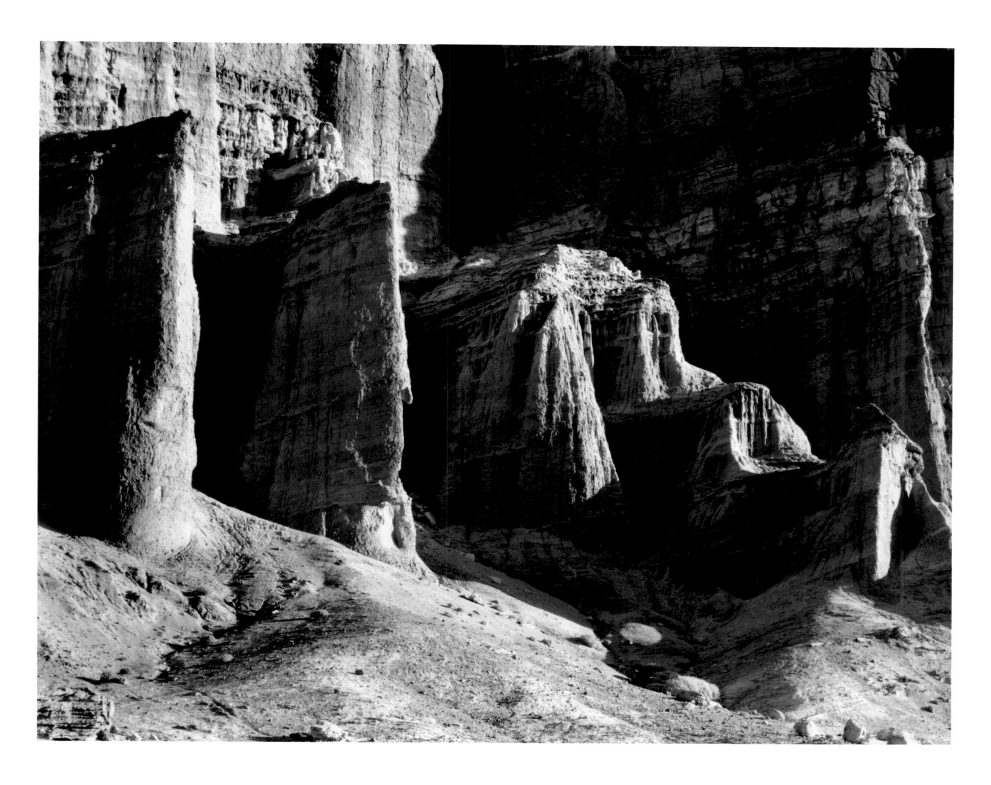

Plate 59 (cat. 106)

Plate 60 (cat. 107)

Plate 70 (cat. 108)

Plate 62 (cat. 111)

Plate 64 (cat. 109)

Plate 65 (cat. 113)

Plate 66 (cat. 115)

Plate 67 (cat. 117)

Plate 68 (cat. 118)

Plate 69 (cat. 120)

All photographs are silver prints.
All signatures and inscriptions are in Weston's hand unless otherwise noted.

The checklist is in the print cataloguing order ("Weston Log") established by Charis Wilson and Edward Weston.

We have noted where an image was included in the 1952 Project (see introduction, p. 11), but unless so indicated, the print included in the exhibition is a vintage print, not a Project Print.

Full citations for the "Bibliography" can be found in the "Selected Bibliography;" the most frequently cited are abbreviated as follows:

C & W, 1940, 1978
> Charis Wilson Weston and Edward Weston, *California and the West*, New York, 1940 (and/or revised edition of 1978)

Conger
> Figure numbers in Amy Conger, *Edward Weston: Photographs from the Center for Creative Photography*, Tucson, 1992.

Westways
> "Seeing California with Edward Weston," series in *Westways* magazine and then also published in the 1939 book of the same name.

Weston Log Number
(as inscribed on back of mount)

1 (plate 1)
San Carlos Lake, Arizona, 1938 A-CD-3G
7⁹⁄₁₆ x 9½ in.
This image was included in the Project.
Bibliography: Conger, 1204/1938.

2
Saguaros, Arizona, 1938 A-CD-4G
7⁹⁄₁₆ x 9⁹⁄₁₆ in.
Signed and dated "Edward Weston 1938," on mount, below print, right;
Inscribed: "Sahuaros *(sic)*/Arizona," on verso of mount, center.
This image was included in the Project.
Bibliography: Conger, 1205/1938.

3
Jerome, Arizona, 1938 A-J-1G
7⅝ x 9½ in.
Signed and dated "Edward Weston 1938," on verso of first mount, center.
Inscribed (but cropped at the top): "Jerome, Arizona," on verso of first mount, top. 1946 Museum of Modern Art label, verso of second mount.
This image was included in the Project.
Bibliography: Conger, 1211/1938.

4 (plate 2)
Dead Rabbit, Arizona, 1938 A-Mi-5G
7⅝ x 9⁹⁄₁₆ in.

5
Landscape, Arizona, 1938 A-Mi-7G
7⁹⁄₁₆ x 9⁹⁄₁₆ in.
Inscribed: "E W 1937 *(sic)*," in another hand, on mount, below print, right.

6 (plate 3)
Prescott, Arizona, 1938 A-P-5G
7⅝ x 9⁹⁄₁₆ in.

7
Saguaros, Arizona, 1938 A-S-1G
7⅝ x 9⅝ in.
Signed and dated "Edward Weston 1938," on mount, below print, right.
Inscribed: "Sauharos *(sic)*/N. Mexico *(sic)*," on verso of mount, center.
This image was included in the Project.
Bibliography: Conger, 1207/1938.

8
Saguaro, Arizona, 1938 A-S-3G
7⅝ x 9⅝ in.
Signed and dated "Edward Weston 1938," on mount, below print, right.
Inscribed: "Sahuaro *(sic)*/Arizona," on verso of mount, center.
This image was included in the Project.
Bibliography: C & W; Conger, 1210/1938.

9 (plate 4)
Saguaro, Arizona, 1938 A-S-13G
9⁹⁄₁₆ x 7½ in.

10 (plate 5)
Saguaro, Arizona, 1938 A-S-18G
9⁹⁄₁₆ x 7⁹⁄₁₆ in.

11
Borrego Desert, 1938 B-Mi-1G
7⅝ x 9⁹⁄₁₆ in.
Inscribed: "E W 1937 *(sic)*," in another hand, on mount, below print, right.
Bibliography: *Westways*, November 1938.

12 (plate 7)
Palm Canyon, Borrego Desert, 1938 B-PC-4G
9½ x 7⅝ in.

13 (plate 6)
Palm Canyon, Borrego Desert, 1938 B-PC-5G
7⅝ x 9⅝ in.
This image was included in the Project.
Bibliography: Conger, 1239/1938.

14 (plate 8)
Palm Canyon, Borrego Desert, 1938 B-PC-8G
9⁹⁄₁₆ x 7⅝ in.
Signed and dated "Edward Weston 1938," on mount, below print, right.
Inscribed: "Palm Canyon/Borego *(sic)* Desert," on verso of mount, center.
Bibliography: *Westways*, November 1938.

2

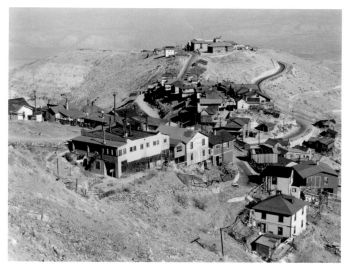

3

5

7

8

11

19

15 (plate 9)
Dead Man, Colorado Desert, 1937 CD-B-2G
7¹¹⁄₁₆ x 9⁵⁄₁₆ in.
Signed and dated "Edward Weston 1937," on mount, below print, right.
Inscribed: "No. 4, Dead Man/Colorado Desert," on verso of mount, center.
"PPA" label verso (1939 World's Fair).
This image was included in the Project.
Bibliography: Edward Weston, "Desert Tragedy," *Life*, June 1937; Charis Wilson, "Of the West . . . ," *U.S. Camera Annual 1940* p. 39; *C & W*, 1940, 1978; Maddow, 1973; Conger, 1013/1937.

16 (plate 10)
Concretion, Colorado Desert, 1937 CD-C-2G
9⅝ x 7⅝ in.
Bibliography: *Westways*, October 1937.

17 (plate 11)
Concretion, Colorado Desert, 1937 CD-C-14G
7¹¹⁄₁₆ x 9⁵⁄₁₆ in.
This image was included in the Project.
Bibliography: Conger, 1007/1937.

18 (plate 12)
Concretion, Colorado Desert, 1937 CD-C-33G
7⅝ x 9⅝ in.

19
Portland Cement Plant, Colorado CD-Mi-4G
Desert, 1937
7⁷⁄₁₆ x 9⁵⁄₁₆ in.
Inscribed: "E W 1938," in another hand, on mount, below print, right.

20 (plate 13)
Clear Lake, Coast Range, 1937 CR-CL-6G
7⅝ x 9⅝ in.
Inscribed: "E W 1937," in another hand, on mount, below print, right.

21 (plate 14)
Abandoned Shack, High Sierras, 1937 DPP-1G
7⅝ x 9⁵⁄₁₆ in.
Inscribed: "E W 1938 *(sic),*" in another hand, on mount, below print, right.
Inscribed in Weston's hand: "No. 309 (crossed out)/Abandoned Shack/High Sierras," on verso of mount, center.
Bibliography: *Westways*, Sept. 1937.

22 (plate 15)
Corkscrew Canyon Entrance, DV-CCE-2G
Death Valley, 1938
7⁹⁄₁₆ x 9⅝ in.
Inscribed: "E W 1937 *(sic),*" in another hand, on mount, below print, right.
This image was included in the Project.
Bibliography: Enyeart, pl. 42; B. Newhall, *Supreme Instants*, pl. 109; Conger, 1324/1938.

23 (plate 16)
Corkscrew Canyon Entrance, Death Valley, 1938 DV-CCE-9G
9⁹⁄₁₆ x 7½ in.

24 (plate 17)
Dunes, Death Valley, 1938 DV-D-4G
7¹¹⁄₁₆ x 9⅝ in.
Inscribed: "E W 1937 *(sic),*" in another hand, on mount, below print, right.

25 (plate 18)
Dunes, Death Valley, 1938 DV-D-5G
7¹¹⁄₁₆ x 9⅝ in.
Inscribed: "E W 1938," in another hand, on mount, below print, right.

26 (plate 19)
Dunes, Death Valley, 1938 or 1939 DV-D-15G
7⅝ x 9⅝ in.

27 (plate 20)
Dunes, Death Valley, 1938 DV-D-19G/1938
7⅝ x 9⅝ in.

28 (plate 21)
Dante's View, Death Valley, 1938 DV-DV-13G
7⅝ x 9⁹⁄₁₆ in.
This image was included in the Project.
Bibliography: B. Newhall, *Supreme Instants*, cat. 110; Conger, 1276/1938.

The following pair of photographs is a comparison between a vintage Edward Weston print (cat. 29) and a Project Print (cat. 30) from the same negative (see Introduction, p. 11).

29 (plate 22)
Floor of Death Valley from DV-DV-16G
Dante's View, 1938
7¹¹⁄₁₆ x 9⁹⁄₁₆ in.
Signed and dated "Edward Weston 1939 *(sic),*" on mount, below print, right. Inscribed: "Floor of Death Valley/from "Dante's View"/ (elevation app. one mile)," on verso of mount, center.
This image was included in the Project.
Bibliography: Charis Wilson, "Of the West . . . ," *U.S. Camera Annual 1940* p. 51; Enyeart, pl. 92; B. Newhall, *Supreme Instants*, cat. 111; Conger, 1395/1938.

30 (not illustrated)
Floor of Death Valley from DV-DV-16G
Dante's View, 1938
7⅝ x 9½ in.
Inscribed: "EW 1938," on mount, below print, right.
This photograph is a Project Print.
Bibliography: see above, cat. 29.

31 (plate 23)
Golden Canyon, Death Valley, 1938 DV-GC-11G
7⅝ x 9⅝ in.

32 (plate 24)
Golden Canyon, Death Valley, 1938 DV-GC-12G
7⁹⁄₁₆ x 9⁹⁄₁₆ in.
This image was included in the Project.
Bibliography: Conger, 1401/1938.

33 (plate 25)
Golden Canyon, Death Valley, 1938 DV-GC-21G/'38
7⅝ x 9⁹⁄₁₆ in.

34
Golden Canyon, Death Valley, 1938 DV-GC-22G/'38
7½ x 9½ in.

35 (plate 26)
Golden Canyon, Death Valley, 1938 DV-GC-32G/'38
7⅝ x 9⅝ in.
Bibliography: Conger, 1403/1938.

36
Golden Canyon, Death Valley, 1938 DV-GC-34G/38
7⅝ x 9⅝ in.

37 (plate 27)
Golden Canyon, Death Valley, 1938 DV-GC-44G/'38
7½ x 9⁹⁄₁₆ in.
This image was included in the Project.
Bibliography: Conger, 1284/1938.

The following pair of photographs is a comparison between a vintage Edward Weston print (cat. 38) and a Project Print (cat. 39) from the same negative (see Introduction, p. 11).

38 (see fig. 6 and plate 28)
Golden Circle Mine, Death Valley, 1939 DV-GOM-1G/'39
9⁹⁄₁₆ x 7⅝ in.
This image was included in the Project.
Bibliography: Charis Wilson, "Of the West . . . ," *U.S. Camera Annual 1940* p. 53; N. Newhall, *Edward Weston: The Flame of Recognition*, p. 57; Conger, 1406/1939.

39 (see fig. 7)
Golden Circle Mine, Death Valley, 1939 DV-GOM-1G/1939
9⅝ x 7⁷⁄₁₆ in.
Inscribed: "E W 1939," on mount, below print, right.
This photograph is a Project Print
Bibliography: see above, cat. 38.

40
Leadfield, Death Valley, 1939 DV-L-6G
7¹¹⁄₁₆ x 9⁹⁄₁₆ in.
Inscribed: "E W 1938," in another hand, on mount, below print, right.

41 (plate 29)
Leadfield, Death Valley, 1939 DV-L-9G
7⅝ x 9⁹⁄₁₆ in.
Inscribed: "E W 1938," in another hand, on mount, below print, right.

42
Salt Beds, Death Valley, 1937 DV-M-5G
7⅝ x 9⅝ in.
Signed and dated "Edward Weston 1937," on mount, below print, right. Inscribed: "14G (crossed out)/20_00_," on verso of mount, upper left; "Salt Beds/Death Valley," center.

34

40

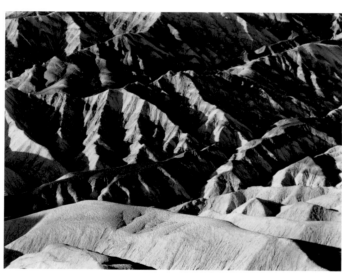

36

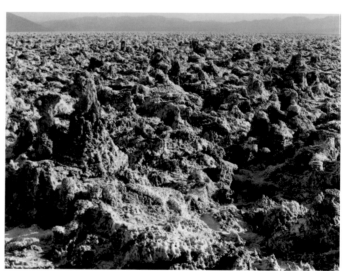

42

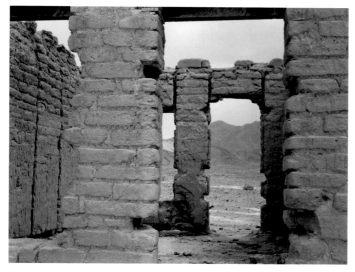

43

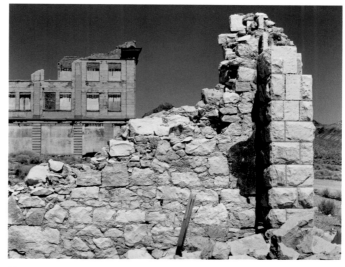

46

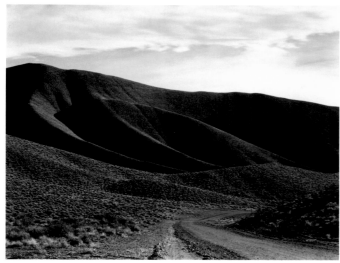

45

43
Harmony Borax Works, Death Valley, 1938 DV-Mi-7G
7⅝ x 9¹¹⁄₁₆ in.

44 (plate 30)
Mustard Canyon, Death Valley, 1939 DV-Mi-17G
7¹⁄₁₆ x 9⁵⁄₁₆ in.

45
Panamints, Death Valley, 1938 DV-P-16G/'38
7⁵⁄₁₆ x 9⁵⁄₁₆ in.

46
Ghost Town of Rhyolite, Nevada, 1938 DV-R-5G
7⅝ x 9⁵⁄₁₆ in.
Signed and dated "Edward Weston 1938," on mount, below print, right.
Inscribed: "Ghost town of Rhyolite, Nevada," on verso of mount, center.
This image was included in the Project.
Bibliography: B. Newhall, *Supreme Instants*, cat. 105; Conger, 1313/1938.

47 (plate 31)
Rhyolite, Nevada, 1938 DV-R-6G
7⅝ x 9½ in.
Inscribed: "E W 1938," in another hand, on mount, below print, right.
Bibliography: B. Newhall, *Supreme Instants*, cat. 104; Conger, 1314/1938.

48 (plate 32)
Rhyolite, Nevada, 1938 DV-R-12G
7⅝ x 9⅝ in.

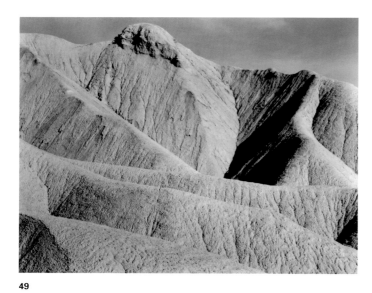

49

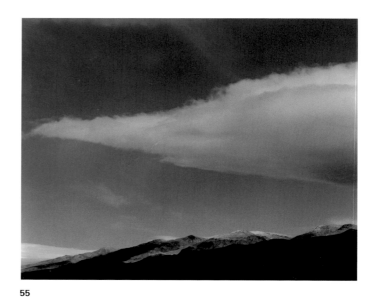

55

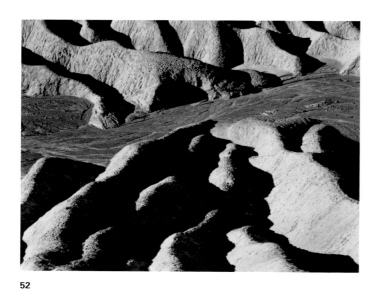

52

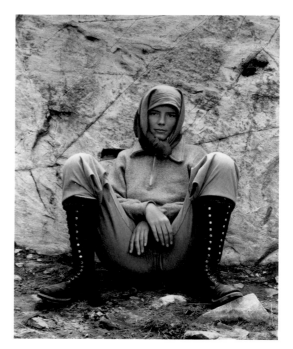

57

49
Twenty Mule Team Canyon, Death Valley, DV-TM-8G
1937 or 1938
7⅝ x 9⅝ in.
Inscribed: "E W 1938," in another hand, on mount, below print, right.

50 (plate 33)
Twenty Mule Team Canyon Entrance, DV-TME-5G
Death Valley, 1938
7⅝ x 9⁹⁄₁₆ in.
This image was included in the Project.
Bibliography: Edward Weston, "Photographing Calif., Part I," p. 61; Foley, p. 48; Conger, 1339/1938.

51 (plate 35)
Ubehebe Crater, Death Valley, 1937 or 1938 DV-U-7G
7⅝ x 9⅝ in.

52
Zabriskie Point, Death Valley, 1938 DV-Z-31G/ 38
7⁷⁄₁₆ x 9⅝ in.

53 (plate 35)
Death Valley, 1939 DV-39C-12G
7⅝ x 9⅝ in.
Inscribed: "EW 1939," on mount, below print, right; "—Death Valley," on verso of mount, center.
Bibliography: U.S. Camera Annual, 1957, p. 151; Conger, 1418/1939.

54 (plate 36)
Clouds, Death Valley, 1939 DV-39C-18G
7⅝ x 9⁹⁄₁₆ in.
Inscribed: "E W 1937 *(sic)*," in another hand, on mount, below print, right.

55
Clouds, Death Valley, 1939 DV-39C-20G
7¾ x 9⁹⁄₁₆ in.
Bibliography: Conger, 1424/1939.

56 (plate 37)
Iceberg Lake, 1937 E-IL-6G
7⅝ x 9⁹⁄₁₆ in.
Inscribed: "E W 1937," in another hand, on mount, below print, right
This image was included in the Project.
Bibliography: Maddow, 1973; B. Newhall, *Supreme Instants*, cat. 84; Conger, 1048/1937.

57
Charis, Lake Ediza, 1937 E-Mi-1G
9⅝ x 7⅝ in.
Bibliography: C & W, 1940, 1978; Bunnell, ed., *Edward Weston on Photography*, 1983; Stebbins, 1989, cat. 98.

58
Alabama Hills, Eastern Sierra, 1937 ES-AH-1G/'37
7½ x 9½ in.

59 (plate 38)
Mono Lake, Eastern Sierra, 1937 ES-ML-3G
9½ x 7⁹⁄₁₆ in.

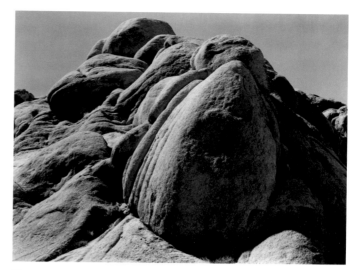

58

60 (plate 39)
Juniper, High Sierra, 1937 J5-4G
9⅝ x 7½ in.
Signed and dated "Edward Weston 1937," on mount, below print, right.
Inscribed: "Juniper/High Sierra," on verso of mount, center.

61
Stucco Figurehead, Metro Goldwyn Mayer, 1939 LA-MGM-5G
9⅝ x 7⅝ in.
Signed and dated "Edward Weston 1939," on mount, below print, right.
Inscribed: "Stucco Figurehead/Metro Goldwyn Mayer/Hollywood," on verso of mount, center.

62 (plate 40)
Metro Goldwyn Mayer, Los Angeles, 1939 LA-MGM-15G
7⅝ x 9⁹⁄₁₆ in.
1946 Museum of Modern Art label verso of mount
This image was included in the Project.
Bibliography: Conger, 1435/1939.

63 (plate 42)
Crab Apple Tree, 1937 LA-Mi-1G
9¹⁄₁₆ x 7¹¹⁄₁₆ in.
Inscribed: "EW 1937," on mount, below print, right; "This is my first print from/my first Guggenheim negative/On the first trip were:/Cole/Charis/E.W." on verso of mount, center.

64 (plate 41)
Dog, Los Angeles, 1937 LA-Mi-3G
7¹¹⁄₁₆ x 9 in.

61

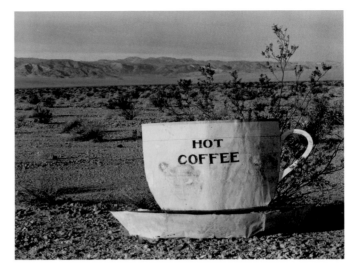

66

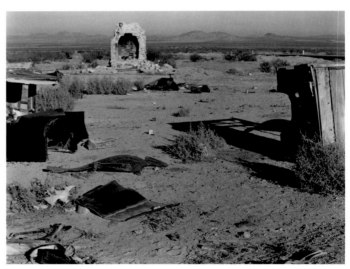

67

65 (plate 43)
Detail — Burned Tree, 1938 M-Mi-4G
9⅝ x 7⅝ in.
Signed and dated "Edward Weston 1938," on mount, below print, right.
Inscribed: "Detail — Burned Tree," on verso of mount, center.
This image was included in the Project.
Bibliography: C & W, 1940; Conger, 1342/1938.

66
"Hot Coffee," Mojave Desert, 1937 MD-HSS-1G
7⁷⁄₁₆ x 9⁷⁄₁₆ in.
Inscribed: "E W 1937," in another hand, on mount, below print, right.
This image was included in the Project.
Bibliography: C & W, 1940, 1978; Conger, 1175/1937.

67
Highway Sixty-Six, Mojave Desert, 1937 MD-HSS-5G
7⁹⁄₁₆ x 9⅝ in.
Inscribed: "E W 1938," in another hand, on mount below print, right.

68 (plate 44)
Mojave Desert, 1937 MD-HSS-6G
7⅝ x 9½ in.
Signed and dated "Edward Weston 1937," on mount, below print, right.
Inscribed: "Mojave Desert," on verso of mount, center.
This image was included in the Project.
Bibliography: Conger, 1176/1937.

69 (plate 45)
Highway Sixty-Six, Mojave Desert, 1937 MD-HSS-14G
7⅜ x 9½ in.

70
Joshua Tree, Mojave Desert, 1937 MD-J-4G
7¹¹⁄₁₆ x 9⅝ in.
Inscribed: "No. 163/Joshua Tree/Mohave Desert," on verso of mount,
center.
This image was included in the Project.
Bibliography: Conger, 1025/1937.

71 (plate 46)
Joshua Tree, Mojave Desert, 1937 MD-J-6G
7¹¹⁄₁₆ x 9⅝ in.
This image was included in the Project.
Bibliography: Conger, 1027/1937.

72
Victorville, Mojave Desert, 1937 MD-V-4G
7⅝ x 9⅝ in.

73 (plate 47)
Wonderland of Rocks, Mojave Desert, 1937 MD-W-13G
7⅝ x 9⁹⁄₁₆ in.
Inscribed: "E W 1937," in another hand, on mount, below print, right.

74 (plate 48)
Wonderland of Rocks, Mojave Desert, 1937 MD-W-22G/37
7⅝ x 9⅝ in.
This image was included in the Project.
Bibliography: Conger, 1021/1937.

*The following pair of photographs is a comparison between a vintage
Edward Weston print (cat. 75) and a Project Print (cat. 76) from the same
negative (see Introduction, p. 11).*

75 (plate 49)
Albion, 1937 NC-A-1G
9¹¹⁄₁₆ x 7⅝ in.
This image was included in the Project.
Bibliography: *Westways*, Jan. 1938; *C & W*, 1940, 1978; Maddow, 1973;
Conger, 1064/1937.

76 (not illustrated)
Albion, 1937 NC-A-1G
9⅝ x 7⅝ in.
Inscribed: "E W 1937," on mount, below print, right.
This photograph is a Project Print.
Bibliography: see above, cat. 75.

77
Albion, North Coast, 1937 NC-A-5G/'37
7⅝ x 9⅝ in.

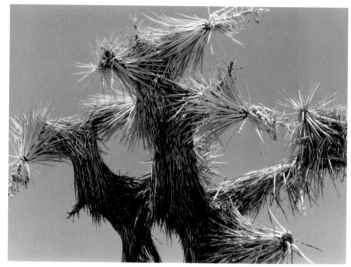
70

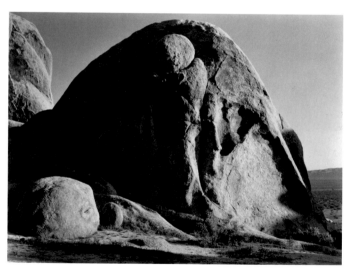
72

77

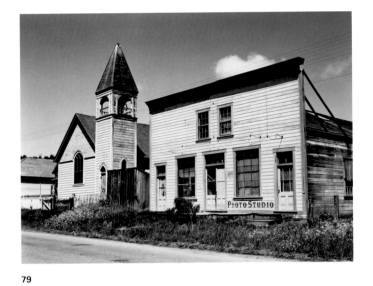

79

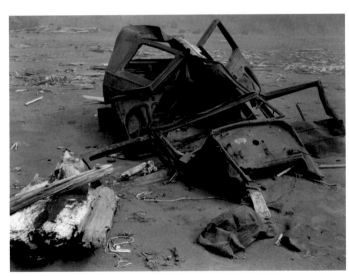

78

81

78

Driftwood and Auto, Crescent Beach, 1939 NC-CC-9G
7¹¹⁄₁₆ x 9⅝ in.
Inscribed: "Driftwood and Auto/Crescent Beach," on verso of mount, center.
This image was included in the Project.
Bibliography: B. Newhall, *Supreme Instants*, cat. 73; Conger, 1461/1939.

79

Elk, North Coast, 1939 NC-E-2G
7⅞₆ x 9½ in.
Inscribed: "E W 1937 *(sic),*" in another hand, on mount, below print, right.
Bibliography: *C & W*, 1940; Conger, 1470/1939.

80 (plate 50)

Little River, North Coast, 1937 NC-LR-9G
7¹¹⁄₁₆ x 9⅝ in.

81

Moonstone Beach, North Coast, 1937 NC-MB-10G
7¹¹⁄₁₆ x 9⁹⁄₁₆ in.
Signed and dated "Edward Weston 1937," on mount, below print, right.
Inscribed: "Moonstone Beach/North Coast," on verso of mount, center.

82

82

Moonstone Beach, North Coast, 1937 NC-MB-12G
9½ x 7⁹⁄₁₆ in.
Inscribed: "E W 1941 *(sic),*" in another hand, on mount, below print, right.

83

Point Arena, 1937 NC-PA-2G
7⅝ x 9½ in.
Inscribed: "No. 661 (crossed out)/Point Arena," on verso of mount, center.
This image was included in the Project.
Bibliography: *Westways*, Jan. 1938; Conger, 1159/1937.

84 (plate 51)

Old Adobe, New Mexico, 1937 NM-A-1G
9⁹⁄₁₆ x 7½ in.
Signed and dated "Edward Weston 1937," on mount, below print, right.
Inscribed: "Old Adobe/N.M.," on verso of mount, center.
This image was included in the Project.
Bibliography: *C & W*, 1940, 1978; Conger, 1198/1937.

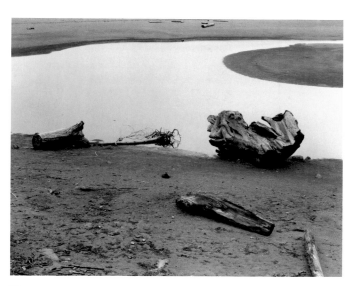

83

85

Albuquerque, New Mexico, 1937 NM-A-2G
7⁹⁄₁₆ x 9½ in.
Inscribed: "E W 1941 *(sic),*" in another hand, on mount, below print, right.
This image was included in the Project.
Bibliography: Conger, 1199/1937.

86 (plate 52)

Albuquerque, New Mexico, 1937 NM-A-3G
9⁹⁄₁₆ x 7⅝ in.

87

Albuquerque, New Mexico, 1937 NM-A-4G
7⅝ x 9½ in.

85

88

87

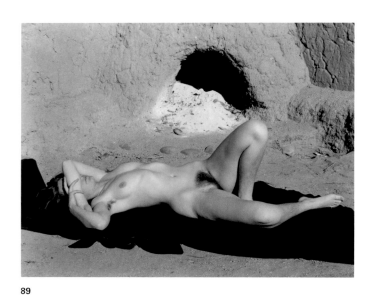

89

90

92

88
Albuquerque, New Mexico, 1937 NM-A-6G/37
9⁹⁄₁₆ x 7½ in.

89
Nude, 1937 NM-A-N2G
7⅝ x 9⁹⁄₁₆ in.
Signed and dated "Edward Weston 1937," on mount, below print, right.
This image was included in the Project.
Bibliography: Charis Wilson, *Edward Weston: Nudes*, pl. 96; Stebbins, 1989, cat. 102; Conger, 1200/1937.

90
Aspen Valley, New Mexico, 1937 NM-AV-5G
9⅝ x 7⁹⁄₁₆ in.
Inscribed: "E W 1937," in another hand, on mount, below print, right.

91 (plate 53)
Santa Fe, New Mexico, 1937 NM-SF-8G
7⅝ x 9⁹⁄₁₆ in.
Inscribed: "EW 1938 *(sic)*," on mount, below print, right.

92
Columbia River, Oregon, 1939 O-CR-1G
7⁹⁄₁₆ x 9⁹⁄₁₆ in.
Inscribed: "E W 1938 *(sic)*," on mount, below print, right.

93 (plate 54)
Wet Kelp, Point Lobos, 1938 PL-K-2G
7⅝ x 9⁹⁄₁₆ in.
Inscribed: "E W 1936 *(sic)*," in another hand, on mount, below print, right.
This image was included in the Project.
Bibliography: Conger, 1356/1938.

94 (plate 55)
Kelp, Point Lobos, 1938 PL-K-7G
9¹¹⁄₁₆ x 7⅝ in.
Signed and dated "Edward Weston, 1938," on verso of mount, center.
Inscribed: "Kelp, Point Lobos," on verso of mount, center.

95
Landscape, Point Lobos, 1938 PL-L-21G
9⅝ x 7⅝ in.

96
Pool, Point Lobos, 1938 PL-P-2G
7⅝ x 9⅝ in.

97
Rocks, Point Lobos, 1938 PL-R-2G
7⅝ x 9½ in.
Inscribed: "E W 1938," in another hand, on mount, below print, right.
This image was included in the Project.
Bibliography: Conger, 1369/1938.

98 (plate 56)
Rocks, Point Lobos, 1938 PL-R-6G
7⅝ x 9⁹⁄₁₆ in.

95

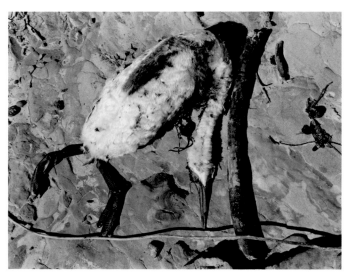

97

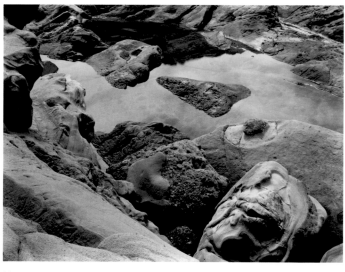

96

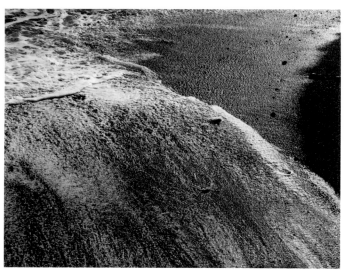

101

99 (plate 57)
Rocks, Point Lobos, 1938 PL-R-11G
7⅝ x 9¹¹⁄₁₆ in.
Inscribed: "©," on mount, below print, left; "© Limited Editions Club, Inc./not for sale," on verso of mount, center.

100 (plate 58)
Surf, Point Lobos, 1938 PL-S-5G
7¹¹⁄₁₆ x 9⅝ in.
Inscribed: "E W 1937," in another hand, on mount, below print, right.

101
Surf, Point Lobos, 1938 PL-S-6G
7⅝ x 9⅝ in.

102
Coast Redwoods, 1937 RH-R-7G
9⅝ x 7⅝ in.
Inscribed: "E W 1937," in another hand, on mount, below print, right.
Bibliography: *C & W*, 1940, 1978.

103
Burned Stump, Scotia, 1937 RH-S-2G
9⅝ x 6¹¹⁄₁₆ in.
This image was included in the Project.
Bibliography: B. Newhall, *Supreme Instants*, cat. 71; Conger, 1154/1937.

104
Red Rock Canyon, 1937 RRC-21G/'37
7⅝ x 9¹¹⁄₁₆ in.

105
Red Rock Canyon, 1937 RRC-22G/'37
7⁹⁄₁₆ x 9⁹⁄₁₆ in.
Bibliography: Conger, 1019/1937.

106 (plate 59)
Red Rock Canyon, 1937 RRC-23G/'37
7⅝ x 9⁹⁄₁₆ in.

107 (plate 60)
— At Ted Cook's, 1937 SC-LB-3G
7⅝ x 9⁹⁄₁₆ in.
Signed and dated "Edward Weston 1937," on mount, below print, right.
Inscribed: "— at Ted Cook's," on verso of mount, center.
This image was included in the Project.
Bibliography: "Speaking of Pictures . . . ," *Life* Dec. 27, 1937, p. 4; Conger, 1032/1937.

108 (plate 61)
Laguna Beach, South Coast, 1937 SC-LB-12G
7¹¹⁄₁₆ x 9⅝ in.

102

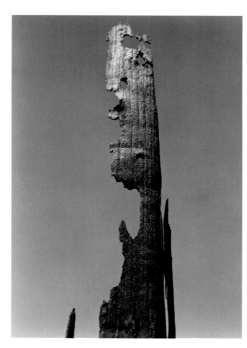

103

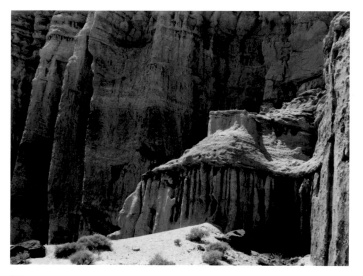

104

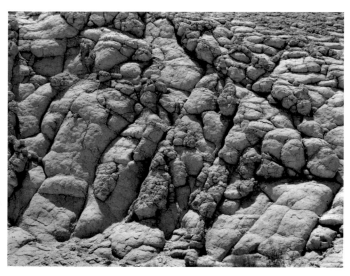

105

The following pair of photographs is a comparison between a vintage Edward Weston print (cat. 109) and a Project Print (cat. 110) from the same negative (see Introduction, p. 11).

109 (plate 63)
Rocks and Surf, California Coast, 1937 SC-SS-5G/37
7⅜ x 9⁹⁄₁₆ in.
Inscribed "EW 1937," on mount, below print, right.
This image was included in the Project.
Bibliography: Enyeart, pl. 108; Conger, 1038/1937.

110 (not illustrated)
Rocks and Surf, California Coast, 1937 SC-SS-5G
7⅝ x 9⁹⁄₁₆ in.
This photograph is a Project Print
Bibliography: see above, cat 109.

111 (plate 62)
Embarcadero, San Francisco, 1937 SF-E-5G
7⁹⁄₁₆ x 9⁹⁄₁₆ in.

112
Roots in Water, Lake Tenaya, 1937 T-Mi-2G
7¹¹⁄₁₆ x 9⅝ in.
Inscribed: "No. 392 (crossed out)/Roots in Water/Lake Tenaya," on verso of mount, center.

113 (plate 64)
Roots, Lake Tenaya, 1937 T-Mi-6G
7⅝ x 9⁹⁄₁₆ in.

114
Trees, Lake Tenaya, 1937 T-T-6G
7⅝ x 9½ in.

112

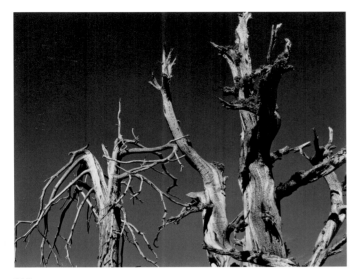

114

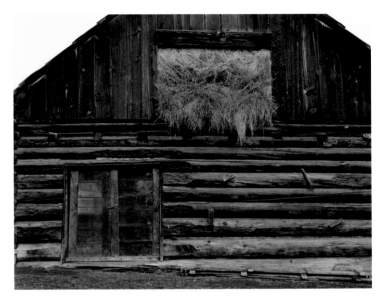

116

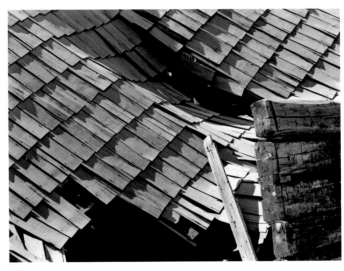

119

115 (plate 65)
At Lake Tenaya, 1937 T-T-7G
8¹⁵⁄₁₆ x 7⁷⁄₁₆ in.
Signed and dated "Edward Weston 1937," on mount, below print, right.
Inscribed: "at lake Tenaya," on verso of mount, upper center; "WW,"
upper right.

116
Barn, Washington, 1939 W-Mi-1G
7¹¹⁄₁₆ x 9⅝ in.

117 (plate 66)
Tent Frames, Yosemite, 1938 YS-B-4G
7⅝ x 9¹¹⁄₁₆ in.
Inscribed: "E W 1938," in another hand, on mount, below print, right.
This image was included in the Project.
Bibliography: Conger, 1250/1938.

118 (plate 67)
Yosemite, 1938 YS-L-10G
7⅝ x 9⅝ in.
Signed and dated "Edward Weston 1938," on mount, below print, right.
Inscribed: "Yosemite," on verso of mount, center.

119
Gin Flat, Yosemite, 1937 Y-Mi-4G
7⁹⁄₁₆ x 9⁹⁄₁₆ in.
Inscribed: "E W 1938 *(sic)*," in another hand, on mount, below print, right.
This image was included in the Project.
Bibliography: Conger, 1084/1937.

120 (plate 68)
Yosemite, 1937 Y-Mi-6G/37
7½ x 9⅝ in.

March 22, 1937		Received notification of award.
March 23 – April 8, 1937		Preparation for first trips: mapping and purchasing supplies.

FIRST YEAR OF GUGGENHEIM GRANT

April 9 – April 17, 1937	Trip 1:	Death Valley
April 18 – April 25, 1937		Los Angeles
April 26 – May 3, 1937	Trip 2:	Mojave and Colorado Deserts
May 4 – May 15, 1937		Los Angeles
May 16 – May 20, 1937	Trip 3:	Colorado Desert
May 21 – June 3, 1937		Los Angeles. Day trip June 3: Ridge Route
June 4 – June 6, 1937	Trip 4:	Mojave Desert and Red Rock Canyon
June 7 – June 8, 1937		Los Angeles
June 9 – June 11, 1937	Trip 5:	Mojave Desert – Wonderland of Rocks (only trip without Charis Wilson)
June 12, 1937		Los Angeles
June 13 – June 17, 1937	Trip 6:	South Coast – Laguna Beach
June 18 – June 28, 1937		Los Angeles
June 29 – July 7, 1937	Trip 7:	Up the coast from Los Angeles to San Francisco
July 8 – July 18, 1937		San Francisco
July 19 – July 29, 1937	Trip 8:	Yosemite and the High Sierra
July 30 – August 5, 1937		San Francisco
August 6 – August 14, 1937	Trip 9:	North Coast
August 15 – August 21, 1937		San Francisco
August 22 – Sept. 8, 1927	Trip 10:	Yosemite
Sept. 9 – Sept. 14, 1937		San Francisco
Sept. 15 – Sept. 22, 1937	Trip 11:	North Coast
Sept. 23 – Sept. 27, 193		San Francisco
Sept. 28 – Oct. 17, 1937	Trip 12:	Northern California (inland)
Oct. 18 – Nov. 8, 1937		San Francisco

Nov. 9 – Nov. 14, 1937	Trip 13:	Down the coast from San Francisco to Los Angeles
Nov. 14 – Dec. 6, 1937		Los Angeles
Dec. 7, 1937 – Jan. 11, 1938	Trip 14:	New Mexico and Arizona
Jan. 12 – Jan. 25, 1938		Los Angeles
Jan. 26 – Feb. 2, 1938	Trip 15:	Borrego Desert and Salton Sea
Feb. 3 – Feb. 7, 1938		Los Angeles
Feb. 8 – Feb. 20, 1938	Trip 16:	Yosemite
Feb. 21 – Feb. 22, 1938		San Francisco
Feb. 23 – Feb. 25, 1938		Carmel
Feb. 26 – March 6, 1938		Los Angeles
March 7 – March 27, 1938	Trip 17:	Death Valley
March 25, 1937		Received notification of extension of grant

SECOND YEAR OF GUGGENHEIM GRANT

June 6 – June 12, 1938	Trip 18:	Yosemite Wildcat Hill, Charis Wilson's and Edward Weston's house in Carmel Highlands, was constructed during this trip. This became their "base."
June 13 – Dec. 13, 1938		Wildcat Hill, Carmel Highlands
Dec. 14, 1938 – Jan. 7, 1939	Trip 19:	Death Valley
Jan. 8 – March 28, 1939		Wildcat Hill, Carmel Highlands
Mar. 29 – April 25, 1939	Trip 20:	North Coast, Oregon and Washington. April 24: married in Elk, California

Adams, Ansel, with Mary Street Alinder. *Ansel Adams: An Autobiography*. Boston, 1985.

Adams, Robert. "The Achievement of Edward Weston: The Biography I'd Like to Read." In Peter C. Bunnell and David Featherstone, eds., *EW 100: Centennial Essays in Honor of Edward Weston. Untitled* 41, Carmel, California, 1986, pp. 25-35.

Alinder, Mary Street and Andrea Gray Stillman. *Ansel Adams: Letters and Images 1916–1984*. Boston, 1988.

Armitage, Merle. *Edward Weston*. New York, 1932.

Baltz, Lewis. "Beyond Romance: Weston Landscape," *Creative Camera* 10, 1986, pp. 30-32.

Brown, Robert W. "For the Photographer: Edward Weston's Work under Guggenheim Fellowship Results in Work on West," *New York Times*, December 8, 1940, Section XI, p. 19.

Bunnell, Peter C., ed. *Edward Weston on Photography*. Salt Lake City, 1983.

Bunnell, Peter C. and David Featherstone, eds. *EW 100: Centennial Essays in Honor of Edward Weston. Untitled* 41, Carmel, California, 1986.

Calmes, Leslie Squyres. *The Letters between Edward Weston and Willard Van Dyke*. Tucson, 1992.

Chalfant, W. A. *Death Valley: The Facts*. Palo Alto, California, 1930.

Conger, Amy. *Edward Weston in Mexico, 1923-1926*. Albuquerque, 1983.

—. *Edward Weston: Photographs from the Collection of the Center for Creative Photography*. Tucson, 1992.

—. *The Monterey Photographic Tradition: The Weston Years*. Monterey, California, 1986.

Danly, Susan and Weston Naef. *Edward Weston in Los Angeles*. San Marino, California, 1986.

Davis, John H. *The Guggenheims: An American Epic*. New York, 1978.

"Desert Tragedy," *Life*, 2:25, June 21, 1937, p. 98.

Enyeart, James. *Edward Weston's California Landscapes*. Boston, 1984.

Federal Writers' Project of the Works Progress Administration for the State of California. *California: A Guide to the Golden State*. New York, 1939.

—. *Death Valley*. Boston, 1939.

Foley, Kathy Kelsey, et al. *Edward Weston's Gifts to His Sister*. Dayton, Ohio, 1978.

Grundberg, Andy. "Edward Weston's Late Landscapes." In Peter C. Bunnell and David Featherstone, eds., *EW 100: Centennial Essays in Honor of Edward Weston. Untitled* 41, Carmel, California, 1986, pp. 93-101.

—. "Edward Weston Rethought," *Art in America* 63, July 1975, pp. 29-31.

John Simon Guggenheim Memorial Foundation. *Charter, Letter of Gift, Constitution and By-Laws*. New York, 1925.

—. *Directory of Fellows 1925-1974*. New York, 1975.

—. *1937 and 1938 Reports of the Secretary and the Treasurer*. New York, n.d.

Jussim, Estelle. "Quintessences: Edward Weston's Search for Meaning." In Peter C. Bunnell and David Featherstone, eds., *EW 100: Centennial Essays in Honor of Edward Weston. Untitled* 41, Carmel, California, 1986, pp. 51-61.

Lomask, Milton. *Seed Money: The Guggenheim Story*. New York, 1964.

Maddow, Ben. *Edward Weston: Fifty Years*. Millerton, New York, 1973.

Newhall, Beaumont. "Edward Weston in Retrospect," *Popular Photography* 18, March 1946, pp. 42-46 (reprinted in Beaumont Newhall and Amy Conger, eds., *Edward Weston Omnibus: A Critical Anthology*, Salt Lake City, 1984, pp. 72-78).

—. *Supreme Instants: The Photography of Edward Weston*. Boston, 1986.

Newhall, Beaumont and Amy Conger, eds. *Edward Weston Omnibus: A Critical Anthology*. Salt Lake City, 1984.

Newhall, Nancy, ed. *The Daybooks of Edward Weston*, 2 vols. Rochester, New York, 1961.

Newhall, Nancy. *Edward Weston: The Flame of Recognition*. New York, 1965.

—. *The Photographs of Edward Weston*. New York, 1946.

—. *Death Valley*, with photographs by Ansel Adams. San Francisco, 1954.

Pitts, Terence R., et al. *Edward Weston: Photographs and Papers*. Guide Series Number Three. Tucson, 1980.

Powell, Lawrence Clark. "California Classics Reread: *California and the West*," *Westways* 62:6, June 1970, pp. 12-15, 60.

Ray, Gordon N. *Guggenheim Fellowships: A Preprint from the Report of the President, 1978*. New York, 1979.

"Speaking of Pictures: Weston's Westerns," *Life*, 3:26, December 27, 1937, pp. 4-6.

Stark, Amy. *Edward Weston Papers*, Guide Series Number Thirteen. Tucson, 1986.

Stebbins, Theodore E., Jr. *Weston's Westons: Portraits and Nudes*. Boston, 1989.

Szarkowski, John. *American Landscapes*. New York, 1981.

—. "Edward Weston's Later Work," *MOMA* 2, winter 1974-75 (reprinted in Beaumont Newhall and Amy Conger, eds., *Edward Weston Omnibus: A Critical Anthology*, Salt Lake City, 1984, pp. 158-159).

Thompson, Dody Weston. "Edward Weston." In Beaumont Newhall and Amy Conger, eds., *Edward Weston Omnibus: A Critical Anthology*, Salt Lake City, 1984, pp. 132-151 (originally published in *Malahat Review*, University of Victoria, British Colombia, 14, April 1970, pp. 39-80).

Weston, Charis Wilson, "Of the West: A Guggenheim Portrait," *U.S. Camera Annual 1940*. New York, 1939, pp. 38-55.

Weston, Charis Wilson and Edward Weston. *California and the West*. New York, 1940.

"Weston Award," *Life* 2:15, April 12, 1937, p. 76, 78.

Weston, Edward. "I Photograph Trees," *Popular Photography*, 6:6, June 1940, pp. 20-21, 120-123 (reprinted in Peter Bunnell, ed., *Edward Weston on Photography*. Salt Lake City, 1983, pp. 115-120).

—. "Light vs. Lighting," *Camera Craft*, 46:5, May 1939, pp. 197-205 (reprinted in Peter Bunnell, ed., *Edward Weston on Photography*. Salt Lake City, pp. 97-102).

—. *My Camera on Point Lobos*. Boston and Yosemite National Park, 1950.

—. "My Photographs of California," *Magazine of Art* 32:1, January 1939, pp. 30-32 (reprinted in *Seeing California with Edward Weston*, Los Angeles, 1939, pp. 5-6 and in Peter Bunnell, ed., *Edward Weston on Photography*, Salt Lake City, 1983, pp. 81-82).

—. "Of the West: A Guggenheim Portrait," *U.S. Camera Annual 1940*. New York, 1939, p. 37.

—. "Photographing California," *Camera Craft* 46:2, February 1939, pp.56-64 (reprinted in Peter Bunnell, ed., *Edward Weston on Photography*, Salt Lake City, 1983, pp. 88-92).

—. "Photographing California, Part II," *Camera Craft* 46:3, March 1939, pp. 98-105 (reprinted in Peter Bunnell, ed., *Edward Weston on Photography*. Salt Lake City, 1983, pp. 92-96).

—. "Seeing California with Edward Weston: The California Coast — San Diego to Monterey," *Westways* 29:8, August 1937, pp. 8-9.

—. "Seeing California with Edward Weston: Carrizo Creek and the Southern Colorado Desert," *Westways* 29:10, October 1937, pp. 8-9.

—. "Seeing California with Edward Weston: Death Valley," *Westways* 29:11, November 1937, pp. 8-9.

—. "Seeing California with Edward Weston: Death Valley II," *Westways* 30:12, December 1938, pp. 6-7.

—. "Seeing California with Edward Weston: Desert Vistas," *Westways* 31:2, February 1939, pp. 6-7.

—. "Seeing California with Edward Weston: High Sierra," *Westways* 29:9, September 1937, pp. 8-9.

—. "Seeing California with Edward Weston: Lake Tahoe and Vicinity," *Westways* 30:10, October 1938, pp. 6-7.

—. "Seeing California with Edward Weston: Lake Tenaya," *Westways* 30:7, July 1938, pp. 8-9.

—. "Seeing California with Edward Weston: Mojave Desert," *Westways* 29:12, December 1937, pp. 8-9.

—. "Seeing California with Edward Weston: Monterey Bay and Vicinity," *Westways* 31:7, July 1939, pp. 8-9.

—. "Seeing California with Edward Weston: Mountain Solitudes," *Westways* 31:6, June 1939, pp. 8-9.

—. "Seeing California with Edward Weston: Northeastern California," *Westways* 30:5, May 1938, pp. 10-11.

—. "Seeing California with Edward Weston: Northeastern California Ranches," *Westways* 31:5, May 1939, pp. 8-9.

—. "Seeing California with Edward Weston: The Northern Coast," *Westways* 30:1, January 1938, pp. 8-9.

—. "Seeing California with Edward Weston: Owens Valley," *Westways* 30:8, August 1938, pp. 6-7.

—. "Seeing California with Edward Weston: Point Lobos and Oceano," *Westways* 30:9, September 1938, pp. 6-7.

—. "Seeing California with Edward Weston: Red Rock Canyon," *Westways*, 30:3, March 1938, pp. 8-9.

—. "Seeing California with Edward Weston: The Redwood Highway," *Westways* 30:2, February 1938, pp. 8-9.

—. "Seeing California with Edward Weston: The Salton Sink and Borego Valley," *Westways* 30:11, November 1938, pp. 6-7.

—. "Seeing California with Edward Weston: Tomales Bay and the Bodega Coast," *Westways* 31:3, March 1939, pp. 4-5.

—. "Seeing California with Edward Weston: Yosemite under Snow," *Westways*, 31:1, January 1939, pp. 6-7.

—. *Seeing California with Edward Weston*. Los Angeles, 1939.

—. "What is a Purist?" *Camera Craft* 46:1, January 1939, pp. 3-9 (reprinted in Peter Bunnell, ed, *Edward Weston on Photography*, Salt Lake City, 1983, pp. 83-87).

—. "What is Photographic Beauty?" *Camera Craft* 46:6, June 1939, pp. 247-255.

Wilson, Charis. *Journal of Guggenheim Year 1937-1938*. Unpublished manuscript in the collection of the Huntington Library, San Marino, California.

—. [Halliday, F.H.], "Edward Weston." *California Arts and Architecture* 30, January 1941, pp. 16-17, 34-35 (reprinted in Beaumont Newhall and Amy Conger, eds., *Edward Weston Omnibus: A Critical Anthology*, Salt Lake City, 1984, pp. 66-69).

—. *Edward Weston: Nudes*. Millerton, New York, 1977.

Wilson, Charis and Edward Weston. *California and the West*. Millerton, New York, 1978 (revised edition of 1940).